How to Photograph

Landscapes & Scenic Views

David Brooks

Executive Editor: Rick Bailey
Editorial Director: Theodore DiSante
Editor: Vernon Gorter
Art Director: Don Burton
Book Design: Kathleen Koopman
Photography: David Brooks, unless otherwise credited

Published by H.P. Books, P.O. Box 5367, Tucson, AZ 85703
(602) 888-2150
ISBN: 0-89586-208-5 Library of Congress Catalog No.83-81658
© 1983 Fisher Publishing, Inc. Printed in U.S.A.

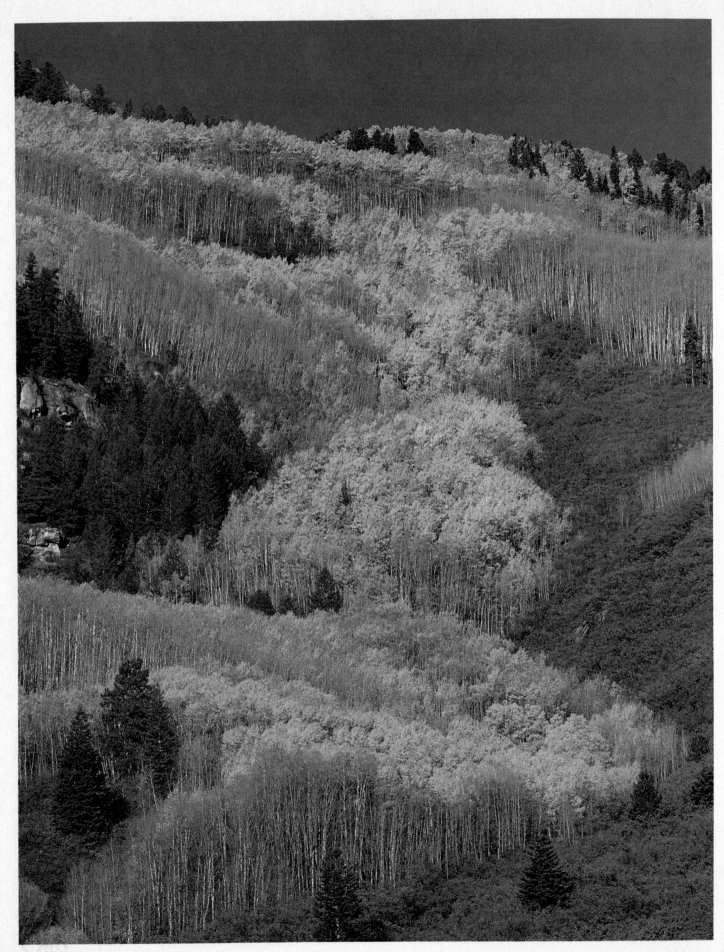

Contents

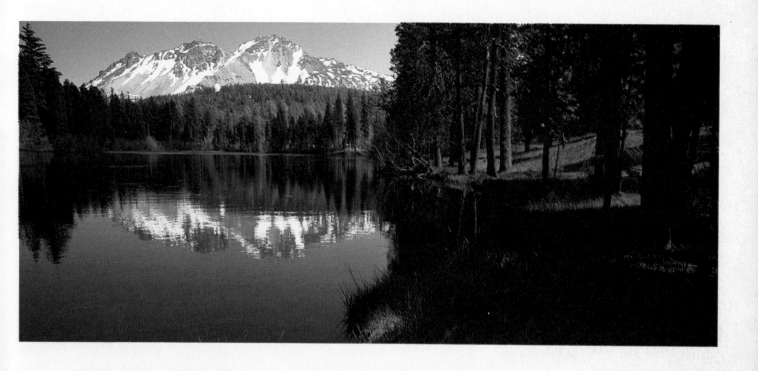

Introduction

This book is for the amateur photographer with a serious interest in photographing landscapes and other scenic subjects. I assume that you understand basic camera techniques and photographic principles. You need not fear any unduly complex theory or laborious procedures in the following pages.

I'll present an organized method of approaching and photographing your subject. The goal is consistent and predictable results. I won't attempt to impose specific ways of working, just because I happen to favor them personally in my work.

Predictable results are important because landscape photography often involves travel. If your photographs are not a success, returning to the scene can be inconvenient, expensive, or even impossible. Your working technique should be *dependable*.

Landscape photography requires *translating* a three-dimensional, real-life scene into an image on photographic film. To do this effectively, you must first truly *see* the subject. Become aware of its physical characteristics, its reflectance values, aspects of the illumination, and the scene's aesthetic appeal. You must also understand your camera equipment and have control of the recording medium, the film.

In the following chapters, you'll read about popular cameras ranging in format from 35mm to 4x5. I'll discuss color films and black-and-white (b&w) films of various types. To help you use these tools, I'll lead you through the decision-making steps of seeing, *visualizing,* and recording the image.

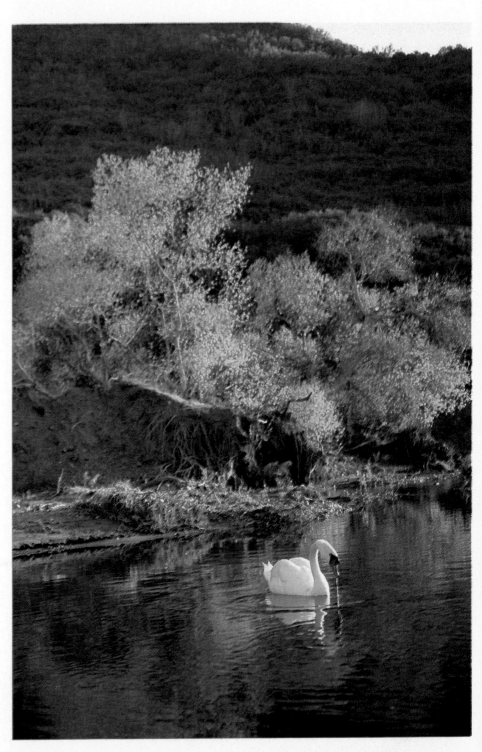

The bright, white swan provides foreground interest. It brings the scene to life. When you use a living foreground, be sure it is in the right place to give a pleasing composition. Also, wait for an attractive *pose.* Notice that the swan alone would also make an attractive picture.

What is Landscape Photography? 1

To understand what landscape photography is, and what it is not, it's useful to briefly review its history. It's also important to examine the reasons why people make landscape and scenic photographs. You should know this, even if you plan to depart from the conventional approach to landscape photography.

A simple chronological rundown of events in the history of photography is not particularly useful here. A much more helpful and stimulating method is a visit to a large library. There you can find a wealth of published illustrations by past masters. You'll also find much written material by and about those who have influenced landscape photography.

FROM SCENIC SNAPSHOT TO LANDSCAPE PHOTOGRAPH

A *scenic snapshot* is simply a photographic record in which aesthetic considerations are not a factor. A *landscape photograph* is made with forethought and deliberation. The snapshot compares with the landscape photo in about the same way a doodle on a notepad compares with a Picasso sketch.

The snapshot has its justifiable place. It lets practically everybody record, store, and even prove to others his most exciting experiences. How often have you heard, ". . . and this is the wife and kids in front of Old Faithful''? George Eastman, founder of the Eastman Kodak Company, understood this need. He marketed it to the world under the now-famous slogan, "You press the button; we do the rest."

The snapshooting tradition

This is a typical photo that could be used for many different display purposes. It doesn't show a specific, recognizable place. And it's attractive and warm.

created by Kodak's Box Brownie lives more strongly today than ever. Millions of people have electronic, auto-focus, auto-exposure and instant cameras.

The landscape photographer assumes conscious responsibility for the result he achieves on film. He considers image composition, lighting, mood, and optimum camera and film technique. When you take control, you *make* a land-scape photograph, rather than just *taking* a snapshot of a scenic view. You do not just point and shoot. You *manage* the production of the photograph from beginning to end. After exposing, you also control film processing to get the quality and mood you want in the final picture.

The snapshooter hopes that his pictures will "come out." The creative photographer cannot afford to have this passive attitude. He must *make* the picture. He can't steal it, or *take* it.

Fox Talbot and Daguerre, two early photographic pioneers, made some of their first photographs of landscape subjects. Although they were scenic views, they weren't really landscapes. These pictures were taken simply for expediency. In the days when emulsions were extremely slow, and exposure times accordingly long, the scenes offered static subject matter. Furthermore, the pictures were made for experimental purposes—not primarily with a beautiful scenic picture in mind.

PHILOSOPHY AND AESTHETICS

Not long after the introduction of the photographic process to the world in 1839, a lively debate began. People argued whether photography had a role in the arts. To some extent, this heated debate continues to this day.

Fox Talbot foresaw legitimate artistic purposes for the process he had helped invent. As might be expected, traditionalists with a vested interest in the painterly arts were emphatically opposed to Talbot's view.

Copying the Painters—Many early photographers tried to give their work the same aesthetic qualities found in paintings of the day. To avoid the sharp and accurate detail provided by the camera—a feature indicative of an image-producing "machine"—many deliberately put the image slightly out of focus. This softened the "photographic" effect and obliterated some fine detail. It made the picture look more like a painting.

To satisfy the demand by photographers to create images that were less real and more idealized, soft-focus lenses were produced. This development was one of the factors that helped to lead to the *pictorial* school. Historians of photography sometimes also call it *subjective, idealistic* or *impressionistic* photography.

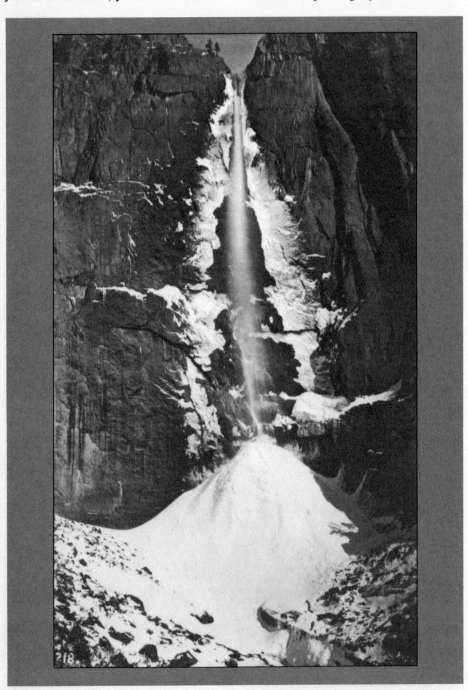

When George Fiske photographed in the 19th century, films were slow. Motion-stopping photography was not possible. But the imaginative photographer could still produce impressive photos like this one by Fiske of the Upper Yosemite Falls, California in late winter. Photo provided by *Center for Creative Photography,* Tucson, Arizona.

But the attempt to copy painting did not entirely do the trick. In spite of painterly effects like soft focus and textured negative paper, the debate about photography as art persisted.

Straight Photography—The pictorialist school dominated landscape photography from the earliest years. In the 1930s, it was challenged by what might be called *straight* photography. Among the leaders who advocated realism in landscape work was Ansel Adams, a young Californian photographer. He was a founding member of the *f-64 Group,* whose members also included Edward Weston and Imogene Cunningham.

The style of the f-64 Group continues today. Even so, the philosophical conflict has not been settled. It probably never will be. But the straight photography done by Ansel Adams in the western United States has become familiar to viewers throughout the world. Together with others—notably Edward Weston, Minor White and Harry Callahan—Adams has founded a veritable *establishment* of fine-art landscape photography.

Pictorialism Persists—The pictorialist influence has not disappeared. It can be recognized in much of the work done by members of many camera clubs associated with the *Photographic Society of America (PSA).* An even greater effort to sustain the movement is being made by the members of the much smaller *New Pictorialist Society.*

Many of the current generation of *fine-arts* photographers have reverted to the old printing techniques originally used by the pictorialists. These include the Carbro, Cyanotype and Gum Bichromate processes. An even further departure from straight photography is the surrealistic multiple images produced by Jerry Uelsmann.

Today, it would be difficult to label many fine-art photos as belonging exclusively to either school—straight or pictorial.

Photography Accepted as Art—In principle, photography is now accepted as a legitimate art form. But controversy still continues regarding what *kinds* of photography this includes. Some purists contend that only those images created for their own sake—and not for commercial gain—are legitimate works of art. Yet, curators of prestigious museums have chosen to hang the works of professional photographers.

Galleries and museums hang fashion photographs by Irving Penn and Richard Avedon. They display professional portraiture by Arnold Newman and Phillipe Halsman. They present editorial illustrations by Ernst Haas, W. Eugene Smith and Eliot Porter. In spite of being commercial work, this photography has been accorded the status of "fine art."

For well over a century, photographers have attempted to establish a niche for themselves in the arts and still, to a large extent, the debate continues.

Ultimately, it is not really appropriate to question whether photography is an art. Or, whether this kind of photography is more of an art than that kind. Surely, in the hands of the true artist, photography cannot fail to be art.

HOW LANDSCAPE PHOTOGRAPHS ARE USED

As mentioned, good landscape photography requires planning. An important consideration in your plan must be the *purpose* of the photograph. You may be creating the image simply for personal expression and satisfaction. Or, you may have a very specific use in mind when you set out to make a photograph. Your photographic style and technique will, to some extent, be determined by the photo's ultimate use.

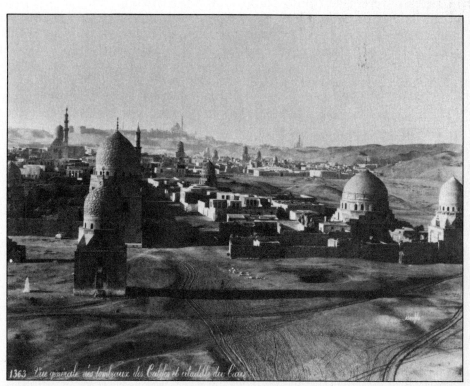

This kind of landscape photograph becomes more interesting and valuable as time passes. The scene shows the citadel and tombs of Muslim leaders in Cairo toward the end of the 19th century. Photograph by Felix Bonfils. Photo provided by *Center for Creative Photography,* Tucson, Arizona.

Documentation—The documentary photograph, like the documentary movie, primarily informs. Almost as soon as photography was invented, it was used to document places of scenic or historic interest.

As travel became easier and more economical, the public's appetite for information about the world increased dramatically. It also generated a demand for pictorial information. And photography provided it.

Because the purpose was to provide accurate and objective information, the photographic style was often straightforward. Usually, little thought was given to creative or interpretive techniques.

Today, it's easy to find excellent, and artistic, documentary photographs. Consider the pages of *National Geographic* and *GEO* magazines, for example.

As cameras and light-sensitive materials were improved, making action photography possible, the documentary photographer recorded more active events. Cameras were taken onto battlefields to record war scenes. With the advent of ever-faster lenses and emulsions, photojournalism was born.

Documentary photography did not *have to* lack artistic appeal. This is clearly evident in the urban landscapes made by the Parisian photographer Eugene Atget about the turn of the century. His street scenes are generally recognized as documentation at the level of fine art.

The impact of documentary landscape photography was soon recognized. It not only informed, but also influenced public opinion. This is especially evident in the images made during the Great Depression under the sponsorship of the United States Farm Security Administration. Many of the photographs—particularly those made by Dorothea Lange, Walker Evans and Arthur Rothstein—are now considered to be important contributions to the art of photography.

In more recent times, documentary landscape photographs have played an important part in social and political debates. For example, they're used to promote environmental causes.

Some recent and contemporary documentary photographers give both historical and artistic value to their documentary photographs. Notable among these are Max Yavno, Lou Stoumen, Morley Baer and Louis Baltz.

Several distinct photographic disciplines are closely accociated with the documentary landscape tradition. One of the more significant of these is architectural photography.

Illustration—There's a considerable overlap between documentary and illustrative landscape photography. In a documentary presentation the picture is always first and foremost. The accompanying words serve merely to explain the photograph. In an illustrative photo, the picture is often secondary, serving to illustrate an existing text.

The illustrative photograph is often tailored to meet a specific need. It may illustrate a book on history or geography, an adventure story or a travel poster. It may sometimes be a highly subjective, interpretive image that greatly distorts the real scene.

Most illustrative landscapes are reproduced in books or magazines. This limits the size of the reproduced image. It also tends to make it a form of personal rather than mass communication. The photographer must carefully determine his approach to subject and technique to achieve the desired effect.

The illustrative photographer has an additional challenge—capturing the prospective viewer's interest. This is no easy task, considering the amount of imagery we see daily. We're bombarded by images in magazines, direct-mail advertising, on television, billboards and many other commercial displays. Before the photographer can influence the viewer, he must first get him to take notice.

Decoration—Ever since landscape photographs were first made, they have been displayed. They are hung on the walls of homes, offices and public buildings as decoration. The photographs were frequently made for other purposes, such as documentary, illustrative, commercial or calendar use. Only relatively recently has landscape photography specifically for decorative purposes become popular.

The rapid growth of this specialty is partly due to the promotional efforts of the *Eastman Kodak Company* and the *American Interior Design Association (AIDA)*. Kodak has sponsored exhibits of the decorative applications of photography at AIDA conventions all over the United States. It has also published books describing the use of photographs in interior design. Supportive materials, technical assistance, and promotional help have also been provided by Kodak to professional photographers and laboratories.

Color photography plays an important part in interior decorating. Photos may be chosen to suit a specific business or activity or to complement a particular design scheme. At home, photo displays generally have a personal significance. Sometimes, photographs are made specifically for display purposes. At other times, existing pictures are selected.

A typical example of the *straight* photography done by Edward Weston, Ansel Adams and some of their contemporaries. This photo, entitled *Driftwood, Dark Roots, Maine,* was made by Paul Strand in 1928. Copyright 1950, 1971 and 1977 the Paul Strand Foundation, as published in *Paul Strand: Time in New England,* Aperture, Millerton, 1980. Photo provided by *Center for Creative Photography,* Tucson, Arizona.

Documentary photography came into its own during the depression of the 1930s. At that time, the *Farm Security Administration* sent photographers around the country to record the conditions of the land and the hardship of its people. This photo was made in western Texas in 1938 by Dorothea Lange. Photo provided by *Center for Creative Photography,* Tucson, Arizona.

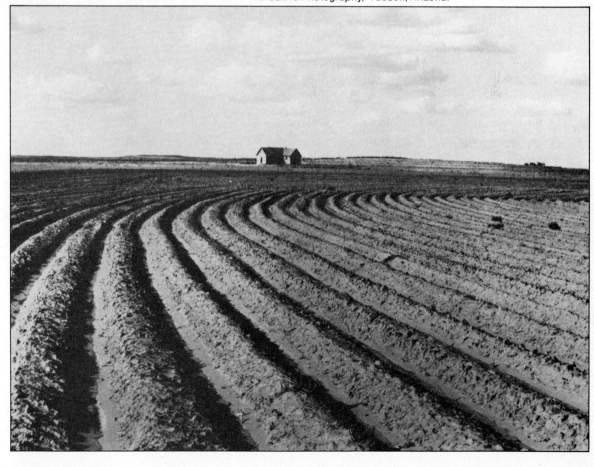

Some independent commercial processing laboratories, notably Meisel Photochrome Corporation, have contracted with individual photographers to build extensive libraries of decorative images. These images are either cataloged for custom sales through interior designers or reproduced in quantity for retail sale. You may find such images at department stores that sell interior furnishings.

There is a great diversity in the photographs currently being produced for decorative purposes. This reflects the broad spectrum of buyers, including industry, hospitals, offices, hotels and home owners.

Some clients of interior designers demand images that complement the atmosphere and activity of their business or institution. Others are concerned that the photographic decoration evoke an appropriate emotional and psychological response. Frequently, a photograph is commissioned especially for a certain purpose or place.

Slide Shows—Shows of projected images have a history almost as long as the printed photograph. Today, slide shows are used universally for promotional and educational purposes and for private entertainment. Naturally, landscape photographs will frequently be part of a *travelog* type of slide show, such as a show of vacation photos.

To create an effective slide show, you should plan ahead. Determine what the basic story line or concept should be. You can then create a *story board,* which functions like an outline for a book. When possible, do all this before even the first picture is taken. Even at this early stage, you should give consideration to the relationship between the visual images and the accompanying commentary.

With such a plan, you'll be able to make your landscape slides with

One of the main attractions of this scene is its texture. To record this in the most dramatic way, low sunlight is best.

The detail in the textured surface of this rough landscape becomes smaller as it recedes into the distance. This helps to give the photo a feeling of depth. The blue haze in the distance helps to enhance the feeling of spaciousness.

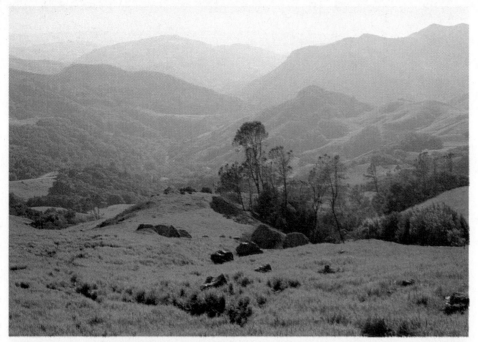

This scene was photographed on an overcast day. Although it is a *soft* image, it has a full tonal range—from the dark trees in the center to the almost white distant sky. Haze increases with distance to create the impression of depth.

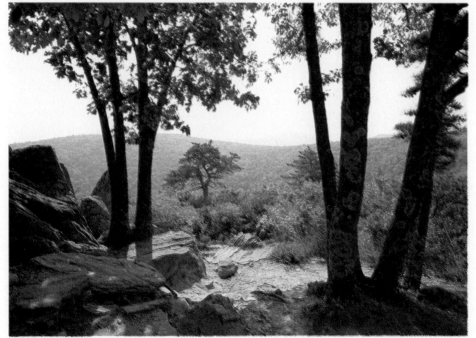

Here, the feeling of distance is created largely by the comparison of similar objects. The distant tree, framed between the foreground trees, gives the viewer a good idea of the distance between the two.

confidence, knowing they'll fit well into the show.

To hold the interest of your audience, be sure to add a change of pace. Alternate distant scenes with close detail, bright colors with subtle hues, restful scenes with pictures of lively activity, and so on.

This emphasis on planning does not mean you can't produce an attractive slide show with existing slides. However, to achieve good continuity, you will usually need to make some special, additional photographs.

In recent years, slide-show production has become particularly challenging with the advent of the *multi-media* presentation. It requires multiple projectors, dissolve units and computerized controls.

Most of the qualities that make a good movie have their parallel in this kind of slide show. Much more is needed than just careful editing to select images that'll tell the story effectively. To create an entertaining and informative show, you must give a lot of attention to flow, continuity, rhythm and drama. When you plan to make a multi-media show, you'll often need to make special photographs that fit your plan exactly.

Slide-show production presents a special challenge to the landscape photographer. Very often the qualities that lend continuity, variety and vitality to a slide show are different from those that lead to a good single landscape photograph. Remember, when you make a slide show you're halfway toward making a movie.

LANDSCAPE SUBJECTS

It isn't possible to separate the various kinds of landscape photography into distinct categories. There is some overlap. However, the following basic definitions will be useful if you're just starting out. **Natural Subjects**—The natural landscape includes virtually everything in our physical environment that hasn't been affected by human activity. *Geological Forma-*

tions describe the basic structure of the earth. This includes hills, mountains and plains without vegetation, sand dunes, desert and rocks.

Plant Life includes forests, meadows, marshes and the individual living organisms, such as trees, flowers, grasses and mosses. *Animal Life* refers to those animals that live in the natural environment in a wild state.

Water as a subject can include everything from a stream, lake, river and ocean to a droplet on the tip of a leaf. Shores and beaches also fit into this category. The *Atmosphere* embraces all the natural, visible conditions of the air and sky—cloud formations, sunsets, fog, rain and mist.

The Human Environment—Most of the world we live in—sadly or happily, depending on your opinion—has been affected by the hand of man. This category includes only those scenes in which the result of human intervention is apparent. Sometimes the distinction between the natural and the human environment may be dubious. Good examples are a forest that has been logged or a meadow that has been cleared.

The *Urban Landscape* encompasses man-made structures in cities, towns and villages. In addition to homes, offices, factories, streets, sidewalks and walls, it includes planted areas such as parks and lawns. The definition applies to both general views and close-ups of small detail. The *Rural Landscape* encompasses farms and ranches and their surroundings. This includes pastures, cultivated fields, houses, barns, fences and windmills, in addition to machinery and domestic animals.

The *Industrial Landscape,* as the name implies, refers to industrial structures and installations, such as bridges, dams, mines, oil wells and refineries.

Aquatic Structures are the man-made objects commonly associated with fresh- and salt-water marine environments. These include

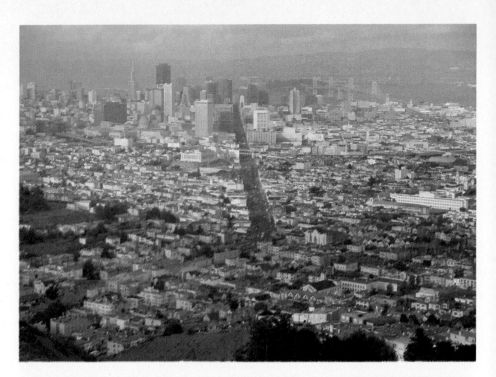

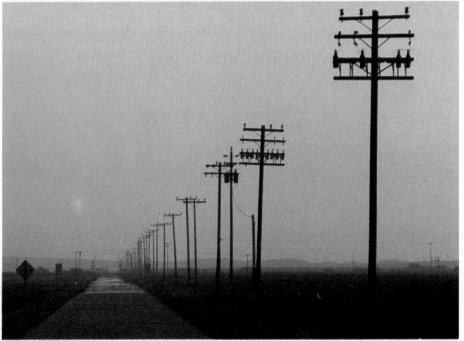

harbors, marinas, piers, jetties and boats. Man-made lakes would not normally fall in this category, unless they look obviously artificial.

Not all photographers who produce landscape images regard themselves first and foremost as landscape photographers. They include the travel photographer, the nature photographer, and the social commentator or "street photographer."

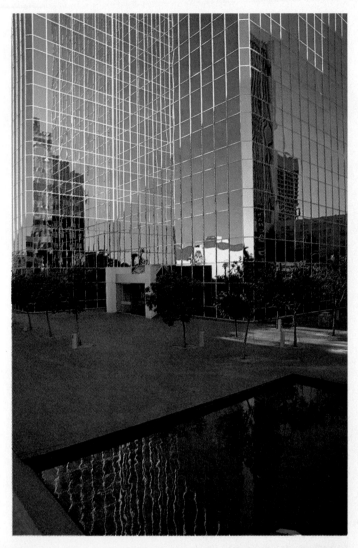

Man's influence on the landscape is wide and varied. A panoramic city view (top left), a row of telephone poles (bottom left), giant glass structures on downtown streets (top right) and a simple rural gas station (below) all offer material for the photographer.

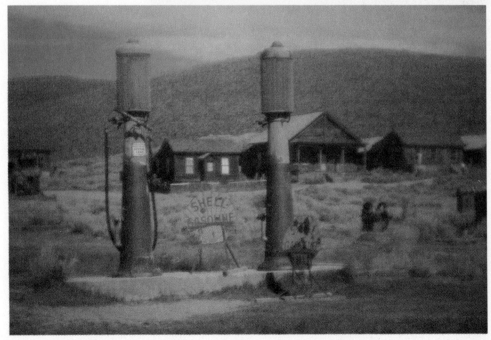

The cluster of yellow blooms in the foreground helps this composition. By contrast, the plants also tend to make the remainder of the scene look especially barren.

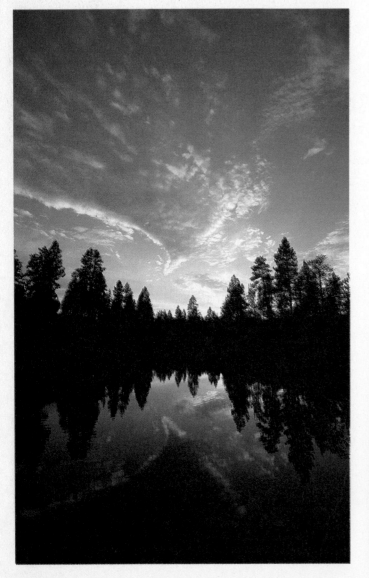

The landscape photographer can achieve many different effects with water. Here, the early morning sky was reflected in the mirror surface of a calm lake. The trees were facing the still-dark part of the sky. They, and their reflections, were recorded in silhouette.

Rural sunrise. I used the farm building to shield the camera from the sun, which had just appeared above the horizon.

Though human vision and photography have much in common, there are also many important differences. In this chapter, sight and its relationship to photography is described. This will help you understand the major physiological and intellectual steps involved in photography. I'll take you from the moment you first see a scene to the final step of holding a finished photograph.

When you see, you perceive. *Perception* must be followed by *visualization* before *realization* of the photograph can occur.

I'll begin by making some comparisons between the eye and the camera.

EYE AND CAMERA

Both the eye and camera are light-tight enclosures. Each admits the light reflected from, or emitted by, a scene through a lens. The lens forms a focused image on a light-sensitive surface.

The Lens—The lens in your eye focuses automatically. All you need do is direct your attention to a specific point on an object or scene. The lens in the eye changes its shape, and thus its focal length, to keep the point of interest in focus. In the focusing process, the eyeball itself does not change shape or size.

A camera lens is different. Usually, you must focus it manually. To make a sharp image in the camera, you adjust the distance between the lens and the film. The basic shape of the lens does not change, although in some lens designs the *relative* positions of lens elements are altered during focusing.

A good-quality camera lens will

I wanted to concentrate the viewer's attention on the shiny metal roof. The subject brightness range was very wide. I wanted to retain textural detail in the roof. I also intended to render the rest of the scene dark without losing detail. This called for very careful operation. I had to select film type, development and exposure carefully. This is a typical example in which the original scene had little resemblance to the deliberately created photographic image.

focus the image with uniform sharpness over the entire film area. The lens in a human eye gives you a useful sharp image only within a small central area. Many of us aren't aware that we never see an entire scene in sharp focus at the same time. We only get the impression that we do. We do it with our natural ability to rapidly scan the subject, refocusing constantly as we do.

If you don't believe it, try this simple experiment: Stand about eight feet from a brick wall. Concentrate your vision on one brick, near the wall's center. With your peripheral vision, you'll see much of the wall. However, detail

will fall off very rapidly from your central point of attention.

The Iris—A feature of practically all camera lenses is an adjustable iris, or *aperture*. With it, you control the amount of light that passes through the lens. The iris in the eye, located immediately in front of the lens, does basically the same thing. However, there are some important differences.

The range of aperture variation in the camera lens is usually considerably greater than in the human eye. The eye compensates for this at the lower end of the brightness scale by *adaptation*. The sensitivity of the eye to light is enhanced.

You can use the image distortion caused by a fisheye lens creatively. This simple scene becomes almost a circular pattern with a focal point at the center. Notice that straight lines curve more and more as they approach the image edge. Lines that run through the center of the picture remain straight. An added bonus with an ultra-wide-angle lens is almost unlimited depth of field.

A wide-angle lens offers great depth of field. In this photo, you can see close and distant objects in sharp focus at the same time. When viewing the actual scene, your eye must scan the various elements to create the illusion of sharpness over a great distance range. Here, the shadows coming toward the camera help to create a three-dimensional effect.

With the aperture in the camera lens you can also control *depth of field*—the zone of sharp focus from front to back. This depth-of-field control does not apply to our vision because of the scanning characteristic described earlier.

The Shutter—The camera shutter controls the length of time light strikes the film. Used in conjunction with the lens aperture, the shutter controls film exposure. Exposure control is essential if you want a high-quality photograph. To put it in extreme terms, excessive exposure can result in a black piece of negative film, with no image detail. Much too little exposure results in a totally transparent sheet of negative film, again with no apparent image.

The nearest thing the eye has to a shutter is the eyelid, but there is really no relationship. The eyelid mainly serves a protective purpose, similar to a lens cap.

The Image-Receiving Surface—In the camera, the image is projected by the lens onto a flat film surface. The film's color balance and light sensitivity is uniform over its whole surface. When you use a good lens, image sharpness extends over the entire picture area. Image brightness will not appear to fall off toward the edges.

The eye behaves differently. Not only is the image projected onto a curved or spherical surface, but the different parts of that surface serve a variety of needs. As you already know, the image appears in full detail only at the center. Color sensitivity decreases toward the edges of the field of view.

The sensitivity, or *speed,* of a specific photographic film is essentially fixed. The light sensitivity of the eye is variable. The eye can *adapt* to enable it to see better in dim light. For example, when you enter a dark theater from the sunlit street, you grope toward your seat. After a few minutes, you can clearly see much of the detail around you.

The eye can also adapt to illumination of different color characteristics. For example, a sheet of white paper will usually look white. It doesn't matter whether you look at it under a blue sky, by the light of a 60-watt tungsten bulb, or under fluorescent lighting. A color-slide film must be designed for one specific kind of light source for good color reproduction.

Here are some other characteristics of the eye that may interest you, although they do not directly relate to the subject of photography: In extremely dim light, the eye tends to lose its color sensitivity altogether.

In very dim lighting, peripheral vision becomes better than central vision. Even though peripheral vision doesn't reveal sharp detail, it is highly sensitive to subject movement. For example, through the corner of your eye you can clearly distinguish the motion of a puff of smoke from a chimney. But you won't realize that it *is* a puff of smoke until you look straight at it.

The Total Image—The important eye characteristics to remember

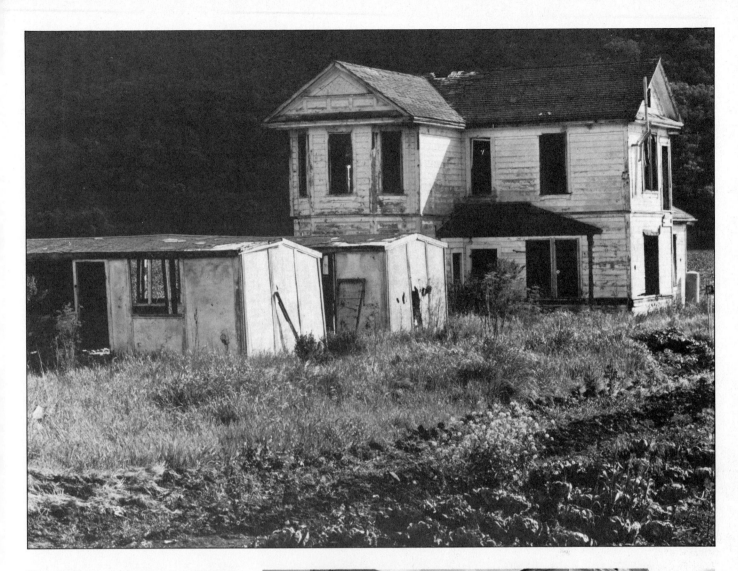

Visualization can include the deliberate choice of color or b&w film for a specific scene. The b&w print concentrates your attention on tones and textures in the house. The foreground has relatively little impact. In the color image, your attention is drawn to the green environment in which the old house stands.

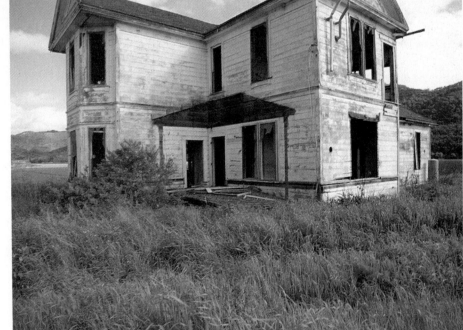

are its way of scanning a scene and its ability to adapt to different light levels. These features, when combined, enable the eye to distinguish a far greater range of subject brightnesses than most films. I'll talk about this more fully under *Visualization,* later in this chapter.

17

PERCEPTION

Perception is more than just physical vision. It is also a *mental* process. It is this mental function that lets each one of us experience the world uniquely. Photographically, it is important to distinguish between perceived things that can be recorded on film and things that *cannot* be translated beyond individual experience.

For example, you may make a photograph of a forest scene that has always appealed to you. The finished photograph may be disappointing and you wonder why this should be. Then you realize that the particular attraction of that scene was always the aroma of cedar and fir and the murmur of the breeze in the tree tops. These involve other senses—smelling and hearing— that are non-visual and cannot be recorded on film.

Of course, the challenge to the creative photographer is to create a visual record that suggests these other sensations. But the important thing to remember is that non-visual sensations cannot be recorded directly in a visual medium.

Our perception can limit, distort and, in some cases, even extend what the eye actually sees.

Learning to See—From early childhood, the mind is conditioned and influenced to see things in a certain way. Here's a typical example. Clouds are usually thought to contain white and some shades of gray, but no color. That's because we have always "known" that clouds are white. When we actually *look,* we find that cloud formations can contain all kinds of different color combinations. These can include pink, orange, purple, and sometimes even some green. There can be a difference between what we *think* we see and what we actually *do* see.

Memory—Recognizing things from experience can affect our perception both positively and negatively. Although familiarity

Often, the subject matter in a scene is less important than the shapes, colors and textures it presents. The interrelationship of the various geometric shapes makes this a successful photograph.

Here, texture and pattern are framed to exclude most of the subject matter. Viewer response will be different from that of a person actually at the scene. The latter will relate the photographed section to the whole subject. To the viewer of the picture, the all-important thing is the pattern and texture. To make such a photo effective, you must be aware that the camera sometimes sees differently than the eye.

may in some cases let you see a subject more effectively, the opposite may also happen. Memory—good or bad—can distort what you perceive. Too much familiarity can also deaden the senses, causing you to see things less consciously and more automatically.

When you go to a foreign country, suddenly you become more aware of your physical surroundings. The architecture is different from that in your familiar environment. Similarly, you may pass the local landmark on your Main Street every day on your way to work, and never notice it. You don't become aware of it until the day it is given a new coat of paint.

A lack of familiarity can sometimes also be a threat, bringing into play a psychological

self-defense mechanism. This is why it is often difficult for new art forms to find acceptance.

Emotion—The way you feel about something or somebody has a striking effect on the way you perceive and translate the subject. Ask a child to paint a picture of his school, neighborhood or dog. You may get to see much more than just a building, place or animal. You may learn something about how the child *feels* about these subjects.

Other Senses—The sense of taste comes under the same heading as sound and smell. It can't be photographed. The sense of touch is a little different. Although it cannot be recorded on film, it is the one sense you can *simulate* effectively. Appropriate lighting brings out surface texture, shape and other tangible features.

Culture—As children, we learn to perceive visual sensations in about the same way we learn to speak—almost automatically. The language we speak, and the way we use it, is determined by the culture we're born into. In a similar way, a large part of our perceptual learning is peculiar to the culture in which we live.

The significance of this was shown quite dramatically during the early days of the Peace Corps. Instructional films made in the United States were shown in primitive societies to people who had never seen a movie before. These people had never experienced two-dimensional representations of the real world—either on paper or on a projection screen. As a result, they did not see the images you and I would see. Instead, they saw only meaningless two-dimensional shapes and patterns.

It's important to realize that much visual experience is influenced by the kind of factors just described. As photographer, you need not fear these factors, or regard them as something undesirable. On the contrary, the process of perception enables each

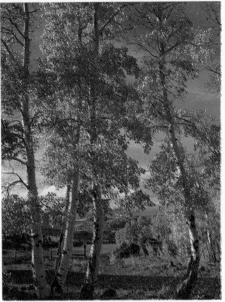

This is an average scene. The overall subject brightness very closely resembles the brightness of an 18% gray card in the same lighting. Subject contrast is moderate. Most built-in light meters would give satisfactory exposure of this scene.

This scene is considerably darker than the equivalent of 18% gray. An exposure-meter reading would lead to overexposure and too bright an image. Here, you must *interpret* the meter reading to give you the kind of image density you had *visualized.* To create a dreamy mood, I used a soft-focus attachment on the camera lens. The soft-focus attachment also helped to reduce image contrast.

This is a landscape by suggestion rather than a real landscape. It's a farm scene that *suggests* surrounding fields and corrals. A soft-focus attachment on the camera lens gave the picture a dreamy, idealized quality.

of us to see the world in a unique way. And what could be more conducive to creative work?

VISUALIZATION

Visualization is the translation of the perceived image into the language of photography. It is the step where you decide what aspects of your viewed experience can be adapted to the photographic process. You must then decide what techniques to use to produce the desired photo. At this stage, you must be able to imagine what the image might look like on film.

When you look at the scene you want to photograph, you must see in your mind's eye the finished print or transparency. You must then choose the photographic techniques best suited to make the *translation* from scene to recorded image.

Essential image-control techniques are explained later. For now, I'll give you a brief glimpse of the important role of visualization.

Sensitometry—This is the science of measuring the response of photographic materials to light. It is important to remember that the eye and photographic film respond to light in different ways.

Remember, the eye scans a scene, point by point, and readily adapts to different levels of illumination. This enables it to distinguish detail within a much greater brightness range than most film. You may see detail in the very brightest and darkest sections of the subject. The film may record those areas as white or black, without any detail. In your visualization of the scene, you must take this into account.

The Zone System—This b&w tone-control system was developed by Ansel Adams and has been written about by many. It presents an organized and rational way of establishing compatibility between the scene's brightness range and the b&w film's sensitometric characteristics.

The Zone System also serves as a constant reminder that an exposure meter does *not* determine *exposure* settings. It merely gives a *light* reading. You must determine exposure by *interpreting* the meter's reading. More about this later.

Incidentally, you can use a tone-control system like the Zone System to translate scene brightnesses into photographic tones, either realistically or not. See *How to use the Zone System for Fine B&W Photography,* also published by HPBooks.

Color or B&W—Your decision must be based on what you consider the dominant characteristics of the scene. Do they include mainly shape, texture and tonality, or does color play a significant part? Do the colors contribute to a harmonious composition, or are they discordant? Is it within your capabilities to modify the color arrangement within the basic composition?

Study the work of distinguished color photographers like Ernst Haas and Eliot Porter, and recognized b&w experts like Wynne Bullock and Laura Gilpin. Try to understand why each picture was made in the way it was. Also, try to imagine the color photographs as b&w and the b&w as color.

Depth of Field—When your eye scans a scene, you get the impression of seeing the entire scene in sharp focus. To create this same impression in a photograph, you must focus carefully and use a small enough lens aperture to give an acceptably deep zone of sharp focus.

If you want to create the impression that you are concentrating on one isolated part of the scene, you can use *selective focusing.* You focus the camera on the point of interest, and then use a lens aperture large enough to put most of the remainder of the scene out of focus. You must use controls like this to record on film things your mind's eye sees.

REALIZATION

You should by now have two different images in your mind. You should *see* the view out there in the real world, and the one you want to record on film. The next vital step is *realization.* It involves the proper use of camera and film to convert the scene into a tangible photographic fact.

You must select image size and format, camera viewpoint and appropriate lens. You must choose the film type, exposure, and the proper film-processing technique. In doing this, you have one goal in mind—the finished photograph.

Each decision you make is likely

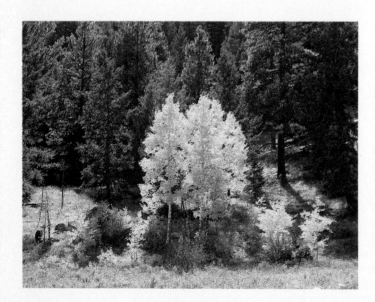

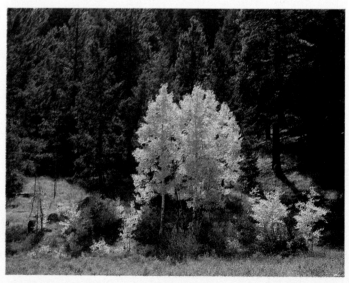

to influence the picture. Look at your photographic technique as a total process of interrelated steps, rather than totally separate acts.

Real control comes with experience. This refers to more than simply making photographs. It involves a total familiarity with your tools—lens, shutter, film, developer and so on.

Don't buy just any film, simply because someone recommends it. Don't rely on the film-speed setting recommended by a film manufacturer. First check how the setting fits with the behavior of your shutter or your aesthetic needs. In short, *experiment.*

Testing and experimentation may seem like a lot of extra work and expense. But the experience you gain from it can give you control. It's well worth the effort. Consider the alternative—being at the total mercy of the tolerance variables found in shutters, lenses and film emulsions.

If you are to be able to translate your visualization into photographic reality, you must know what the film can do in your *particular* kind of work. You must know what the emulsion speed is in relationship to your *particular* shutter's performance. You must also be aware of the tonal manipulations a variation in film development may allow you.

Get to know your tools. Stay

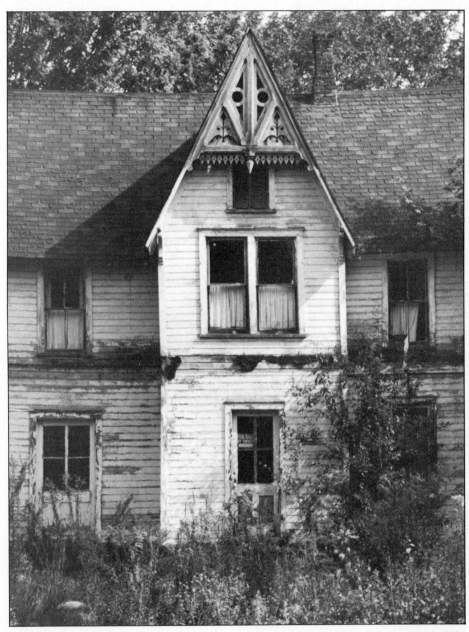

The range of important tones in this photo is not great. It extends from highlights to midtones. There are no deep shadows that require detailed reproduction. Therefore, film selection, exposure and processing don't present any unusual difficulties.

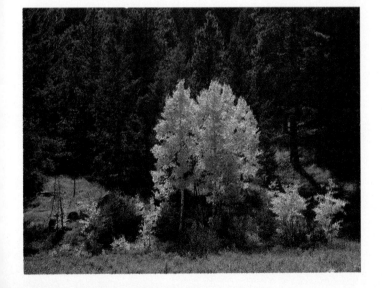

Often the best insurance for a well-exposed photograph lies in *exposure bracketing.* Make a meter reading. Interpret that reading to give what you *think* will be optimum exposure. Then, take additional shots of the same scene, giving more and less exposure. The extra cost of film is well worth the ability to choose the best of several exposures. I exposed the photo in the middle according to the meter reading. The others received 1/2 step less and 1/2 step more exposure. All three are acceptable photos—depending on the mood you're trying to create.

with them unless you have good reason to change. And remember, the best way to learn the techniques of any craft is to actually practice them. The whole thing is a kind of two-way street. Visualization leads to realization; realization, in turn, can lead you back toward more effective visualization. It's a "feedback" system.

The following chapters contain the information and guidance you'll need to effectively develop both your visual abilities and your skills in landscape photography. Don't be afraid to make mistakes. You can learn from them. To help you, keep a record of what you do.

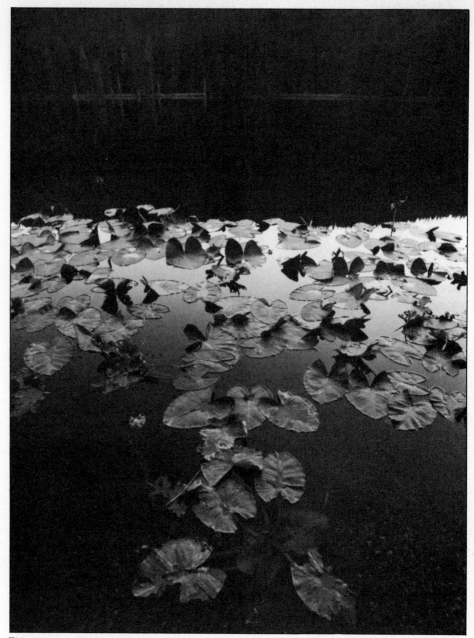

This scene called for the reproduction of tonal detail in highlight and midtone areas *and* in deep shadows on the far side of the lake. To accommodate this wide tonal range, I chose a film and developer combination that gives a soft result. I also had to place exposure carefully.

Obviously, your choice of camera equipment has a decisive effect on the photographs you make. Using tools ideally suited to the job will make your job easier. However, don't be fooled into thinking that the most expensive equipment automatically assures success. Excellent images can be made with simple equipment, although perhaps not as conveniently as with more elaborate gear. Remember that as you read this chapter.

Several interrelated factors affect your choice of equipment. They include price, portability, versatility and quality. You must also consider the characteristics of your subject matter, your working style and the end-use of the picture.

Don't become obsessed with one specific product that appeals to you. Try to assemble a truly useful set of tools. Also, don't be tempted to add to your equipment too fast. Limitations of skill and experience could prevent you from getting full benefit from it. When you *really need* equipment with a greater range of capabilities, you'll know it. That'll be the time to act.

CAMERA CHOICE

You have a wide range of camera choices for your landscape work. When making your selection, ask yourself some key questions. Which of the following features are particularly impor-

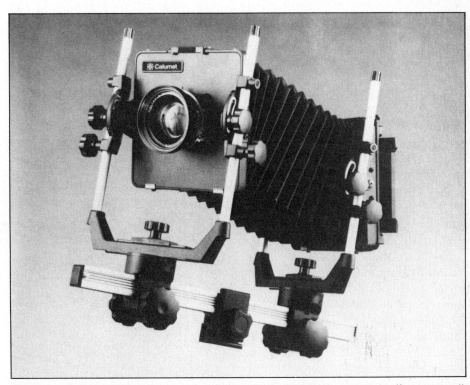

The Calumet 540 is lightweight, compact, versatile and modestly priced. It offers monorail features without the bulk usually associated with these cameras. The bellows are detachable. The front and back standards can be swung through 180° so the camera can be packed flat. Camera movements are virtually unlimited.

tant—camera portability, image size, accessory range, film selection, cost? You may also have some purely personal preferences. For example, you may be happiest with a 35mm camera because you have used one for many years and work confidently with it.

If you find it difficult to make up your mind, don't make the mistake of solving the problem by getting and using several different camera types. First become experienced with just one.

35mm CAMERAS

When you think of 35mm, you usually think of color slides. In fact, the most common reason for using 35mm in landscape work is to produce slides and slide shows.

Film Availability—The variety of available 35mm films is much more extensive than with any other film format. And, because the 35mm format is universal, lesser-used film types are generally available—even in remote places.

The cost of film per exposure is less with 35mm than with larger

formats. This either makes your photography less costly or gives you the opportunity of making numerous exposures of one scene to guarantee one excellent result.

Portability—Typically, hikers, backpackers and climbers make landscape photographs. They all want to carry a load as light and compact as possible. More often than not, their choice is 35mm equipment. The film is also light and compact. Literally hundreds of exposures are contained in a few small cassettes.

Image Size—Even though a small *film* size may be a very attractive feature, a very small *image* can be a distinct disadvantage in some applications. Landscapes usually contain a lot of fine detail, and the detail may be far away. It'll reproduce very small on the film. Film graininess and the limits of image resolution may prevent such an image from reproducing well.

If you want to make enlarged prints, the main disadvantages of the small 35mm format come into play. If, in other respects, 35mm is the most suitable format, you can minimize these disadvantages by using a slow-speed, high-resolution film.

Special Techniques—There are special photographic techniques that demand additional equipment and accessories. Before you buy, consider *all* the kinds of subjects you may want to photograph. Equipment for close-up photography, for example, is much more readily available to the 35mm photographer, as are lenses of extreme focal lengths. The same applies to filters and various special-effect devices.

Most accessories for 35mm cameras are readily available. This tends to make them considerably cheaper than larger-format accessories.

SLR or Rangefinder—If you think that 35mm is the format for you, there's still one more choice you must make. Do you want the popular single-lens reflex (SLR) or a rangefinder camera?

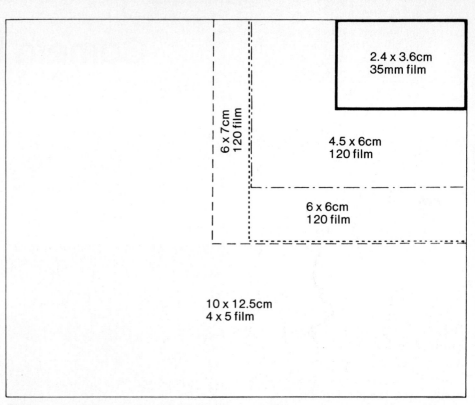

These are the popular film formats, from 35mm to 4x5 inches. You can see that the width-to-height ratio varies considerably. This affects image composition. The illustration also shows why it's best to use a larger film format when you intend to make big enlargements. To achieve the same print size, the linear enlargement of a 35mm negative must be more than four times as great as that of a 4x5 negative. Its *area* enlargement must be about 14 times as great. The smaller the degree of enlargement, the more quality will be retained in the print.

An SLR offers through-the-lens viewing, so you always see what will be on the film. With a rangefinder camera at close range, you may experience *parallax error*. The image seen in the viewfinder does not correspond exactly with the image on the film.

For most SLRs, you can get a wide range of interchangeable lenses. Only two rangefinder-camera manufacturers—Minolta and Leitz—offer interchangeable lenses comparable in function to those for a modern SLR.

A rangefinder characteristic preferred by some photographers is the bright viewfinder image. For handheld work, many like the quiet and smooth camera operation, thanks to the absence of a moving mirror.

Many automatic fixed-lens rangefinder cameras are modestly priced and intended mainly for the snapshooter. However, some of the more expensive models offer very high-quality optics and workmanship, in addition to compactness. Their main limitation is the non-interchangeability of lenses.

MEDIUM-FORMAT CAMERAS

Medium-format cameras, available in a variety of models and designs, use 120 or 220 roll film. A variety of image formats is possible by varying the dimension of

the image along the length of the roll. The image dimension across the *width* of the film is always about 2-1/4 inches (6cm).

For more detailed information about medium-format cameras, see *How To Select & Use Medium-Format Cameras,* by Theodore DiSante, also published by HPBooks.

Format Choice—The smallest format is 4.5x6cm. The next in size is 6x6cm, also referred to as 2-1/4-inch square. The 6x7cm format was introduced some years ago as the "ideal" format. Its dimensions correspond with the aspect ratio of standard enlarging papers. The largest image size in common use on 120 film is 6x9 cm, often called 2-1/4x3-1/4-inch format. It is used with medium-format press and view cameras.

Design Differences—Cameras designed to use 120 film offer many features. You should decide which of these are best suited to the kind of landscape photography you plan to do.

Like the most popular 35mm cameras, most medium-format cameras are SLRs. They use interchangeable lenses and accessories to make up a comprehensive photographic system. The design of the cameras—with the exception of the Pentax 6x7—differs considerably from that of 35mm SLRs. Because of the larger image, and the accordingly longer focal lengths of the lenses, the cameras are usually heavier and bulkier.

SLR—To make a choice between various medium-format SLRs, you must consider several factors. The cameras are of different sizes and configurations and offer different features.

If minimum size and weight are important, you may want to choose between one of the Bronica ETR and the Mamiya M645 cameras. They are similar in many ways, but the Bronica ETR-S offers interchangeable film magazines. The others do not. An M645 camera has a focal-plane

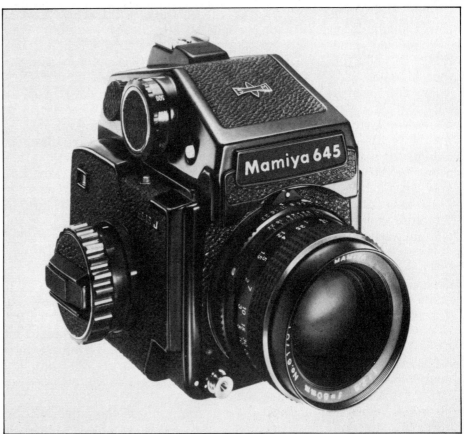

The Mamiya M645J is a compact and relatively inexpensive medium-format SLR, giving a 4.5x6cm image. A full range of accessories is available, including an extensive lens selection.

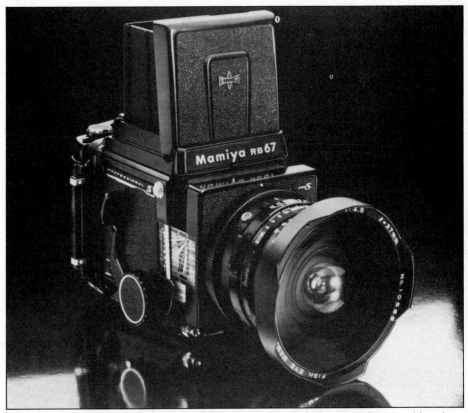

The Mamiya RB67 Pro-S is a highly versatile medium-format SLR system. It has a wide selection of lenses. The 37mm fisheye is shown here. In addition, there are interchangeable viewfinders, focusing screens and film backs—including one for Polaroid films.

shutter. The Bronica cameras use lenses with built-in leaf shutters.

Hasselblad cameras offer interchangeable film magazines. So do the Mamiya RZ67 and RB67. They also provide a revolving back that allows you to use vertical or horizontal formats while keeping the camera body upright. Film holders for the Rolleiflex SLX are also interchangeable. However, they aren't true magazines, because they have no dark slide and therefore cannot be interchanged without wasting film.

If you want the relatively large 6x7cm image size, you have a choice among the Mamiya RB67 or RZ67 and the Pentax 6x7. The Pentax resembles a large version of a 35mm SLR.

Twin-Lens Reflex—Twin-lens reflex (TLR) cameras have two lenses, one for viewing and focusing and the other for making the picture. Though seemingly on the verge of extinction, these cameras can still be found and are still used by landscape photographers.

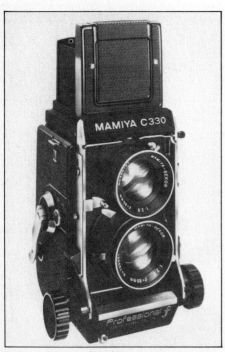

Twin-lens-reflex (TLR) medium-format cameras were popular for many years. One of their drawbacks was a lack of lens interchangeability. Two popular TLR cameras still made are the Mamiya C330f and C200. Each offers interchangeable lens pairs. The film format is 2-1/4-inch square (6x6 cm).

Typically, a TLR has a fixed lens of 75mm or 80mm focal length and a between-the-lens leaf shutter. The camera is compact and easy to use in the field. However, its popularity has decreased markedly. This is because of the lack of interchangeable lenses, plus the relative disadvantage of viewing through a lens other than the picture-taking lens. Currently made TLR cameras include the Mamiya 330 and 220, which offer interchangeable lenses. There's also the Yashica Mat-124G. A few inexpensive TLRs are made in China.

View and Press Cameras—The smallest member of the view- and press-camera family is particularly well suited to many different landscape situations. There are three basic designs to choose from, each providing a maximum image size of 6x9cm.

Medium-format monorail cameras, such as those made by Cambo, Arca and Galvin, are particularly suitable for all kinds of architectural and landscape photography. They offer shifts, swings and tilts, so you can control focus and perspective.

Although larger monorail cameras are too bulky for convenient field use, medium-format versions are sufficiently compact. They make a lightweight and portable package.

The traditional folding field camera offers a limited amount of shift, swing and tilt. It is much more compact than the monorail kind when folded for carrying. It's usually made of wood.

Probably the most versatile camera in this class is the medium-format press camera. Some good brands are the Horseman and Linhof Technika. In addition to having some of the features of the field camera, the press camera has a coupled rangefinder and an optical viewfinder. Handheld use is possible. The press camera, including its rangefinder and viewfinder, is made mainly of metal. It's relatively heavy.

Each of the three camera types just discussed offers some additional advantages. You can expose sheet film in holders and 120 roll film in magazines—in four different formats, plus 70mm film in a special magazine. You can also use several types of instant films in special camera backs. Within the range of focal lengths most commonly used for landscape work, each lens has its own shutter. Lenses are as small and light as most lenses for 35mm cameras. They are more portable than lenses for medium-format SLRs.

LARGE-FORMAT CAMERAS

Large-format cameras—for 4x5 and larger sheet film—have found renewed popularity in the last few years. For the commercial and industrial photographer, the traditional format for many types of assignments is 4x5 or larger. The recent increase in demand for larger cameras is probably based on a growing recognition of their advantages to the landscape photographer.

Some of the advantages are obvious. The large film area gives superior image quality. The camera movements offer focus and perspective control. Among the advantages that are perhaps not as immediately obvious is the ability to use one sheet of film at a time. You can process it to meet the specific needs of the picture. You can interchange films of different types and speeds in one camera at will, and with ease. Last, but not least, you can focus and compose an image that is easily visible to the unaided eye.

Folding View Camera—These cameras are made of either wood or metal. They are lightweight and very compact when folded for carrying. This makes them particularly suitable for carrying into the field in an over-the-shoulder camera bag, together with lenses, film and other accessories. Because of their easy portability, these cameras are also called *field cameras*.

There are many camera types to choose from. Brand names include Wista, Toyo, Ikeda, Horseman and Nagaoka. Each camera features movements adequate for most landscape applications, although not as extensive as those of the monorail-type camera discussed later. The field camera must be used on a tripod. This limits its use to photographing essentially static subjects and scenes.

The 4x5 field camera is as easy to carry and use in the field as the larger of the medium-format SLR cameras. Its slightly greater bulk is offset by its lesser weight, even when accessory lenses are included.

For the b&w photographer, the 4x5 format offers much greater control, through camera swings, shifts and tilts, and individual sheet processing, at not much greater cost. In color, however, the cost of 4x5 sheet film and processing is significantly higher than even with the largest 6x9cm format on 120 roll film. You can, of course, find a compromise in your work. Use 4x5 sheet film for b&w work and 120 film in a special roll-film adapter for color photography.

Monorail View Camera—This camera is relatively bulky and requires a large carrying case. The numerous metal parts ensure precise and accurate adjustments and maximum rigidity. They also make the camera relatively heavy. As these features indicate, most monorail cameras are designed for studio use. They are not ideal for frequent assembly and disassembly. However, when extensive corrective camera movements are called for, such as in architectural photography, they are also useful on location.

The Sinar F, Linhof Master TL and Horseman 450 are lightweight modular-system cameras. They are relatively easy to disassemble. Monorail cameras are available not only in the 4x5 format, but also in 5x7 and 8x10. With a roll-film back, you can adapt a 4x5 camera to make 6x9cm images on 120 roll film.

Press Camera—This is a folding camera using a coupled rangefinder and an optical viewfinder. It's suitable for handheld use but has some disadvantages. It is usually bulkier and heavier than a field camera for the same format. It normally has a relatively short bel-

lows extension and limited shifts, swings and tilts. The selection of lenses coupled with the rangefinder is also limited with most makes. Among others, 4x5 press cameras are currently made by Linhof, Wista and Toyo.

AUTOMATIC EXPOSURE CONTROL

The many electronic advancements incorporated in modern cameras seem to make casual photography of average subjects almost foolproof. They even seem to discourage thoughtfulness. However, exposure automation can be either an asset or a hindrance to the landscape photographer. It depends on the design of the auto-exposure system and the kind of photography you're doing.

Most 35mm cameras today have some form of automatic exposure control. By all means consider choosing one of them. If you don't, your selection of cameras will be drastically limited. What is most important is to understand the characteristics of your specific system. Know when to rely on it and when to override it.

Advantages and Disadvantages—When photographing moving subjects or working in rapidly changing lighting conditions, you'll be grateful for the instant decision made by an automatic-exposure camera. But if you want to do high-quality work, you should be able to set exposure manually when you want to.

It is important to remember that the meter in your camera can measure light intensity, but is not able to think. It can't translate its reading into a useful exposure indication under *all* conditions. You must interpret the meter's recommendation.

Know What the Meter Reads—Most meters have a light-sensitive cell or cells designed to respond differentially to various portions of the framed scene. This is called the meter's *weighting*. When a

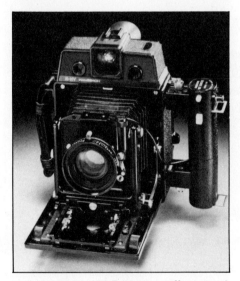
The Horseman VH-R camera offers great versatility for the landscape photographer. There's an eye-level viewfinder and rangefinder for handheld use. With the camera on a tripod, you can use ground-glass viewing and focusing. The camera offers limited swings, tilts and shifts. Image format is 2-1/4x3-1/4 inches.

These are Toyo 4x5 and 8x10 all-metal field cameras. They are more expensive than their wooden counterparts. However, if you want precision, rigidity and durability, they're a good investment. The cameras are lightweight and pack into a compact space for carrying. Swings, tilts and shifts are limited.

meter provides full response only in the central area, the response decreasing toward the perimeter of the image field, the meter is called *center-weighted.*

In some camera models there is less response to the upper portion of the format, when the camera is held for a horizontal picture. This assumes that the upper portion of the picture will usually be bright sky, and that the camera will mostly be used for horizontal-format pictures. It also assumes that you will want correct exposure for the lower part of the scene rather than for the upper part.

Often these are fair assumptions, but not *always.* If you are not photographing any sky, and if the distribution of light and dark tones in your scene differs substantially, the meter's recommendation may no longer be relevant. The same may be true when you select to shoot a vertical composition.

It helps to have a visual reference in the camera's viewfinder to show the sensitivity pattern of the meter. Otherwise, it's virtually impossible to accurately compensate for an inappropriate meter reading.

Some cameras, like the Canon F-1, the Olympus OM-3 and OM-4 and a few Leicaflex models, measure a limited area of the viewfinder image. The metering area is clearly outlined on the viewfinder screen.

The auto-exposure systems offered in all major brands of high-quality 35mm and medium-format SLR cameras function accurately. But there's a catch. They do so only when metering the kind of scene they were designed to meter—an average scene. (An average scene reflects about 18% of the light reaching it. It does not have excessive contrast or unduly large areas of highlight or shadows.)

To make the automatic mode useful under non-average conditions, a compensation control is necessary. It is a manually controlled exposure-compensation dial on the camera, having a four-exposure-step range.

Aperture-Priority or Shutter-Priority—When depth-of-field control is most important, select a metering system that permits you to set the lens aperture manually. The system then selects an ap-

propriate shutter speed for an average scene. This is called *aperture-priority* operation.

If you need to control shutter speed manually, to stop subject movement, for example, choose a *shutter-priority* system. After you set the shutter speed, the metering system automatically selects the correct aperture for an average scene.

If control of aperture setting *and* shutter speed are important, you can work manually or select a multi-mode automatic-exposure system. The latter enables you to select either aperture-priority or shutter-priority.

OTHER CAMERA FEATURES

When choosing a camera for landscape photography, there are additional features you should evaluate for their specific usefulness in *your* work.

Viewfinder Screen—Many SLR cameras offer interchangeable focusing screens. Some you can change yourself. Others must be changed by an authorized repairman.

The focusing screens that come with most SLR cameras have

The sensitivity pattern of a typical 35mm SLR light meter is usually weighted toward the center and bottom. This allows for compositions with bright sky in the upper part. Generally, you don't want the sky to affect the exposure setting. It also allows for the fact that the most important part of the image is usually in the central area. Be careful when you take vertical-format landscape pictures. In this situation, a meter of this kind *will* be unduly influenced by light from the sky.

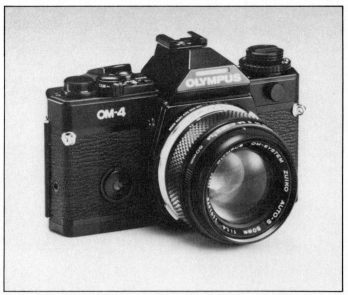

The Olympus OM-4 and OM-3 cameras have a built-in meter with a narrow-angle spot sensitivity. The meter features a memory and computer function that can average readings from several parts of the scene.

focusing aids, designed to make critical focusing easier. They include a central split-image rangefinder and an area of microprisms. These are usually surrounded by ground glass. In addition, a Fresnel field lens helps to keep the corners of the screen area bright.

Considering the nature of usual landscape subjects, the split-image rangefinder and microprisms are of limited value. They're most useful in dim light and for focusing on distinct subject components. These conditions are not common in landscape photography.

When you use lenses of very long or short focal length, the split-image and microprism focusing aids tend to turn into a dark pattern. This makes them non-functional.

Central focusing aids distract some photographers from visualizing the total scene on the focusing screen. Therefore, for most landscape applications a plain matte focusing-screen is more desirable. It also lets you use lenses of extreme focal lengths or small maximum apertures without difficulty.

If you work frequently with architectural subjects, a plain focusing screen with a grid of vertical and horizontal lines is helpful.

Depth-of-Field Preview—This device, incorporated into some camera models, lets you manually close the lens aperture to the setting indicated on the lens. This shows you the actual depth of field on the camera's viewing screen. The depth-of-field preview also darkens the screen image accordingly.

When the maximum lens aperture is very large, the depth-of-field preview can help reduce flare within the camera's viewing system. This can give a visual image that more closely corresponds to the image you'll get on film.

Self-Timer—The self-timer's main purpose is to give you time to get into the picture before making the exposure. For the landscape photographer, it can also be an effective substitute for a

cable release. Use it when the camera is on a tripod and you are using a slow shutter speed. A few seconds will pass after you push the shutter button, before the exposure is made. This eliminates the chance of camera vibration. It can mean the difference between a sharp picture and one blurred through camera movement.

Most 35mm cameras have a self-timer. Many larger cameras and their lenses don't.

Mirror Lock-Up—This is another useful feature for preventing camera vibration during exposure. With it, you can lock up the SLR camera's reflex mirror against the focusing screen. Because this eliminates mirror movement just before exposure, any vibration the mirror might have caused is avoided. This is particularly important when you shoot with an extremely long lens. Of course, while the mirror is in the up position, you can't view through the viewfinder.

The mirror lock-up feature is built into almost all medium-format SLR cameras. However, it is being eliminated from even professional-quality 35mm cameras. This may be because it is no

longer needed to accommodate the latest designs of extreme wide-angle and fisheye lenses. In addition, some camera manufacturers believe that vibration due to mirror movement has now been sufficiently reduced.

Other Features—Electronically controlled shutters, available on some cameras and lenses, give accurate exposure times. This also applies to speeds considerably longer than one second, the slowest mechanical speed available just a few years ago.

A feature like the tilting lens adjustment on the Rolleiflex SL66E can be a great advantage in some landscape work. With it, you can increase effective depth of field.

Undoubtedly, you'll be able to think of other features you'd like when photographing landscapes.

LENS SELECTION

The selection of lenses available today, especially to the 35mm photographer, is enormous. Not many years ago, it was normal for a photographer to work with just one lens. Occasionally, one or two additional lenses of different focal lengths were also used.

In recent years, camera lenses have become lighter and more compact. You can take an extensive selection of types and focal lengths into the field without carrying a heavy load.

But this situation was not totally due to a lack of lens availability. When large b&w film formats were used almost exclusively for landscape photography, it was usual to crop the image in the darkroom during printing. There was no need to do so in the camera when shooting. Thus, the need for camera lenses of different focal lengths—to give wider or narrower angles of view—was not great.

With the advent of the popularity of the 35mm slide, careful in-camera image composition and cropping became necessary. This is because the slide is projected essentially in its entirety. A range of focal lengths became necessary, so the photographer could make full use of the small film area from any chosen camera viewpoint.

Using interchangeable lenses is easy with an SLR because you view through the lens. In addition, the popularity of SLRs has stimulated the development of zoom, soft-focus and perspective-control lenses.

Every subject or scene could conceivably be photographed with just one standard lens and still framed in the desired way. But this assumes you have unlimited mobility and can place the camera anywhere. This is obviously not possible. The alternative is to bring your subject closer through the use of a long-focal-length lens. This is similar to bringing an inaccessible distant object closer with a pair of binoculars. Or, you can take in a larger area of the scene by the use of a shorter-focal-length lens.

But that isn't the whole story. Besides including different amounts of the scene, different focal lengths affect the visual characteristics of the image. The key word here is *perspective*. Let's take a brief look at what this is all about.

PERSPECTIVE

This often misunderstood word basically refers to the appearance of objects or scenes, as determined by their distance from the viewer. The viewing distance determines the relative apparent sizes of the various components at different distances from the viewer.

The first essential rule about perspective is that it is *always* dependent on the viewing position, or distance. This is true whether the "viewer" is a human being or a camera. From the same viewpoint, a camera lens of *any* focal length will see the scene in the same way. The relative sizes of foreground and background objects are unchanged.

Now, you may think that the focal length of your camera lens *does* significantly influence perspective. But that's not correct. What *does* influence the apparent perspective you see is the *distance* from which you view the finished photograph.

If you view a contact print or transparency from a distance equal to the focal length of the lens that made the picture, you will see the perspective the camera saw. If you view an enlargement, you will see the correct perspective only at a viewing distance of the focal length of the original negative or slide *multiplied by the linear enlargement.*

For example, the correct viewing distance for an 8x10 print, made from a full 4x5 negative exposed in the camera through a 200mm lens, will be 2x200mm. You should view the photo from a distance of 400mm, or about 16 inches.

If you look at a photograph from closer than this correct distance, the perspective will be *foreshortened*. Distant and close subject parts appear unnaturally close together. If you view the picture from too far away, the perspective is *exaggerated*. The distance between close and distant subject parts appears greater than it was at the actual viewing position.

When the word *perspective* comes up in the pages that follow, remember the following points.

First, *actual* perspective out in the "field" is determined by viewpoint only. Second, *apparent* perspective in a photograph is determined by the distance from which it is viewed. To *simulate* in the photograph the perspective you saw in the scene, you must consider two things. They are the focal length of the camera lens used and the final image magnification. These two factors determine the correct viewing distance.

STANDARD LENS

Your first photographic experience is usually with a standard camera lens. Its focal length is approximately equal to the diagonal length of the film format. Its diagonal angle of view is between about 40° and 59°.

If you use a standard camera lens, you'll generally recreate actual perspective when you view an 8x10 enlargement of the full frame from the normal viewing distance of about 12 to 15 inches. With a projected 35mm slide, you see actual perspective at a viewing distance from the screen equal to about the diagonal dimension of the projected image.

WIDE-ANGLE LENS

The most obvious reason for using a wide-angle lens is to record a relatively wide field of view from a specific viewpoint. The confines of a city street, for example, can often prevent you from moving farther away from the subject or scene you want to record. In such a case the only way to include the desired subject is to use a lens with a wider angle of view.

Beyond this obvious use, the wide-angle lens has other functional advantages.

Depth of Field—Depth of field is dependent on image magnification and lens aperture. The wider the angle of view of the lens, the lower the image magnification. For this reason, a wide-angle lens offers a relatively great depth of field. This feature makes the wide-

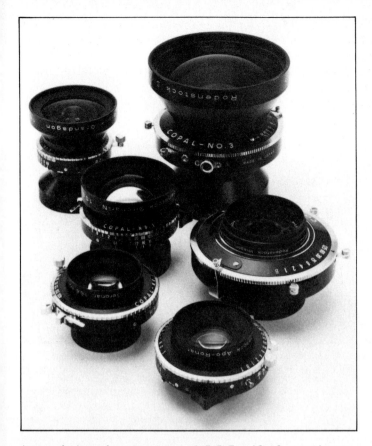

Lenses for large-format cameras—4x5, 5x7 and 8x10—must be purchased separately. Rodenstock of West Germany makes a full line of high-quality lenses for every sheet-film format. A selection is shown here. These lenses are designed to cover a larger area than the image format. This is necessary so you can use camera movements without causing image cut-off.

The most popular focal length for a second 35mm SLR lens is 28mm. This Vivitar f-2.8 28mm offers some of the latest technological advances. Many metal parts have been replaced with a lighter material. Fewer screws are used. The assembly is more precise and the design more damage-proof than in earlier models.

Osawa offers compact, lightweight lenses in focal lengths from 24mm to 650mm for 35mm SLR cameras. The lenses are manufactured with a variety of permanent mounts to fit the major brands of 35mm SLRs. Shown at right are Osawa Mark II zooms.

The Canon FD 400mm f-4.5 Super Telephoto lens is compact and lightweight, in spite of its long focal length. It can be stopped down to f-32 for good depth of field. A tripod-attachment facility ensures steadiness of the camera/lens combination during use. An appropriate narrow-angle lens shade is built into the lens.

When you want to frame an image precisely in the camera, a zoom lens can be useful. In landscape photography, you don't always have access to the exact spot that gives best composition. This 35-105mm zoom lens gives you a continuous focal-length choice between 35mm and 105mm.

angle lens particularly useful when you want to include sharply-defined detail in the near foreground.

Exaggerated Perspective—We rarely view an image made with a wide-angle lens in correct perspective. To do so, we would have to view the image very close to the eye. When you hold the image farther from your eye, you see an artificial deepening of the scene. This can be particularly effective in certain kinds of landscape work. For example, it lets you convert a winding road into a *long* winding road. Or, it can give dominance to an object near the camera against a small and apparently distant background.

TELEPHOTO LENS

This lens has a longer focal length than the standard lens. Basically, it acts like a telescope or a pair of binoculars. It provides a larger image and a more limited angle of view. The primary purpose of the lens is to bring subjects closer and make them relatively larger.

Selective Framing—A telephoto lens is particularly useful for selecting a small part of a scene and framing it to fill the picture. This is, of course, especially useful when it's impossible to move closer to the subject. For example, you may you want to show the architectural detail of the castle on the hill, rather than its geographic surroundings. To do so, you may need to use a telephoto lens.

Limitations—You should be warned that many of the practical advantages gained by the use of a wide-angle lens are lost when you use a telephoto lens.

Because of the increased image size, and partly because of the bulk of the lens itself, image blur due to camera movement is more likely. You can guard against this, when lighting conditions permit, by using a faster shutter speed for handheld photography. Here's a good rule of thumb: For sharp pictures, use a shutter speed about

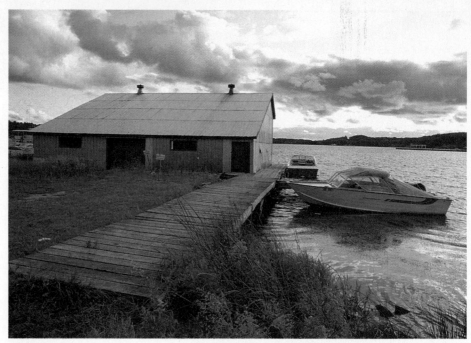

With a wide-angle lens, you can create the illusion of great distance. The wider field of view enables you to include very close objects. The size relationship between very near and distant subject parts helps to enhance the feeling of distance. A wide-angle lens will also make parallel receding lines converge more noticeably. This, too, helps to enhance the feeling of distance.

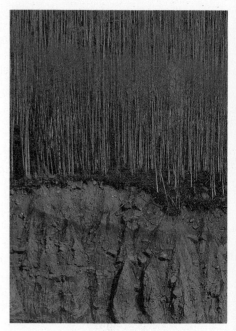

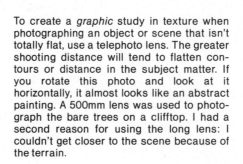

To create a *graphic* study in texture when photographing an object or scene that isn't totally flat, use a telephoto lens. The greater shooting distance will tend to flatten contours or distance in the subject matter. If you rotate this photo and look at it horizontally, it almost looks like an abstract painting. A 500mm lens was used to photograph the bare trees on a clifftop. I had a second reason for using the long lens: I couldn't get closer to the scene because of the terrain.

equal to, or faster than, the reciprocal of lens focal length. For example, with a 100mm lens use a shutter speed of 1/125 second or faster. With a 400mm lens, use a speed of 1/500 second or faster.

When lighting conditions do not permit a fast shutter speed, use a

tripod. With very long lenses having tripod-mounting collars, a fourth leg—such as a monopod—may be necessary for the camera body. This ensures sufficient steadiness for the whole assembly.

Depth of field is less extensive

with telephoto lenses than other lenses because image magnification is greater. You must focus carefully on the part of the scene you want to record most sharply. To gain more depth of field, you must use a smaller lens aperture. This in turn will call for a longer exposure time—and the need for a tripod.

Advantages—Some of the so-called "limiting" characteristics of a telephoto lens can be used to your advantage.

The relatively shallow depth of field lets you isolate a subject from a distracting background by putting the background out of focus.

In a photograph viewed normally, at 12 to 15 inches, the telephoto lens will apparently *compress* the distance between foreground and background. Distant mountains will appear bigger in relationship to a building in the foreground. The appearance of a receding street will be shortened, with the result that the cars on it will appear much closer to each other. This can make traffic seem much denser. Of course, you can eliminate this effect by viewing the photograph from a greater distance, to get correct perspective.

ZOOM LENS

Even today, with the great improvements in design, zoom lenses represent a compromise. Generally, only the best and most expensive zoom lens will give you excellent image quality along its full range of focal lengths. The best advice is, use a zoom lens only when it gives a practical advantage. To most landscape photographers it doesn't offer great advantages, even though the range of focal lengths sounds attractive.

If you are a hiker or backpacker who wants to travel light and not carry a lot of lenses, you'll find a zoom lens useful. Or, if you want the most precise framing, you might also have justification for investing in such a lens.

Three kinds of zoom lenses are available. The oldest and most common is the zoom telephoto. More recently, zoom lenses including a standard-lens focal length have become popular. The least common zoom lenses are those that offer focal lengths within the wide-angle range.

Standard-Range Zoom—In my opinion, this type of zoom lens is most useful in landscape photography. The lens also tends to be more compact and lighter than most telephoto-range zooms. If you're going to carry just one lens, a 35-70mm zoom is a good choice. It gives you a focal-length range to either side of the standard.

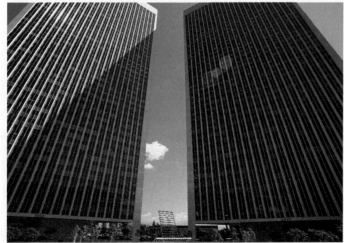

Sometimes you *want* the walls of tall buildings to converge toward the top for special visual effect. In that case, just point your camera upward. Here, the diagonal line of the shadow on the left building helps to accentuate the feeling of converging lines.

To make this architectural photo, I pointed the camera horizontally. All vertical lines are parallel.

Wide-Angle Zoom—If you find the zoom feature attractive and anticipate working in areas where space is limited, consider the wide-angle zoom. Because these lenses are less readily available and are usually more expensive, they haven't gained the acceptance they might deserve.

For photography in the city, the wide-angle zoom is ideal. It is light and compact—often no larger than a standard camera lens. It will give you a useful variation of angles of view, especially the 24-50mm kind.

Telephoto-Range Zoom—In general, the telephoto zoom lens is the most popular. It's also the most likely to be recommended by a camera salesperson. However, it is probably the least useful for landscape photography—unless your subjects are mainly detailed close-up views within a scene. The lens is relatively large and heavy. If you don't need it, don't carry it.

Significant Limitations—When weighing the pros and cons of a zoom lens, give a little thought to some inherent drawbacks of zooms.

With the exception of a wide-angle zoom, these lenses are invariably larger and heavier than even the longest comparable fixed-focal-length lens. For example, a 200mm lens is usually smaller and lighter than an 80-200mm zoom.

With a few exceptions, zoom lenses are slower than their fixed-focal-length counterparts. This can be a disadvantage in dim light. In addition, the zoom lens generally has a smaller range of apertures that provide best lens performance. Also, because of its many glass elements, a zoom is subject to adverse effects of lens flare. You can experience flare, even though the lens elements have multiple coatings.

At small lens apertures, image degradation due to diffraction also tends to be greater in a zoom lens.

A fixed-focal-length lens of comparable quality will be less subject to wear. This is because it does not have the many moving mechanical parts of the typical zoom lens.

SPECIAL-PURPOSE LENSES

The lenses I'll discuss here can be a dilemma for the landscape photographer. You may seldom need one, but when you do, it becomes totally indispensable. Also, special-purpose lenses are usually more expensive than regular camera lenses.

Perspective-Control Lens—This lens is in a special mount that allows the lens to be moved up, down or sideways in a plane parallel to the film plane. In its normal position, the lens is centered on the lens axis. To make the movements possible without partial image loss, the lens—usually of wide-angle design—has greater-than-normal image-covering power.

The need for perspective control with the use of camera movements is most common in photography of tall buildings. To photograph this Mormon temple in St. George, Utah, I used the rising front of the camera. It enabled me to get the whole building into the picture *and* avoid the apparent *falling in* of the walls toward the top.

The purpose of the lens is *perspective control*. For example, by raising the lens position, you can photograph the top of a building without tilting the camera upward. By keeping the film plane parallel to the face of the building, you avoid the convergence of the vertical sides of the building in the photograph.

Minolta and Canon perspective-control lenses for 35mm SLRs also feature control of the focal plane. This lets you enhance depth of field in certain situations. The Minolta lens has a control ring that changes the subject plane that will be in best focus. It can change the plane from flat to curved—either concave or convex. The Canon lens features a lens mount that tilts and shifts. When you use the tilt for focus control, you can recenter the image on the lens axis sufficiently for total image coverage.

Perspective-control lenses can give the 35mm and medium-format SLR user some of the controls available to the view- or field-camera user. To use the lens shifts or tilts effectively, mount the camera on a tripod. Also, a plain matte focusing screen with a grid of parallel lines is a great help in setting the perspective-control adjustments.

Most contemporary perspective-control lenses have the same features as conventional lenses of the same focal length. Some of the earlier models, however, don't have automatic aperture and meter coupling. These can't be used with automatic exposure control.

Mirror Lens—Also known as a *catadioptric* lens, the mirror lens generally has a very long effective focal length in a remarkably compact body. Compared with conventional telephoto lenses of comparable focal length, the mirror lens is a fraction of the size and weight. It is usually less expensive, too.

For general landscape photography the mirror lens has very limited application. In addition to its focal length frequently being too long, the lens has no adjustable aperture and offers limited depth of field. It is suitable for photographing small subject matter, such as birds or wild animals, at a distance. In such a situation, shallow depth of field can be an asset.

Let me warn you of the effect of small specular reflections, such as you might get from the surface of a back-lighted lake. Due to the characteristic design of the mirror lens, each of these little reflection points will reproduce in the photograph as an illuminated "doughnut."

The speed of all but the relatively short 250mm to 300mm mirror lenses is slow—about *f*-8. This gives a considerably darker viewfinder image than a conventional lens of a similar focal length. This means you must focus very accurately, particularly as there is no adjustable aperture that you can stop down.

You can control image brightness with a built-in set of neutral-density (ND) filters.

Soft-Focus Lens—Most photographers associate soft-focus lenses with portraiture. However, the *pictorialist* school, mentioned in Chapter 1, used soft focus in landscape photography. The style tended to "idealize" the interpretation of the landscape. Today, the pictorialists are being recognized as significant contributors to landscape interpretation. Regardless of philosophies and trends, a soft-focus lens can render many landscape subjects well. Sometimes it can capture the essence of a visualization as no other lens can.

The selection of soft-focus

The soft-focus lens or attachment is most frequently associated with portraiture. There are occasions when it can also be used effectively in landscape photography. The softness of this woodland scene gives it an idyllic atmosphere. Here, the soft-focus lens also played a more practical part. It helped reduce image contrast.

Most standard macro lenses enable you to focus closer than even close-focusing zoom lenses. So, if you're interested in making close-up nature photographs like this one, use a macro lens. It's good for normal landscape shooting, too.

lenses available is limited. Two brands are available for large-format cameras—the Rodenstock Imagon and the Fujinon SF. Each is available in three different focal lengths. The Imagon is adaptable to medium-format SLR cameras.

Mamiya makes soft-focus lenses for its medium-format cameras, the RB67, RZ67 and M645. Minolta is one camera manufacturer offering a soft-focus lens for a 35mm camera. In addition, both Spiratone and Sima have moderately-priced soft-focus lenses that are adaptable to all popular 35mm SLR cameras.

The Fujinon, Mamiya and Minolta lenses provide the maximum soft-focus effect at the largest lens opening. The effect decreases, and eventually disappears, as the aperture becomes smaller. When the lens is fully stopped down, it operates like a conventional non-soft-focus lens of moderate telephoto design.

The soft-focus effect is due to one of two optical designs. One method uses a variable and adjustable degree of spherical aberration. The other has its inherent spherical aberration controlled through a special aperture disk containing one central and many surrounding smaller openings. The latter design, used in the Imagon, Fujinon and Mamiya lenses, is best suited for landscape subjects requiring extensive depth of field. The diameter of each of the multiple openings is much smaller than that of a conventional single aperture of the same value would be. This causes these lenses to provide a greater depth of field than their effective aperture values would suggest.

Macro Lens—Use one when you want to make "landscape" photographs from close up of subjects like leaves, flowers or fine detail in wood. Macro lenses are available in focal lengths of 50mm and 100mm for 35mm cameras. They attach directly to the camera and are focused in the normal way. Macro lenses are designed to give the best optical quality when used at close range.

ACCESSORIES

You'll find thousands of photographic accessories on the shelves of camera stores and advertised in magazines. Some are novelties and not essential. Others serve very specific purposes for particular applications. Among those genuinely useful to the landscape photographer are a handheld light meter and a carefully selected set of filters. You also shouldn't be without an effective lens shade and a sturdy tripod.

HANDHELD LIGHT METER

An exposure meter is a built-in feature of most cameras except large-format sheet-film models. So why spend good money by adding a second, handheld, meter to this equipment? There are two good reasons.

First, most built-in meters do not provide information that is specific enough for critical exposure control in landscape photography. Second, different types of handheld meters offer a

For this view, I aimed the camera horizontally. To get the top of the crane into the picture, I would have had to point the camera upwards. This would have made vertical lines converge in the image. An alternative would have been to use a camera with movements.

I made this landscape close-up with a macro lens. The limited depth of field was useful here. It put emphasis on the sharp bloom in the foreground while keeping the background flowers recognizable.

variety of light-reading capabilities that a built-in camera meter cannot provide.

As mentioned earlier, most built-in meters give a reading based on an average of the light reflected from the scene you see in the viewfinder. Many give emphasis to the central portion of the image field. Sometimes, meter sensitivity is less in the upper part of the frame, when the camera is held for a horizontal-format picture. This compensates for bright light from the sky. Rarely is the exact reading area, or the sensitivity distribution of the meter, indicated in the viewfinder.

In other words, you get a meter reading without knowing exactly *what* area is measured. This may be acceptable for general snapshooting. It does not make for dependably accurate exposures under a wide variety of shooting conditions.

Spot Meter—The only way you can get an accurate indication of the light reflected from small parts of the subject is with a spot meter. It has a very narrow angle of view. You can think of it as a sort of "telephoto" exposure meter. Because it enables you to select small areas for measurement, the spot meter allows you to base exposure on the specific tonal value you want to record. It can also provide you with an exact indication of the brightness range of the scene.

The optical design of a spot meter is similar to that of an SLR camera. The spot meter has a lens that focuses an image through a pentaprism on a viewfinder screen, seen through a viewfinder eyepiece. The angle of view of the visible scene is similar to that of a moderate telephoto lens. The meter's sensitivity area is outlined by a small spot in the center of the image. This spot covers an angle no wider than about one or two degrees. To use the meter, you simply aim the spot at the part of the subject you want to read.

With a spot meter, you can determine subject brightness

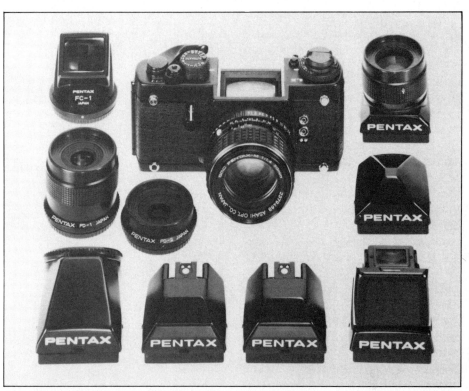

A system camera like this offers great operating versatility and convenience. In addition to lens interchangeability, you have a selection of viewfinders and focusing screens. This kind of system enables you to shoot under varied conditions, from distant telephoto photography to extreme close-ups.

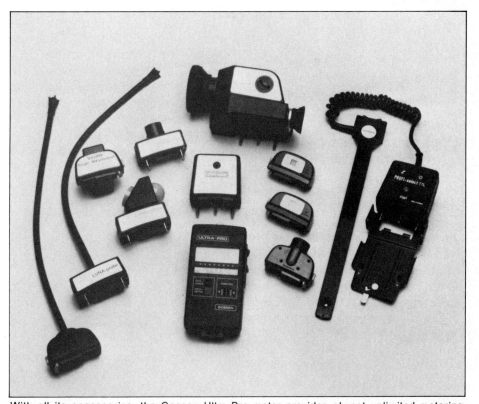

With all its accessories, the Gossen Ultra-Pro meter provides almost unlimited metering options. It includes a memory and micro-processor. Normally, the meter is used for incident-light or averaging reflected-light readings. An attachment enables you to use it also as a variable-angle spot meter in the film plane of large-format cameras. In addition, you can adapt it for use as a color-temperature meter or even a densitometer, through the use of a fiber-optic probe.

range and relate that information to film response. Of course, to get the best from such a meter you must use it carefully. Give due consideration to the role the brightness values are to play in the *realization* on film of your *visualization* of the scene. You must use a spot meter with a thorough understanding of how film responds to light. Otherwise, it will give you no better result than you might obtain with a meter built into the camera.

Incident-Light Meter—This meter is designed to read the light falling on the subject, not the light reflected from it. A translucent plastic hemisphere "sees" the light from the source. A light-sensitive cell below the hemisphere measures the intensity of the light.

The exposure indicated by an incident-light meter is for an average subject. This has moderate contrast and no excessively large areas of highlight or shadow. It reflects about 18% of the total light reaching it. If the subject is considerably lighter or darker, or has high contrast, you must compensate for this.

Like the spot meter, the incident-light meter must be used correctly, if useful readings are to result. As a landscape photographer, remember that an incident-light meter is designed to give an exposure reading at the subject position. Out in the field you will often find that you can't take your meter right up to the subject. At times you will get a reading from the camera position that does not accurately indicate the lighting conditions at the subject. For example, the distant scene you want to photograph may be shaded by a cloud while you are in bright sunshine. Or, the reverse may be the case.

I'll have more to say about the use of light meters for exposure determination later.

FILTERS

Landscapes and their illumination can vary greatly. I would

These Kodak gray scales and color-control patches can be obtained from your photo dealer. Gray scales and color patches are also included in the *Kodak Professional Photoguide* and the *Kodak Color Darkroom Dataguide.*

recommend that you always carry some basic filters when you're on a photographic trip, even though you may rarely use them.

For B&W Film—In b&w work, filters generally serve to increase—and sometimes decrease—image contrast. They are useful for separating colors that would otherwise reproduce in almost the same tonal values. The most common example is using a deep yellow or orange filter to separate the tone of a blue sky from white clouds. With b&w film, I suggest you take along at least a No.8 yellow, No.15 deep yellow, No.25 red and No.13 yellowish-green filter.

For Color Film—For color work, take along filters in the 82 (bluish) and 81 (yellowish) series. These enable you to compensate for changes in the color characteristics of the illumination. Also take some color compensating (CC) filters to eliminate other color imbalances. There can be many causes for these. They include the effect of an expanse of blue sky or of overhanging green foliage on the subject.

Polarizer—A polarizing filter is especially useful for color photography. First, it is the only

filter that lets you darken a blue sky to bring out white clouds, without causing a color imbalance in the photograph. Second, by removing specular reflections from a subject, it can help you to get much more saturated colors. However, this last method only works effectively when the camera is aimed at a specific angle—about 35°—to the subject plane.

Haze and UV—A skylight filter is designed to absorb ultraviolet radiation. It can remove the ultraviolet and excessive blue in an outdoor scene in open shade under a clear blue sky. It can reduce atmospheric haze. Some photographers leave a skylight filter on the camera lens at all times to physically protect its front surface. I don't. I believe the adverse effect the filter's presence can have on image sharpness and contrast outweighs any protective benefit it may provide. This is particularly true when the filter has had time to become somewhat soiled and scratched.

Special Effects—You can create special effects with a wide range of additional lens accessories. These include diffusion, cross-screen and star attachments, and fog fil-

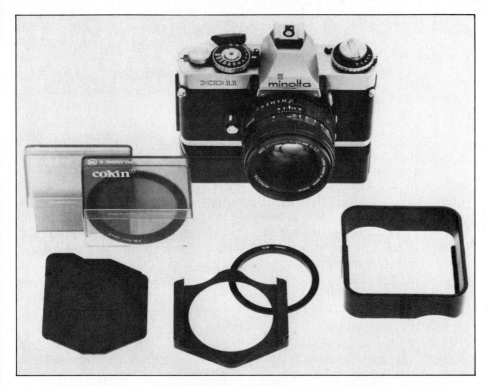

ters and graduated color filters. Follow the manufacturer's instructions. By using these accessories with caution and judgment, you can create some very interesting images. There's no harm in using "trick" filters, even in landscape photography. But limit their use to situations in which the result is likely to be functional, and not just gimmicky. Later, I'll talk about filters and their use in greater detail.

LENS SHADE

A lens shade is a simple but very helpful device. Many claim that the anti-flare coating on all glass-to-air surfaces in a modern lens makes a lens shade unnecessary. But you can easily prove for yourself that this is not so.

Simply point your camera toward a subject with the sun above and behind it. Let the sun shine on the front lens surface but keep it outside the camera's angle of view. Look at the image in the viewfinder and use your hand to gradually shade the lens from the sun. You'll see a considerable improvement in image contrast and detail as your hand comes down.

The lens shade not only shields the lens from direct sunlight. It can also prevent light from reflections and bright areas just outside the camera view from hitting the lens. These could cause deterioration of image contrast and detail.

There are many different kinds of lens shades—some more effective than others. The simplest is the metal shade made specifically for one lens. Also available is the flexible rubber type that can be folded back when not needed. Some models need not be removed from the camera for the attachment of a protective lens cap. If a rubber shade is too wide or too short for a lens, it will not provide as effective protection from unwanted light as a shade made specifically for that lens.

A bellows lens shade is by far the most effective. You can adjust it to the angle of view of virtually any lens. In addition, it has a slot for filters just in front of the lens position. Many have a similar holder at the front, for masks and vignetting devices.

CAMERA SUPPORT

Landscape photography calls for thoughtful image composition. Some of the best photographs are made in relatively dim light, requiring relatively long exposure times. Frequently, you'll want to include foreground interest in sharp focus—requiring a small lens aperture. What this means is that you'll need a firm support for your camera.

Tripod—A tripod is a device with three extending legs. It should have a movable head, so you can aim the camera easily, and a means of attaching the camera to that head. More complex and heavy tripods, generally with a central rising column, are also called *camera stands*.

Stability is the most important characteristic in a tripod. Especially outdoors, many pictures are spoiled by camera movement caused by wind. Also, the camera head should swing and tilt with ease and lock firmly in position. Other features important to the landscape photographer are, of course, compactness and lightness.

If your landscape photography involves making frequent stops at different locations, a *quick-release device* will be handy. Several tripods feature these. Some camera manufacturers, such as Hasselblad, make a special camera/tripod adapter that does the same job.

Bogen and Gitzo also make excellent tripods with such a device. The Bogen model uses a six-sided plate that attaches to your camera's tripod socket. It is easily secured or released by adjusting one of three claws on the tripod head.

The Gitzo head uses a simple modification of a standard tripod-head securing screw design. You remove the screw from the tripod head through a slot in the platform and attach it to the tripod socket on the camera body. You can then easily attach or remove the camera by sliding the screw into or out of the slot on the tripod head. To lock the camera in place on the tripod, tighten the collar that's part of the securing screw.

Monopod and Chain-Pod—In addition to the tripod, there are other devices designed to hold a camera steady. They include the monopod and chain-pod. A monopod is a one-legged camera support. It can be particularly attractive when minimum weight is important. It's also useful for photographing animals and birds with a telephoto lens. It combines some stability with easy camera mobility for aiming.

The chain-pod is even more portable. It consists simply of a chain, with a screw that attaches to the camera's tripod socket. You stand on the lower end of the chain to hold it firmly on the ground. You then pull upward on the camera to create sufficient tension in the chain. This should give you a little more stability than you would have with a camera held normally.

The monopod and chain-pod lack one important asset of the tripod. They do not enable you to keep the camera in one fixed position for the entire operation of viewing, focusing and shooting.

Clamp-Pod—A clamp-pod is a tripod head attached to a "C" clamp or similar device. It enables you to securely fasten your camera to fences, railings and other rigid structures. Under the right conditions, it provides a support as steady as a tripod. It also lightens your load considerably. But you are dependent on good attachment locations.

Bean Bag—Even bean bags can be used. Most of these are not as steady as a good tripod. I would recommend them only as a makeshift substitute. The bean bag can sometimes be useful for telephoto photography in the field.

Place one or two small bags, about half full of beans, buckshot or ball bearings, under the camera. This way you can establish a firm camera support on the ground, a rock or a large tree branch. At the same time you can maintain some flexibility for aiming the camera.

The tripod is an important piece of equipment for the landscape photographer. All too often, high-quality cameras are supported by flimsy, cheap tripods. This professional model is a good choice. It's lightweight, yet sturdy. Its head can be rotated and tilted forward, backward and sideways. The center post can be cranked up and down. A bubble level is included for checking horizontal camera orientation. The legs can be adjusted easily and accurately.

The monopod resembles a single tripod leg with a camera platform at the top. It is helpful in situations where you need some camera support but are not able to set up a tripod. When not in use, a monopod is usually smaller than a collapsible umbrella. The models shown here are available with a neck strap. By placing the foot of the monopod in a pocket at the lower end of the strap, you can convert the unit to a chest pod.

4 Films

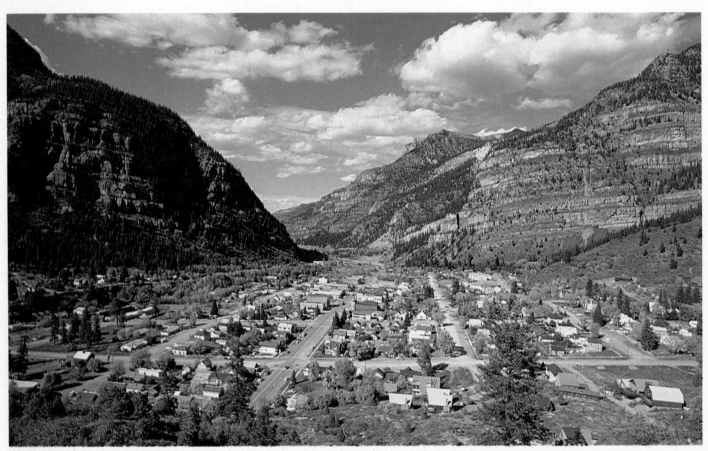

When you want to retain full detail in a sunlit scene, use a slow, fine-grain, high-resolution film. This scene was recorded on Kodachrome 25 film. It's an emulsion hard to beat for image resolution.

Your first decision in choosing a film is going to be an easy one. If you want color photographs, use color film; for b&w pictures, select b&w film. Beyond that point, you may need some guidance because there's a wide selection of both color and b&w films available. Each has characteristics that make it suitable for specific applications.

BASIC CHARACTERISTICS

It's usually not advisable to think simply in terms of choosing the "best" brand. First, I believe the quality of your photographs will depend less on the specific film brand you are using than on some of the basic characteristics of the film. These include speed and contrast. Second, the film that's best for you is dependent on the kind of result you like. For example, some films give richer and more saturated colors than others. Some have higher contrast than others.

Color Negative or Positive—If you're interested in making color photographs, you'll have to decide whether a negative film or a positive transparency film best serves your needs. For making large color prints I recommend color negative film, especially if you're using a medium- or large-format camera. If you want 35mm slides for projection, use a color-transparency, or color-reversal, film. From this you can also make prints and enlargements.

Film Speed—An important factor in film choice is film speed. This is another term for a film's sensitivity to light. A fast film is more sensitive to light and needs rela-

tively less exposure. *Faster* is not necessarily *better*. In general, it is better *only* when you actually need the speed. This may be when there's dim light, or because you need a short exposure time, or because you want to stop down the lens for good depth of field.

In terms of image quality, *slow* speed is generally better. The slower the film, the smaller the grain size in the image and the better the image resolution. If you want to enlarge your landscape photographs and retain good image quality, use the slowest film practical.

Contrast—The inherent contrast characteristics of a film determine how the film responds to different scene brightnesses and how tonal values in the scene will be recorded. The ideal film to use will depend on the brightness range of the subject. For example, to get the best from a shadowless scene, illuminated by the diffuse light of an overcast sky, you'll need a fairly contrasty film. But to retain good shadow detail in a subject lit by harsh, direct sunlight, a film of lower contrast will give you a better result.

Film Processing—The inherent contrast and speed of a b&w film can be changed to a significant extent by development technique. In b&w work, it's hardly possible to think of film characteristics without also considering processing. The ingredients in a developer, the strength of the solution and the development time can all affect the end-result almost as much as the inherent characteristics of the film.

This kind of processing control is very limited with some color films and impossible with others. With them, you must carefully watch the illumination and control the exposure.

Color Saturation and Balance— Color saturation means much the same as color intensity. It is dependent to a large extent on the nature of the subject and on how it is illuminated. Under similar

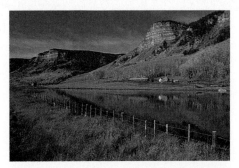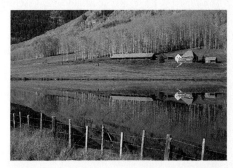

I photographed this scene twice within a few seconds, without filters. I wanted to show that different film brands record colors differently. The left photo was made on Kodachrome 25 film, the other on Fujichrome 100. Notice the difference in the color of the grass, foliage and buildings. It's not a question of determining which film is *better*. Select the one that suits your purposes best.

circumstances, however, different film brands tend to give differing degrees of color intensity.

Color balance refers to the correct relationship of the various hues in the spectrum, rather than to their intensity. It is most effectively controlled by color filtration. However, even with correct filtration, color balance can vary considerably between film types. The only way to find out which film most suits your application and your personal taste is to try different film types.

Predictability—Current color and b&w films are remarkably consistent products. You can usually expect a film to behave in much the same way each time you use it under similar conditions. However, you may sometimes see a small difference between manu-

facturing batches. This difference may be in contrast, color balance or film speed.

If you want to be sure of consistent results for as long as possible, buy a large quantity of film from the same manufacturing batch. The batch number is on each film package. Store film that you're not going to use for some time in a refrigerator or freezer.

Remove film from refrigerator or freezer several hours before use. Don't open and load the film until it reaches room temperature. This prevents harmful condensation on the film.

Inconsistencies in color and speed—particularly of slide films—are most likely caused by inconsistent processing. Some labs are more dependable than others. When you've found a good one,

Color rendition is affected by the light-transmitting characteristics of lenses. It can also be affected by so-called *neutral* lens attachments. The picture at left was made with a multiple-element color-corrected lens; the picture at right, with a single-element lens. For the left picture, a *neutral* black vignetter was used over the lens. The picture doesn't have the excess of blue evident in the right photo for two reasons. First, because of the color correction in the lens. Second, because the neutral vignetter actually absorbs an appreciable amount of ultra-violet radiation. I include this example only to illustrate that the choice of color filters is not a totally independent one. It's dependent partly on the characteristics of the lens and any attachments being used.

stay with it. I'd recommend that you use a lab that regularly handles the work of discerning professional photographers.

COLOR FILMS

Several factors affect your decision to use either a color negative film for print-making or a reversal film that provides positive transparencies.

COLOR-REVERSAL FILMS

In 35mm and medium formats, color-slide films offer you the widest variety of characteristics. Films are available balanced for use in daylight or tungsten illumination, and possessing slow, medium or high speed.

If you need only one of each picture, these films are the most economical because the slide is the direct end-product of film processing. No separate printing or enlargement step is required. As I said earlier, if you want prints later, they can be made easily from slides.

Many serious landscape photographers prefer to use slide film. This may be partly because of lower cost. However, its main attraction is the brilliance and wide tonal range of a projected image.

Perhaps the only significant disadvantage is the relatively limited exposure range of about five to six exposure steps. This means that the subject brightness range—or contrast—should not exceed a ratio of about 1:32 and 1:64. This limit, which is fairly similar for most slide-film types, *can't* be extended through special processing techniques.

Low-Speed Films—Kodachrome 25 is the only slow color-slide film balanced for use in average day-light (5500K). Its speed is ISO 25/15°. Extremely fine grain and high image resolution make this film an exceptionally good choice for landscape photography. This is especially true if you intend to project a large image or make a big enlargement.

Medium-Speed Films—These include the popular speed of ISO 64/19° and go up to a speed of ISO 200/24°. Most color-reversal films are in this range. There are three distinct types of film in this category—Kodachrome, Ektachrome and Fujichrome, and Agfachrome. Each group has a different processing technique. Color-reversal films from 3M and Sakura are compatible with the Ektachrome E-6 process. Among Agfa films, Agfachrome 200 is an exception. It is designed for E-6 processing. It is sold with processing prepaid.

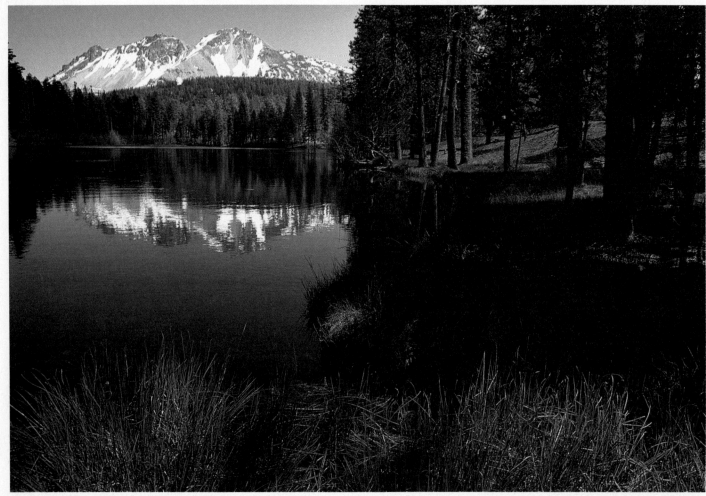

This is a scene with extreme contrast. The tonal range extends from deep shade to sunlit snowcapped mountains. This range is even beyond the wide exposure range of slow-speed color-slide films.

Kodachrome and Agfachrome films, except Agfachrome 200, have special processing requirements that do not allow user-processing. Nor can you change the film's effective speed by a change in development time. In the United States, Agfachrome films are sold only with processing included.

Any films compatible with the E-6 process *do* allow user-processing and some film-speed adjustment. This includes Agfachrome 200. You can process it yourself, although it is sold only with processing prepaid.

All the medium-speed films mentioned are available in the 35mm format. In the 120 size in the United States, Agfachrome CT-18 was removed from the market a few years ago but I believe it, or a similar film, is to return soon. Ektachrome 64 and 200 are available in both daylight and tungsten versions. New Fujichrome 50, 100 and 400 films have been announced.

Where graininess and image sharpness are concerned, Kodachrome does considerably better than the other ASA 64 films. However, the new Fujichrome 50 does put an E-6-type film in almost the same class. I find the Agfachromes to have image resolution comparable to E-6 films of the same speed. But Agfachrome films, with the exception of the new 200, have more apparent graininess.

Ektachrome 64 and 200 can't really be compared, because of the considerable speed difference. It's to be expected that the fast version will not match the sharpness and fine grain of the slower film. I find the sharpness and grain of the new Fujichrome 100 film greatly improved and comparable to Ektachrome 64.

The differences in graininess and resolution that have been mentioned are generally subtle. They become significant only when big enlargements are made. When it comes to color rendition,

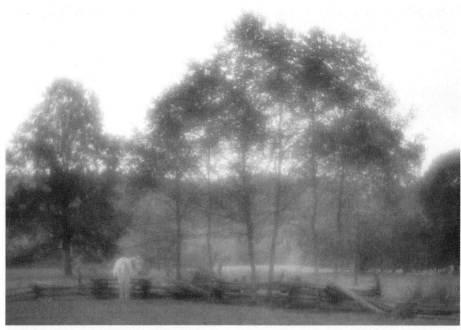

A very low light level after sunset called for a high-speed film for a handheld exposure. To give the image its soft pastel appearance, I used a diffusion attachment on the lens and deliberately overexposed the scene.

however, there's much more cause to choose your film carefully. It should suit the subject conditions and the kind of color reproduction that fits your visualization of the scene.

I find Kodachrome 64 to have the most neutral color balance. It records shades of gray and subtle pastel colors most accurately. In my opinion, Ektachrome gives results that are on the cool, or bluish, side. At high altitude, on a beach or on an overcast day, Ektachrome film can produce an image that is excessively blue. This leads to a reduction of the brilliance of the warm colors. Of course, filtration can correct this to a large extent.

My experience shows Agfachrome films to be biased slightly toward red, although not so much that neutral colors suffer unacceptably. Agfachrome is particularly well suited to softly lit scenes or subjects. Its inherent contrast is greater than that of other medium-speed reversal films. With this characteristic, it can preserve good separation between subtle tonal differences.

The color balance of Fujichrome is decidedly warm. This is special-

ly true when Kodak processing is used instead of Fuji processing. I find it renders natural scenes containing yellows and greens with intense brilliance. It is also an excellent choice for use at high altitudes and on overcast days. It handles all but the most severe such condition without the need for a yellowish 81-series filter.

High-Speed Films—Most of these transparency films have a speed of ISO 400/27°. The exceptions are 3M's 640T and 1000 daylight films. Each film is available in 35mm only except Ektachrome 400 and Fujichrome 400, which also come in 120 rolls. These films have relatively coarse grain and high contrast.

Other than speed, the only reason to use such films is to accentuate the coarse grain to create special visual effects. For this purpose, 3M's 640T and 1000 produce the most striking results. I would recommend them, even though the 640T calls for an 85B color conversion filter for proper color balance in daylight. The filtration reduces its speed to ISO 400/27°.

The 640T is also a useful film for photographing artificially lit

interiors, especially when you can't use a tripod.

Ektachrome and Fujichrome 400 films are comparable in color balance and other image characteristics.

COLOR-NEGATIVE FILMS

Color-negative films are currently most popular for making snapshots. They don't call for expensive and cumbersome projection equipment. It's easy to have any number of prints made and the pictures are easy to carry and show. However, when printing cost is included, these films are more expensive per image than slide films.

A special attraction of the negative film type is the creative control it provides *after* you've exposed and processed the film. In the darkroom, you control the printing process. You can adjust the color balance, enhance detail in highlight areas or lighten deep shadows. In addition, you can crop the negative any way you choose.

One thing you can't control at any stage is image contrast. Therefore, it's important that you choose a film with contrast characteristics compatible with your kind of photography.

Color-negative films are available in medium and high speeds. Let's look briefly at each.

Medium-Speed Films—Color-negative films in this category offer the widest selection. Speed ranges from ISO 64/19° to ISO 125/22°.

The films available in the sizes for all amateur cameras include Kodacolor VR 100 and VR 200, Fujicolor HR 100 and private-label films made by 3M, Sakura and others. These are all C-41-process films that provide a moderately contrasty negative. They're suitable for photographing low- to medium-contrast subjects having a brightness range of about 1:32. This is equivalent to about five exposure steps.

Of the medium-speed films, I find Kodacolor VR to record neu-tral tones most accurately but to give relatively less brilliant, saturated colors. Fujicolor HR gives me the richest, most saturated colors but has a slight tendency to a warm color bias. It reproduces greens well.

Three other color-negative films from Kodak are intended for professional use. They are also available to the large-camera user, as they are made in sheet-film size. The most commonly used is Vericolor III Professional, Type S. It is balanced for 5500K daylight and electronic flash. It is used mostly for portraiture. However, its relatively low contrast also makes it useful for landscape photography under contrasty conditions. Its colors are slightly subdued and unsaturated. Its ability to reproduce neutral tones is excellent.

Vericolor II Commercial, Type S, has higher contrast than the above, but is basically similar in other respects. It is also balanced for use in daylight and with electronic flash.

Vericolor II Professional, Type L, is balanced for 3200K artificial light and is, therefore, of limited use to the landscape photographer. Its other characteristics, including contrast, are similar to those of Vericolor II Commercial, Type S.

High-Speed Films—Kodacolor VR 400 and VR 1000, and Fujicolor HR 400 are the most commonly available, but some private-label films also fall into this category. All have slightly more contrast than their slower Kodacolor and Fujicolor counterparts—but their color rendition is similar.

They have more noticeable grain structure and lower image resolution. These put the fast films at a distinct disadvantage compared with the excellent image quality of the medium-speed group of films. As a result, the fast films have little to recommend them to the discerning landscape photographer. The exception is the rare occasion when the extra speed is needed.

Optimum image resolution depends not only on lens quality, but also on film characteristics. Kodachrome 25 is the most popular choice when resolution of detail is most important. Lighting conditions have to be good enough to permit you to use this slow-speed film.

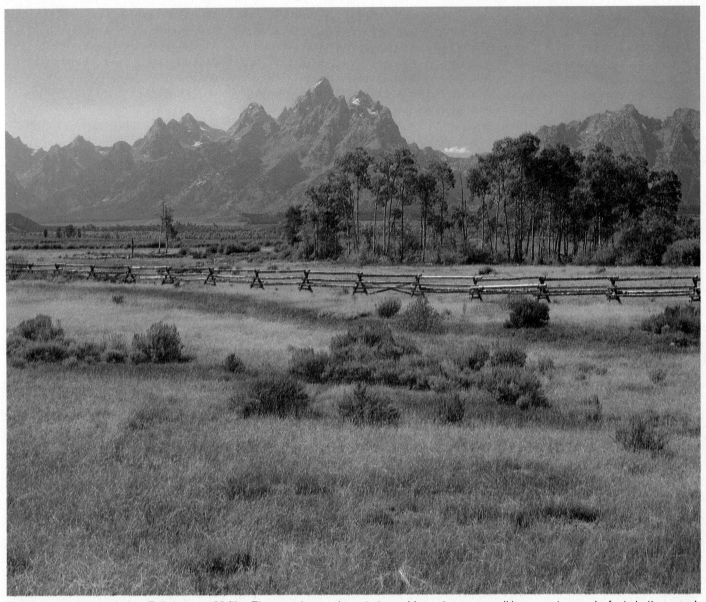

This scene was recorded on Fujichrome 100 film. The speed was adequate to enable me to use a small lens aperture and a fast shutter speed. The latter was important to prevent a stiff breeze from moving the tripod-mounted camera during exposure.

B&W FILMS

Describing b&w films can present some difficulties. Different film sizes sometimes have different characteristics although they are given the same name. For example, there are two distinct Kodak Tri-X films. There's regular *Tri-X,* available in the 35mm and 120 sizes only. And there's *Tri-X Professional,* which is made in 120 roll-film and all sheet-film sizes, but not in 35mm.

The two films reproduce tonal values a little differently. Regular Tri-X has a speed of ISO 400/27°; the professional version's speed is ISO 320/26°. Professional Tri-X also has higher red-sensitivity, making it particularly suitable for studio use under tungsten lighting.

When you study the characteristics of b&w films you must also remember that fine grain and high resolution are much more important with the small formats. These two qualities tend to deteriorate with an increase in film speed.

You can manipulate and change the inherent characteristics of b&w films to a large extent by careful control of film development. You cannot do this with most color films. For this reason, at least a few words need to be said about the effects of various changes in b&w film development procedure. That's why, after the discussion about films in this category, you'll find a special section on *Control Through Development.*

Low-Speed Films—This group includes films with a speed of ISO 50/18° or lower. It includes Kodak Panatomic-X, Ilford Pan F and Agfapan 25. These are the films of finest grain and highest resolving power made for general use. Their inherent contrast is about the same, or a little higher, than that of the medium-speed films. Within their inherent exposure range, these films have a potential for good tonal separation at both the highlight and shadow ends of the scale.

All three of the above film types are made in 35mm and 120 roll-

This photo contains a lot of important detail at the dark end of the tonal scale. It was made on Agfapan 25 film, which gives good tonal separation in shadow areas. Exposure was just enough to record the detail. The film was developed in Agfa Atamol fine-grain developer.

film sizes. But you may not always be able to find the 120 film on camera store shelves. With each of the film types, the emulsion is the same for both sizes. However, the processed films may look a little different due to the different anti-halation dyes used.

In a small- or medium-format camera, slow film is generally not a serious limitation in landscape work. In bright daylight, with the fast lenses available today, it can be an advantage. Most lenses give best image quality—not to be confused with depth of field—in the mid-range of their aperture scale. This is between about f-5.6 and f-11 with most standard 35mm-camera lenses.

An aperture in this range with average daylight and slow film calls for a shutter speed in the mid-range of most camera shutters. Typically, the shutter speed would be between 1/60 and 1/250 second.

The most inhibiting factor for the landscape photographer is not low film speed, but excessive negative contrast. The typical development time for such films is already short. Therefore, lowering contrast by reducing development, as described on page 51, is not feasible. One solution is to use a slow-working, fine-grain type of developer. However, this may cause some loss in the film's already low speed.

In such a situation, I recommend using an energetic developer such as Kodak HC-110 or Agfa Rodinal, highly diluted. With HC-110 you might try dilutions D or E, rather than B. Rodinal may be diluted 1:75 or 1:100, rather than 1:50. This helps to control contrast while at the same time extending the development time.

Increasing contrast with slow films, when necessary, is easier. These films respond readily to moderate increases in development time, giving higher negative contrast without a significant loss of resolution.

If your subjects are likely to vary considerably in contrast, I advise you to use two different

To photograph this relatively low-contrast scene, I had to maximize tonal separation in the high to middle tonal values. Shadow areas were relatively unimportant. I used Kodak Verichrome Pan film and extended development in Agfa Rodinal to increase image contrast.

films. You'll need either two camera bodies or one camera with interchangeable film magazines. Use a slow film for low-contrast scenes and either Verichrome Pan or one of the three general-purpose films listed under *High-Speed Films* for more contrasty subjects.

Medium-Speed Films—Films with a speed of ISO 100/21° to ISO 125/22° are generally regarded as medium-speed films. They include Kodak Plus-X, Ilford FP-4 and Agfapan 100.

Similar to the Tri-X films mentioned earlier, there tends to be some confusion regarding Plus-X. The emulsions in the different sizes produce significantly different responses. The 35mm and 120 versions give good shadow detail. The sheet-film and 70mm versions are particularly good at recording detail in scene highlights.

All sizes of Ilford FP-4 film, however, have the same characteristics and the same speed of ISO 125/22°. Agfapan 100 has a speed of ISO 100/21°. Its characteristics are also the same in all sizes.

One special characteristic of modern medium-speed films can be both an advantage and a shortcoming to the landscape photographer. Both 35mm and 120 sizes have a micro-thin emulsion, designed for the best possible image resolution. This obviously helps you get the greatest possible detail in your landscape images. But it does not permit you to reduce development much for the purpose of reducing image contrast.

Sheet film is not quite as restrictive because it has a slightly thicker emulsion coating. Agfapan 100 seems the least restrictive in this respect, especially when developed in a highly diluted solution of Rodinal.

Perhaps the best way for the 120-film user to get lower contrast and a wider tonal range is to use Kodak Verichrome Pan film. When developed in dilute solutions of high-energy developers, such as Kodak HC-110 or Agfa Rodinal, the film loses little of its original speed of ISO 125/22°. It also gives good tonal separation in both shadows and highlights with contrasty subjects.

To increase image contrast with the Plus-X, FP-4 and Agfapan 100 films, more concentrated solutions of the above developers can be used, together with extended development times.

This scene was shot with Kodak Technical Pan film 2415, an exceptionally fine-grained, high-resolution 35mm film. It's useful to the photographer who wants large-format image quality from a 35mm film. The inherent contrast of the film is high for landscape work. I used Kodak Technidol LC developer, an extended-range formula that lowers the contrast.

High-Speed Films—These films include Kodak Tri-X, Ilford HP-5 and Agfapan 400. With the exception of Tri-X Professional, all have a speed of ISO 400/27°. Agfapan 400 has lower inherent contrast than the other two. It requires more development to reach a similar contrast. Its grain structure is comparable to that of Tri-X Professional and more apparent than that of Tri-X and HP-5.

High-speed films are rarely needed in landscape photography. They have coarser grain and lower image resolution than their medium-speed counterparts. And, the additional speed is almost never needed. The exception might be in dim light when you're using a telephoto lens, and need to stop the lens down for maximum depth of field.

With high-speed sheet films, graininess and lower resolution are not as serious a problem.

Fast films can be exposed for a lower-than-recommended film speed and developed in a soft-working, fine-grain developer. This can yield a wide exposure range with very contrasty subject matter. Under such conditions, the apparent grain is also minimized and the resolution enhanced.

Control Through Development—As indicated earlier, the characteristics of a b&w negative depend on both the film type and the kind of developer and development technique you use. You can vary your processing technique to deliberately extend a film's response to the long brightness range of a contrasty subject. Or, you can control development to enhance image detail in either the highlights or the shadow areas. You can also increase a film's basic speed by special development.

For the sake of simplicity, I'll separate the developers most useful to the landscape photographer into three distinct groups.

Relatively *high-energy* developers produce negative density dif-

I used a high-speed film here for two reasons. It enabled me to expose for shadow detail while using a small lens aperture for maximum depth of field. The film was able to accommodate the subject brightness range, from deepest shadow to brightest highlight.

ferences that most accurately represent differences in brightness along the entire exposure range. They give the best contrast and detail at both the highlight and shadow ends of the scale. Among these developers are Kodak HC-110, Agfa Rodinal and Ilford Microphen.

The relatively *soft and fine-grain* developers include Kodak's D-76 and Microdol, and Ilford's ID-11 Plus and Perceptol. They reduce contrast and tonal detail in the highlight areas. This is attributed

to their high content of sodium sulfite, which is believed to dissolve some of the silver in the film's emulsion during development. The greatest development activity takes place in the most heavily exposed parts of the film—the highlight areas. Therefore, this dissolution is greatest in those areas. The overall effect is better tonal separation in the shadows and midtones than in the highlight areas. These developers reduce the effective speed of the film.

The subtle tones and texture of these trees were subdued even further by very soft lighting. For finest image resolution and optimum contrast, I used slow Agfapan 25 film. The film was developed in Rodinal.

I shot this photo on Kodak Technical Pan film 2415. It offers extremely fine grain and sharpness. In landscape photography, it has the added advantage of rendering a blue sky darker than other panchromatic films. To record the sky in this manner on another panchromatic film, a deep-yellow filter would have been required.

The overall density range of the negative can be reduced by the use of a *compensating* developer. These include Ethol T.E.C., Edwal Minicol and FG-7. These developers limit development action in proportion to the exposure received by the film. The highlight areas are developed to a relatively lower negative density than they normally would be. This enables you to produce a soft negative from even very contrasty subject matter. In terms of contrast and tonal detail, there's a gradual decrease from the shadow to the highlight areas.

For more information about b&w image control through changes in negative development, see *How to use the Zone System for Fine B&W Photography,* also published by HPBooks.

SPECIAL-PURPOSE FILMS

Special films like those listed here can be used in landscape photography to create unusual effects or to meet specific technical needs.

Kodak Technical Pan 2415—This high-contrast film is available in 4x5 sheet film and 35mm. The 35mm film is of particular value to the landscape photographer because of its super-fine grain and ultra-high image resolution. In these respects it is far superior to even the low-speed, general-purpose films. You can lower contrast, for average landscape scenes, by the use of a very dilute soft-working or compensating developer. Kodak Technidol LC developer is made especially for this film.

Under these conditions, the film has about the same effective speed as the low-speed films mentioned earlier. When used with the best lenses, this film can give greatly enlarged images of a quality you would only expect from much larger negatives.

Kodak High-Speed Infrared 4143—This film is extremely grainy and has relatively poor image resolution. You can't really regard it as a landscape film. However, if you want to experiment with special effects, consider trying it. Used with a deep red filter, it records living foliage in pale tones. Clear blue sky reproduces as very dark or black in a print. When the 35mm negative is enlarged, the inherent coarse grain of the film can add to the unusual effect.

Kodak Recording Film 2475—This film also has very coarse grain, which can be used to create an impressionistic image of appropriate subject matter. Image resolution is relatively poor. The film's extremely high speed can be an important limitation. It can make it difficult to use in the normally bright illumination associated with landscapes.

Chromogenic Films—These are not so much special-purpose films as general-purpose films of a new kind. Both Ilford XP-1 and Agfa-Gevaert Vario XL use type C-41 color negative processing. They produce a negative image made up of dyes. The silver image is bleached out during processing. These films have finer grain and higher resolution than other films of their speed, which is ISO 400/27°.

For a dimly lit interior, high-speed film serves several useful purposes. It makes possible a reasonably short exposure time together with a small lens aperture for maximum depth of field. The film also has a wide exposure range. This enables you to record a high-contrast scene like this satisfactorily.

Mechanics of Image Control 5

In this chapter, I discuss the three major camera controls. With them, you control the image in the camera and on film. They are focus control, lens-aperture setting and shutter-speed setting.

Your eyes focus automatically when you look at an object, and they adapt to a wide range of brightnesses. You can see detail in relatively bright and dark areas. A camera lens and film do not have this adaptive capability. The characteristics of the scenes you photograph can vary greatly. You need mechanical and optical controls for image sharpness and exposure.

In the past few years, camera designers have increasingly used electronics and computer technology to automate exposure control and even focusing. Some cameras are programmed to automatically adjust both the shutter speed and the lens aperture to give you correct exposure.

Such features can be useful when most photographs are made of average scenes in average illumination. But some of the best landscape photographs are of *unusual* scenes under *exceptional* lighting conditions. As a creative landscape photographer, you cannot afford to take the chance that an automatic exposure system will provide acceptable information under these conditions. You must make the transition to manual control.

You need total control of lens aperture settings and shutter speeds. This gives you deliberate

Wide-angle lenses for 35mm cameras have great depth of field. Even when stopped down only part of the way, they can provide sharpness from a few feet to infinity. This depth appears especially great because wide-angle lenses make distance appear greater than it actually is.

command of image sharpness and depth of field. In addition, you can choose to either freeze or blur subject components that are in motion during exposure.

FOCUS AND IMAGE SHARPNESS

Your eyes automatically adjust their focus for subjects at varying distances. Simply by looking at an object, you get a sharp image. When your eyes are focused on a close object, such as a flower, only a limited zone is sharply defined. Everything in front of and beyond that zone is blurred and indistinct. You only realize this when your attention is suddenly called to a more distant element.

Many snapshot cameras need not be focused by the user. They have short-focal-length lenses, set at a relatively small lens aperture, to give extensive depth of field.

The lens is set at a distance that records everything from the most distant scene to very near objects with acceptable sharpness. The closest focused distance is generally three or four feet.

If you're going to do creative landscape work, I don't recommend a camera like this. To control image sharpness, you must have access to some *unsharpness,* too.

YOU HAVE CONTROL

Camera manufacturers make focusing devices that enable you to focus accurately on discrete subject parts. These devices include split-image rangefinders, microprism patterns and brilliant focusing screens. With them it is apparent, at least with relatively close subjects, that you can move the plane of sharpest focus by adjusting the lens. But the devices do their job so well that you often

The two planes of interest I wanted to record sharply were the two small boats in the foreground and the fishing vessels behind them. The distant scene was in a haze. It wasn't important to record it sharply. I focused about a third of the way between the small boats and the fishing vessels. I then stopped the lens down until I had sufficient depth of field to include both planes sharply.

don't realize until you look at the finished pictures that there is a *zone* of sharpness. It extends in front of and behind the plane of best focus.

This zone of sharpness is called *depth of field.* In landscape photography the first consideration is generally not simply *where* to place the plane of critical focus. Rather, it's how much distance from near to far—or how much depth of field—should be recorded sharply.

DEPTH OF FIELD

When you focus the camera lens, you don't focus on one

point. You focus on a plane perpendicular to the lens axis—the central line of view of the lens. Depth of field is contained between two planes. They are the nearest and farthest plane, perpendicular to the lens axis, between which all objects are recorded with acceptable sharpness.

Factors Controlling Depth of Field—The extent of depth of field on either side of best focus depends on two factors—relative image size and lens aperture. For a specific image size, the smaller the lens aperture—the higher the *f*-number—the greater the depth of field. At a specific lens aperture setting, the larger the image, the more limited the depth of field.

The relationship between image size and depth of field is often misunderstood. It is often wrongly thought that a short-focal-length lens gives more depth of field than a lens of longer focal length.

Assume that two lenses of different focal lengths are used at different distances from a subject to make camera images of identical sizes. If the same lens aperture is used, depth of field will also be identical.

If you use the two lenses from the same viewpoint, the shorter-focal-length lens will give greater depth of field. But this is only because the resultant image is smaller.

When you change lenses without changing camera position, remember that a longer focal length will give you a larger image. This results in less depth of field. You can extend the depth of field by using a smaller lens aperture.

You should be particularly careful when using a zoom lens. Generally, you will use a zoom from one viewpoint, to frame a scene in the exact way you want it. As you zoom to an effectively longer focal length, it is easy to forget that you are also reducing depth of field.

If you should find it necessary to use a smaller lens aperture at a longer focal-length setting, you'll have to compensate by giving a longer exposure time. The longer lens focal length, combined with the longer exposure, may lead to a loss in image sharpness caused by camera movement. Use a tripod when possible.

Creative Use of Depth of Field—A shallow depth of field is not necessarily a disadvantage. For example, when you photograph wild animals or birds with a telephoto lens, the blurring of foreground and background detail isolates the sharply focused main subject and makes it stand out.

The extensive depth of field possible with a wide-angle lens enables you to include sharply defined close-up elements with a distant landscape. This can give the photograph a three-dimensional effect. It also provides a clue regarding the scale of the scene. For example, a nearby figure standing at the rim of the Grand Canyon can help to emphasize the grandeur of the scene.

Depth-of-Field Scale—Most modern lenses for SLR cameras have a scale indicating depth of field at any focused distance and aperture setting. This scale does more than *tell* you what depth of field you're going to get. It also lets you creatively and deliberately *choose* the depth of field for a specific pictorial situation. I'll explain this shortly.

Visual Control—The most direct indicator of the effect of lens aperture on depth of field is visual. Most SLR cameras have a depth-of-field preview button. When you press the button, the lens diaphragm automatically closes down to the *f*-number setting you've previously set on the lens. In the viewfinder you'll see the depth of field that will be recorded on film. By adjusting the aperture setting and focus, you can visually control the zone of sharp focus.

A word of warning here: Normal visual acuity is not adequate—especially when you use a small camera—to provide a reliable evaluation of acceptable sharpness. This is especially true when the image is to be enlarged considerably. Remember that the viewfinder image darkens as aperture size decreases. If the subject

Depth of field decreases as focal length increases and the distance of the point of sharpest focus decreases. If you need a fast shutter speed to stop subject movement, a large lens aperture is called for. This decreases depth of field further. For this telephoto shot, I focused carefully on the legs of the birds.

is in dim light, evaluating depth of field is even more difficult.

As a safety margin, make a habit of closing the lens an additional step beyond the point where you thought you saw adequate depth of field on the focusing screen. In fact, in large-format photography this is common practice. The photographer finds the focus setting and lens aperture that provide a visual indication of the needed depth of field on the ground glass. He then closes the lens down one additional step before making the exposure.

Depth-of-Field Tables— It is rare now, but at one time it was customary for lenses and cameras to be supplied with a depth-of-field table. It was usually in the lens or camera instruction manual. Aperture values were on a vertical scale and some typical focusing distances on a horizontal scale. From these tables, it was easy to read off depth of field for a wide variety of situations.

PLACING THE PLANE OF CRITICAL FOCUS

In landscape photography, focusing involves more than just setting the camera lens for best focus in a certain subject plane. When focusing, you have to think in *three dimensions*. You must choose two planes, perpendicular to the lens axis, between which everything in the scene is to be recorded sharply.

First, use the camera's focusing mechanism and distance scale as a simple measuring device. Focus on the closest and most distant subject elements that define the limits of the zone you want in sharp focus. The two readings you get tell you the required depth of field in actual distance values.

Using Depth-of-Field Scale— Adjust the focus setting so the two extreme distances you determined fall within the area defined by one pair of aperture marks on the lens depth-of-field scale. Let's say you focus on the closest important element in a scene, and find it is 10

With a standard or wide-angle lens, depth of field is extensive at all but the largest lens apertures. Virtually everything is in sharp focus in these two pictures. At right, I used color to create a focal point. Although everything is equally sharp, the eye is naturally drawn to the yellow wagon wheels.

feet away. You then focus on the most distant point you want sharply defined and find it's 30 feet from the camera.

Now move the lens focusing ring until the 10-foot and 30-foot marks on the distance scale are an equal distance on each side of the focus mark in the center of the depth-of-field scale. This will place the 10-foot and 30-foot marks opposite the same aperture numbers on the depth-of-field scale. To obtain sharp focus from 10 feet to 30 feet, use that lens aperture. The focus mark in the center of the depth-of-field scale now indicates the point of sharpest focus for which the lens is set.

Lens Without Depth-of-Field Scale— Zoom lenses, and some other SLR lenses, may not have a depth-of-field scale. Even so, you can follow the basic procedure I've just described.

Begin by focusing on the closest and most distant elements you want sharply defined. Determine their distances from the camera. Then adjust the distance scale so these distances are equally spaced on each side of the focusing mark on the lens barrel. Press the depth-of-field preview button and slowly move the lens aperture ring from the largest aperture—smallest *f*-

number. Close the aperture down slowly.

When the near and far points you want within the depth of field appear to be sharp, note the aperture number on the aperture scale. To give you a safety margin, close the lens down one more step, leaving the lens focus setting as it is.

The point of critical focus should now lie about one third of the way from the nearest to the farthest acceptably sharp point. For example, if the near distance is 20 feet and the far distance is 50 feet, the lens should indicate that critical focus is at 30 feet.

When There's No Distance Scale— The method just discussed also works with view cameras having a proportional, symmetrical focusing movement and no distance scale. First note the camera extension for best focus for the nearest and farthest point you want to record sharply. Then alter the extension so the lens is midway between these two points.

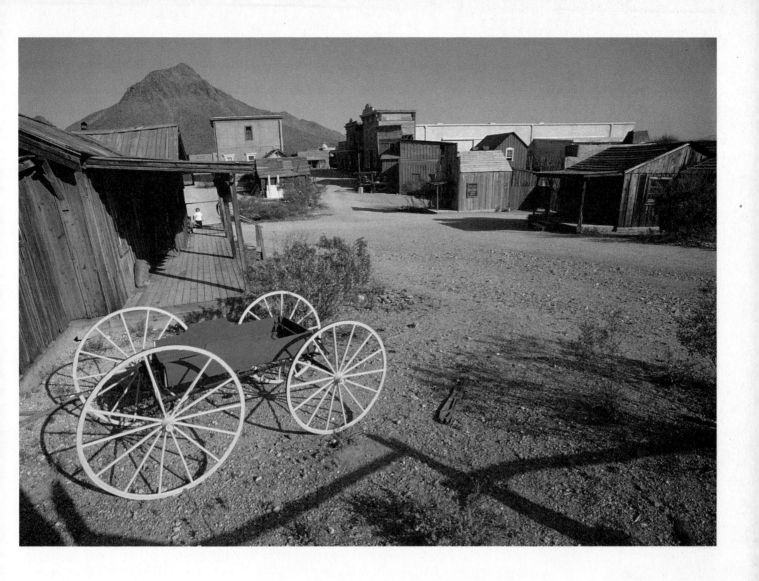

The point of critical focus in the scene should now be one third of the way between the nearest and farthest acceptably sharp points. Close the lens aperture down until you see the depth of field you need on the focusing screen.

You can make your own distance scale for your camera. A football field with clearly marked yard lines can be a useful aid. Temporarily attach a narrow piece of stiff white card parallel to the camera focusing track. Focus on a series of yard lines on the field and indicate the distance on the card. You will have to prepare a separate distance scale for each lens having a different focal length.

If, in addition to the distance scale, you also have a depth-

of-field table for each lens, depth-of-field control in the field will be relatively easy.

Make Comparisons—If you don't have access to depth-of-field tables for your lenses, you can refer to depth-of-field data for lenses of identical focal lengths. Some camera stores, older members of camera clubs and some libraries may be able to provide these for you.

The *Kodak Professional Photo-guide No. R-28* contains a depth-of-field guide for lenses ranging in focal length from 75mm to 350mm. You can use this guide in a similar way to the depth-of-field scale on an SLR camera. But you'll also need a distance scale for your lens-camera combination.

CAMERA SWINGS, TILTS AND SHIFTS

View and field cameras have movable fronts and backs. These camera movements fall into three categories. *Swings* enable the film plane or the lens board to be displaced about a vertical axis. With *tilts*, you can displace the film plane or the lens board about a horizontal axis. *Shifts* enable the rear or front of the camera to be raised, lowered or moved sideways in their own plane.

The swings and tilts of the lens board affect focus. It is these movements I'll discuss here. I won't talk about the swings and tilts of the film plane. They are equally important, but focus control is not their primary function.

With the lens on a large-format camera you sometimes don't get adequate depth of field, even at an aperture as small as f-64. However, there's another technique you can use. Most large-format cameras enable you to tilt the lens board forward. To record this scene, I kept the camera back vertical and tilted the lens board down until the entire scene was sharp. I closed the lens down by a couple of stops, just to be sure everything was really sharp.

toward the plane of the scene. For overall sharpness with the lens aperture wide open, the following condition must be met. An extension of subject plane, image plane and lens-board plane must meet at a common point.

Ideally, you should keep front tilt to a minimum. To get the depth of field you want, you can use a combination of aperture control and camera movement. The greater the tilt, the more likely you are to get image cut-off. This is due to the center of the film plane being too far away from the lens axis. This problem can be cured to some extent by shifting the film plane toward the new position of the lens axis.

Lens-Board Swing—Frequently, the main part of your scene recedes in a vertical plane instead of horizontally. An example is a fence going diagonally through the field of view. The above principles of lens tilt basically apply. Only now, instead of *tilting* the lens board, you must *swing* it through a vertical axis toward the plane of the subject. Some subjects may call for some of each—a little bit of lens tilt and a little bit of swing.

When Tilts and Swings Won't Work—Lens-board tilt or swing enables you to get one subject plane in sharp focus. For example, if you are photographing a large flat field, you can get it all in sharp focus with lens-board tilt. Now suppose that a man is standing in the foreground, so that his head is in the line of view of the horizon. When you tilt the lens board to get the distant horizon sharp you are at the same time making the man's head less sharp.

Their purpose is mainly to control image perspective.

Lens-Board Tilt—The most important camera movement for focus control in landscape photography is the forward tilt of the lens board. In many circumstances it enables you to do what the lens aperture control also does—control or increase depth of field.

With the film plane parallel to the main subject plane, you get best focus over the entire subject when the lens board is also parallel to these planes. A typical example

would be head-on photography of a building. However, in landscape photography the film plane and the main subject plane are rarely parallel. Typically, the film plane might be almost vertical and the subject plane almost horizontal.

In this typical landscape situation, you can increase depth of field by tilting the lens board forward. This is common practice among large-format camera users.

Here's how it works. To increase depth of field in a horizontal scene, tilt the lens board forward

With large-format cameras, exposure times tend to be longer than with small, handheld cameras. With the right kind of subject, you can get image blur that is not unattractive. In this scene, surf was draining from shore-line rocks and sand. The blur of the moving water gives the image life. The extent of blur depends on the speed of the motion and the exposure time given. To be sure of a good result, take several pictures at different exposure times. The camera should be on a tripod. Otherwise, the long exposure time would also lead to unwanted camera movement.

Here, the only way to extend depth of field is by closing the lens aperture, moving the camera back to get a smaller image, or a little of each.

SLR Controls—The regular lenses on most 35mm and medium-format SLRs are mounted with the lens axis fixed at right angles to the film plane. One exception is the Rollei SL66E, which has a limited amount of lens tilt.

Canon makes a 35mm perspective-control lens that tilts. You can also rotate this lens through 90°, so that the tilt effectively becomes a swing. This enables you to use tilt or swing for both horizontal- and vertical-format pictures.

Minolta offers a 35mm perspective-control lens that permits the subject plane of critical focus to be varied from convex to concave. The adjustment is made with a control ring on the lens barrel. Combined with its lens shift facility, this lens can provide different planes of critical focus suitable for many subject types.

Several brands of focusing bellows for SLR cameras, including that made for the Mamiya M645, provide lens-panel movements similar to those found on view and field cameras.

SHUTTER SPEED AND MOTION

We generally think of landscape photography as making pictures of static scenes, with little or no movement involved. But motion—wanted or unwanted—can affect your work. You should know how to use it, control it and, when necessary, eliminate it.

Unwanted movement is most often caused by camera motion during exposure. It can cause a blurred image and a resultant loss of image detail. Desirable movement is generally in the subject. Typically, it includes such things as falling water, and grass or foliage waving in the breeze.

SUBJECT MOVEMENT

Subject motion in parts of a landscape is the exception rather than the rule. When it does occur, it is not often a serious problem. Usually, there is considerable dis-tance between camera and subject, so the reproduction of detail is small.

Subject motion can be a problem when you don't expect it or notice it. When you are aware of it, you can make the decision to freeze it with a sufficiently fast shutter speed. Or, you can creatively control it with an appropriately longer exposure time.

If the leaves on a distant tree are moving in a stiff breeze, a shutter speed of 1/125 second will probably record them apparently sharply. If you move in close on one tree branch, the same shutter speed will cause the leaves to record with an unacceptable blur.

Remember, the closer you are or the larger the subject, the more noticeable the subject motion. Here's a good example. Suppose you are photographing a distant waterfall with a rapidly moving stream in the foreground. You are using a 1/15 or 1/8 second shutter speed to make the water in the stream appear streaked on the film. The distant waterfall will now appear relatively sharp, al-though its water may be moving

Foliage and flowers can be in constant motion, even in a slight breeze. Unless you are deliberately aiming for the result shown here, use a shutter speed of 1/60 second or faster.

much more rapidly than the water in the stream.

CAMERA MOVEMENT

A prime concern of all landscape photographers should be camera movement—or the *absence* of it. An essential ingredient of a good landscape photograph is sharply defined subject detail. Probably the most frequent single cause for disappointing landscape photographs is image blur caused by camera motion during exposure.

Handheld Camera—If you want to make landscape photographs with a handheld camera, there's no reason why you shouldn't do so. But don't move the camera during the exposure. How long can you hold a camera absolutely steady without moving it? If you're using a 35mm camera, there's a simple, well-tested rule that can help.

The shutter speed should be no slower than the reciprocal of the focal length of the camera lens in millimeters. For example, with a 50mm lens, use a shutter speed of 1/60 second or faster. Longer-focal-length lenses are more difficult to hold steady. With a 100mm lens you should use a shutter speed of 1/125 second or faster. With a 400mm lens your slowest shutter speed should be 1/500 second, and so on.

For best results, learn to hold the camera steady, no matter what shutter speed you are using. If you abruptly jab the shutter button,

you can get a blurred image at surprisingly fast shutter speeds. Take a stance that is comfortable for you. Gently press the shutter button until you hear the shutter operating.

Here are some additional tips. Keep your arms against your body. Breathe in just before releasing the shutter, and hold your breath during the moment you make the exposure. When possible, brace yourself against a suitable firm support, such as a wall or fence post. When using a 35mm SLR for vertical-format pictures, hold the camera firmly against your forehead.

Tripod—The best way to prevent camera movement is to use a sturdy tripod to support your camera. To avoid jarring the camera during exposure, use a cable release to operate the shutter. If you don't have a cable release and your camera has a self-timer, use that instead. The delay between its release and the shutter opening allows the camera to settle before the exposure.

I can't overemphasize the benefits of using a tripod. Frequently, the most desirable illumination occurs early or late in the day, when the light is dim. Slow-speed films have the finest grain and best image resolution. For adequate depth of field, you'll often need to use a small lens aperture. All of this adds up to longer exposure times—and the need for a tripod.

A last word of advice. When there's a wind, don't leave a focusing cloth draped over a view camera at the time of exposure. It'll act like a sail, and make the camera wave in the breeze. If you want to shield the film holder or magazine from the sun, use the withdrawn darkslide, or some other suitable object.

Deliberate Camera Movement—Sometimes you may want to add motion to part of an otherwise static scene by camera movement. The subject element you want to record sharply must be close to the camera. The part of the scene you want to blur should be far away. The existing light on the near subject must be dim, and you must have electronic flash. It's also useful to use a relatively slow film.

Set a slow shutter speed—perhaps about one second, depending on the nature of the scene and the amount of motion you want to record. Use a lens aperture that will give slight underexposure for the distant part of the scene. Set the electronic flash to provide the right amount of light at the chosen aperture to expose the foreground satisfactorily.

Frame the close-up portion of the scene in the way you want it. Press the shutter button while at the same time starting to move or pan the camera across the scene. The flash will fire to freeze the foreground, while the background will be blurred by the longer available-light exposure.

You can also use camera movement to deliberately blur the entire scene, when the subject is suitable.

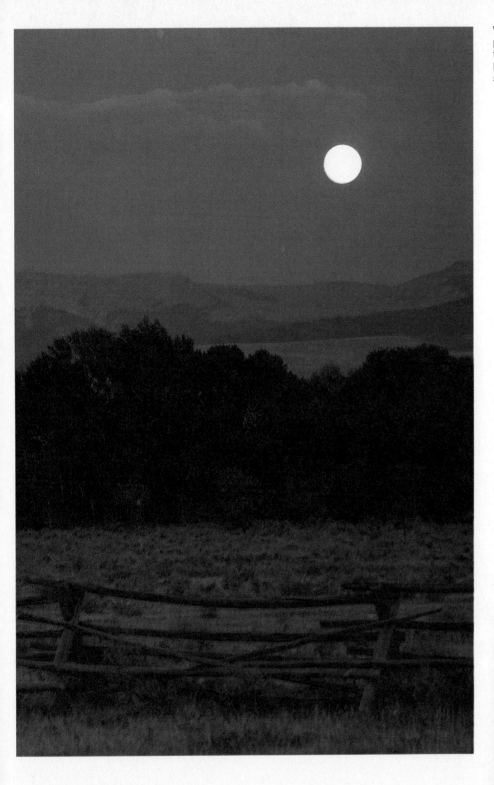

When you shoot the moon, use a long tele-photo lens—200mm or longer. Otherwise, the image of the moon will be disappointing-ly small. Exposure times will be long, so a sturdy tripod is a must.

When you use a long telephoto lens with a relatively slow film and small lens aperture, use the camera on a tripod. Long lenses are difficult to hold still at any but the faster shutter speeds.

EXPOSURE CONTROL

So far in this chapter I've said a lot about how you can use lens aperture to control image sharpness and how shutter speed affects camera or image motion. Now I'll talk about aperture and shutter speed again, but in a different context.

For good film exposure, you must be able to control the light that enters the camera. You have two controls to do this. *Lens aperture* regulates the *brightness* of the light that strikes the film. *Shutter speed* controls the *duration* for which the light is permitted to reach the film. Shutter speed and aperture combined give the effective *exposure*.

An automatic exposure system, or a light meter, is *given* one piece of information by you—the speed of the film. Its light-sensitive cells enable it to *detect* another piece of information. This is the amount of exposure the film requires to record an average scene satisfactorily.

In using these two pieces of information, the metering system has to make some basic assumptions. It must assume that both the speed of the film and the camera's shutter speeds are accurate. It must also assume that the scene is *average*. An average scene has a total average reflectance of about 18% of the incident light.

THE METER CAN'T THINK

I prefer to think in terms of *light* meters rather than *exposure* meters. A light meter measures light intensity. This is a mechanical operation. The name *exposure meter* implies that exposure is measured. But exposure is not really *measured*—it is *deduced* by you from a light reading. To prove to yourself that a light meter can't think, try this simple test.

Take three cards—one white, one mid-tone gray, and a third black. Photograph each one separately, filling the image area with each card. Expose according to the camera meter's reading. In the processed film you will see that each of the frames representing the white, gray and black cards is of equal density.

This happens because the meter doesn't know that the cards are different. The meter is designed to measure average scenes—those reflecting about 18% of the light striking them. It has been programmed to recommend settings that reproduce these faithfully. To the meter, the cards were not white, gray and black. The meter saw three 18% gray cards in different levels of illumination—bright, average and dim. It reproduced them faithfully—each one as an average gray.

Because a light meter works in

To determine subject-brightness range and exposure level for a scene, you need to identify three subject values. They are the brightest detailed highlight (A), the darkest detailed shadow (B) and a midtone gray of about 18% reflectivity (C).

this way, many manufacturers of automatic-exposure cameras provide an exposure-compensation control. It enables you to make adjustments for subjects that are unusually dark or light. Because many landscape subjects are *not* average, this control lets you override the meter's assumption that they are.

INTERPRETING A METER READING

There are two other important factors that an averaging light meter cannot sense. Sometimes the subject brightness range is so great that special compensation is necessary, either in exposure or in film processing. Sometimes, a scene has a typical brightness range but an unusual tonal distribution. In each of these situations, the meter is likely to indicate incorrect exposure.

It is essential for you, as a creative landscape photographer, to interpret the readings provided by the meter. But before you can interpret them, you must know exactly what the meter is reading. For this purpose an average reading of the scene is rarely satisfactory. You must be able to read small selected parts of the scene.

A *spot meter* is ideal for this. You can also use a regular averaging meter by holding it close to the subject, or near a substitute that has the same reflectance and is in identical illumination. However, you must be careful that the meter and your body do not cast any shadows on the surface you are reading.

When you can selectively read the brightness range of different subject parts, you begin to have control. You can determine whether the scene is within the recording capability of the film you are using. You can also base exposure on a specific selected subject part, rather than having to rely on an average reading.

This scene called for a film and developer that would record detail at both ends of the tonal scale. I used Agfapan 100 film and Rodinal developer. I made meter readings from the brightest part of the wall and the darkest section of the tree. Exposure was placed to record detail in both extremes.

This contrasty scene called for a wide exposure range. I used Kodak Verichrome Pan film and developed in soft-working D-76 at 1:1 dilution.

In the photo above, each tonal value occupies a relatively large area. It's easy to make meter readings from each with virtually any kind of reflected-light meter. In the photo at right, the tonal values are distributed unevenly in small patches. Reading individual tones here requires careful use of a narrow-angle spot meter.

Equipment Tolerances—Correct exposure is not only dependent on film speed and on an accurate meter and its proper use. It is also dependent on variations in your equipment. One of the more obvious examples involves the camera shutter. Not all shutters give you the exact exposure times indicated by their settings. An indicated shutter speed of 1/125 second may be as slow as 1/90 second on some shutters and as fast as 1/160 second on others.

To get really meaningful exposure-meter readings, you must relate your meter to your camera equipment, and to the specific film you are using. This also includes the film developer and processing technique. This involves making some practical tests. Of course, these tests should be repeated whenever the operating conditions change. For example, you may change to a different film or processing technique, or use a different camera and shutter.

EXPOSURE-CONTROL TESTS

If you want to be sure of consistently obtaining exposures that suit your visualization, you have two options. You can use the manufacturer's recommended film speed and bracket all your exposures. This is an expensive solution, and one that could be described more accurately as trial-and-error than real control.

The second solution is testing the variables mentioned. Of course, even when you have made the tests, you will sometimes want to bracket exposures. But you will not do it as frequently. And you will bracket over a more limited range, without guessing.

I suggest and describe some testing methods that are easy to perform and especially useful to the landscape photographer. You can find additional information on film-speed and contrast testing in my book, *How to Select & Use Photographic Materials and Processes,* also published by HPBooks.

The purpose of making tests is to determine an effective film speed that applies to your working conditions. The tests are necessary because lenses, shutters, films and processing techniques vary. But don't be alarmed—you're only testing the *compatibility* of your tools, not their absolute *accuracy.* So don't rush to your camera repairman, unless you have evidence of significant malfunction.

FILM-SPEED TEST

Film speed is based on the amount of exposure that produces a specific minimum film density above the density of unexposed film after processing. With developed negative films this is the density difference between film exposed to no light and film exposed to the least amount of light needed to produce some detail.

With color-slide films, the opposite end of the brightness scale is involved. Here, film speed is determined by the exposure needed to produce detailed diffuse highlights distinguishable from clear film. The clear film represents specular highlights or direct light sources.

These criteria are summarized in the old adage, "Expose negative film for the shadows and transparency film for the highlights." This is illustrated by the fact that the exposure recommendations in the instruction sheets for Kodachrome 64 transparency film and Kodacolor 100 negative film are identical, although the speeds of the two films vary by the equivalent of 2/3 exposure step. The additional exposure for the negative film ensures that shadow detail is recorded.

The Tools—You'll need a matte gray card of 18% reflectance and a white-to-black gray scale. Both of these are contained in the *Kodak Professional Photoguide, No. R-28.* Inside the cover of *SLR Photographers Handbook,* by Carl Shipman, published by HPBooks, you'll also find an 18% gray card.

You should also have a black card. You can produce a good black by fully exposing and developing a piece of glossy b&w printing paper.

Mount all of the above on a large, flat card. Ideally, you should now place this test target in front of a scene that is typical of the kinds of subjects you photograph. Set up your camera so you will get on film the whole test target and a reasonable area of the scene behind it.

Ideal illumination is sunlight, giving you distinct shadows and highlights and an extensive subject brightness range in the background scene. Be sure the light on your test target is even and that no unwanted reflections reach the lens.

The Test—Set your exposure meter to the film-speed setting recommended by the film manufacturer. Take a meter reading off the gray card only. Move up close with your camera, if necessary, to exclude other elements of the scene from the meter's field of view. Expose the film accordingly. Then bracket your exposures to either side of the recommended exposure. In 1/3-step increments, make six exposures on each side of the first exposure. Process the film in the standard way recommended by the manufacturer, or the way you have been regularly using.

Keep a careful record of all settings and other details of the test.

Test Evaluation—Examine all your exposures carefully. With color-reversal film, look for the slide that gives the most accurate neutral gray. Also look for the slide that has the best tonal separation in the brightest areas. Look for just detectable density differences between the two lightest steps on the gray scale.

With negative film, look for the frame that gives you just enough detail in the darkest shadows. Look for just detectable density differences between the two darkest steps on the gray scale.

Also, evaluate the image of the

This scene contains only small and unimportant highlight areas. Exposure was based on the dark sign in the foreground. The midtones readily fell within the exposure range of the film.

actual scene behind your test target. Look for highlight and shadow detail and general image density.

Using the above criteria, select the most satisfactory frame. Determine the exposure difference between this frame and the one recommended by the meter. From this, you can find the best film-speed setting for your specific equipment variables and your personal taste.

Suppose the most satisfactorily exposed frame had 1/3 step less exposure than recommended by the meter. This indicates that you should increase film speed by one increment. For example, a speed of 125 would become 160. If you find that the best exposure lies somewhere between two of your test frames, you can make an appropriately smaller adjustment.

Typically, the newly determined film-speed setting is called the Exposure Index (E.I.). It implies a

tested film speed for practical use.

Exposure Base Selection—The effective speed of a film is not necessarily the same along its entire exposure range. Two films of different contrast may have the same speed in the midtone area of medium gray. But their speeds will differ at one or both ends of the scale. For this reason, it is important to be consistent in film-speed testing procedures.

Suppose you used a high-contrast scene for your speed test. Let's assume you did the test three different ways. First, you exposed the gray card, next the highlight area, and finally an area of deep shadow. You evaluated the film speed in each case, based on an accurate rendition of each of the tonal areas photographed. You would find that the film speed would differ a little in each test.

If your landscape photography is mostly on b&w film, you'll normally expose for the shadows. It

will make sense for you to base your film-speed test on a shadow reading, rather than on a reading from an 18% gray card.

If you use mainly transparency film and base your exposures on highlight areas, base your film-speed test on relatively bright subject areas.

CONTRAST TEST

With color-reversal films, the subject brightness range that can be satisfactorily recorded is predetermined by the film manufacturer. You must work within a brightness range that does not exceed the film's capabilities.

B&W Negative Film—There's another adage relating to b&w negative films. It says, "Expose for the shadows and develop for the highlights." This is another way of saying that you can control negative contrast by development.

Increased development time

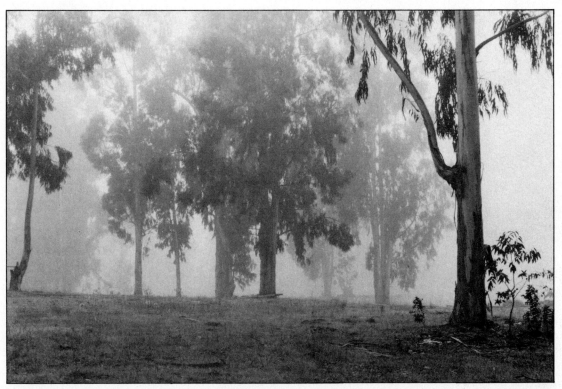

In a fog scene like this, low contrast is an inherent part of the image. You don't want to overcorrect this by increased film development. Print the image just dark enough to get a good black in the darkest foreground parts. This should give ample tonal separation in the subtle, foggy areas in the distance.

and developer temperature, greater developer-solution concentration, and more agitation during development all increase negative density. This is especially true in the bright areas of the subject. This leads to higher image contrast. A reduction of all the above leads to decreased contrast. Also, there are special high-contrast and soft-working developers.

To establish the subject brightness range your b&w film can record, you must make a test that includes film processing. You must realize that development modification affects film speed somewhat. When you develop for increased contrast, film speed increases. When you develop for a less contrasty result, you lose some speed.

To determine what subject brightness range your b&w film-and-development combination can record, begin by examining

the best result from your film-speed test again. See whether there is tonal separation between the two lightest steps on the gray scale, or in the brightest highlight areas of the scene.

If shadow areas in the negative have recorded satisfactorily and highlight areas are opaque and have no tonal separation, reduce the film contrast. If the highlight areas show tonal separation, but the negative is gray rather than black in those areas, you must increase contrast.

Photograph the test target and the scene again, using the Exposure Index you just determined. Modify film development to increase or decrease contrast, as appropriate. Examine the result of the test once again. Repeat the test, if necessary, making the needed adjustments in development. If you change development considerably, you may also have to make a small compen-

sation in the effective film speed, as I indicated earlier.

When you have the desired image qualities, make a note of exactly how you achieved them. Then use the same methods whenever the same operating conditions apply.

Development Control—You can increase the contrast of slow-speed films by increasing development time up to about double the normal recommended time. However, you should not reduce development time by more than 25% of the recommended time. Trying to reduce contrast to this extent could distort the tonal rendition. It would usually also give you too low a film speed. If development at a reduced time is not done carefully, it could also lead to a mottled result.

To reduce contrast to accommodate a subject brightness range of about eight exposure steps, use the developer in a specially diluted

This picture is partially interior and partially exterior. The brightness difference between the two is extreme. Here is what happens when you try to find a compromise exposure. I got just too little detail inside the building and image burn-out through the window. If the film's exposure range is too limited for the scene, one solution is to add some light to the interior.

The bright white facade of the church and the puffy clouds would have misled an averaging meter. The result would have been an underexposed picture. Spot-meter readings from the window frame and the clouds indicated that the tonal range was not too wide for the film. I averaged the spot readings.

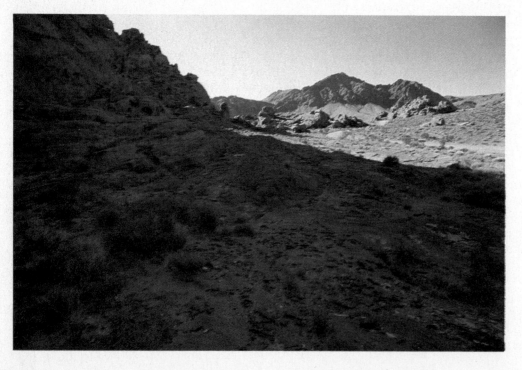

The inherent subject reflectivity range in this scene is not excessive. However, the lighting makes the scene very contrasty. Part of this desert scene is in bright sunlight and the rest in deep shadow. This example shows that subject contrast depends on both the reflectivity characteristics of the scene and on the light striking it.

This picture, made a moment after sunset, was taken with the camera in the automatic-exposure mode. To be sure of the best possible result, it's advisable to bracket exposures. However, at sunset you must work fast because the light conditions change by the second.

This is hardly the *average* subject automatic-exposure cameras are designed for. An automatic camera would overexpose this scene. It's important to know when you're confronted by a non-average subject. Then, you must know how to meter the scene and interpret the reading.

To record this scene the way I wanted it, the background had to be bright and the foreground in deep shade. An averaging meter might have given me the right exposure—with luck. It would have depended on the areas covered by the bright and dark subject parts and where these areas fell within the meter's sensing range. A localized reading from the dark and bright areas would give me a more reliable exposure indication. In fact, I took a reading from an 18% gray card, lit directly by the sun.

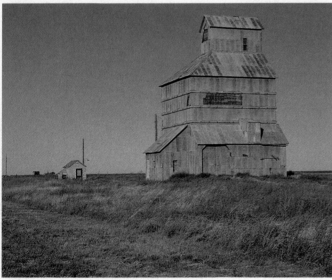

The top picture received normal exposure, as indicated by an averaging meter. I bracketed exposures. The lower photo was underexposed by about 2/3 exposure step. It provided richer tones and a more saturated blue sky. I think it's a better picture.

The Macbeth ColorChecker is a useful tool for the color photographer. This color-rendition chart includes color patches and a neutral gray scale. By photographing it, you can determine the color characteristics of different films under different lighting conditions. You can evaluate the effect of filters. You can judge the effect of exposure on contrast, tonal separation and color saturation.

form. Extend the development time beyond that normally recommended. The more energetic developers, like Kodak HC-110, Agfa Rodinal and Ilford Microphen, are particularly suitable.

When subject contrast is even higher, special development techniques are needed. One of these consists of alternating between the developer and a water bath. An even more satisfactory method is to use an extended-range developer such as Perfection Micrograin.

EXPOSURE PLACEMENT

The film-speed test described earlier determines the film speed that gives a gray corresponding to the gray in the subject. However, to achieve creative control in your photography, you may not always want to record gray faithfully. You may want to shift the tonal scale up or down, to get a specific effect.

You needn't accept the accurate exposure for gray that your meter provides. You can deliberately *place* the exposure where you want it. For example, if the meter was aimed at a neutral gray in the scene, and you want to record that area lighter, you can do so by simply giving more exposure. By doubling the recommended exposure, you will record the metered part about one exposure step lighter than 18% gray.

In a similar way, if you took a meter reading from a snow scene, you certainly don't want to record the snow as a dull gray. To record the true brightness of the snow, you must *place* the exposure where you want it. To get white, with some detail of texture and light and shade, you will need to increase the indicated exposure by about three to four exposure steps.

With color-transparency film, contrast cannot be controlled in processing. Therefore, you will sometimes have to sacrifice some image detail. By placing exposure thoughtfully, you can sacrifice the least important image part and give good exposure to the most

important area. You may need to give up some shadow detail to retain subtle tonal differences in the highlight parts of the scene.

Color-negative films will record a longer tonal range than color-slide films. However, the range of tones reproducible in a color print is about the same as in a color slide. Some of the longer range of the negative can be preserved in the print by skillful dodging and burning in. However, even with color-negative film, careful placement of exposure pays off in better image quality.

In b&w photography, when the subject brightness range is short, you can maintain maximum detail in the brightest and darkest parts by careful exposure placement. Instead of giving the minimum needed exposure for the shadows, as usually recommended, give 1/2 to 1 step more exposure. You'll then get the best tonal separation in the shadow areas. At the same time, you'll retain full detail in the highlight sections.

MAKE A TEST ENLARGEMENT

If you have access to a darkroom and make your own b&w prints, you can confirm the results of your visual evaluation. You do it with a test print.

Use your normal print developer and a normal-grade enlarging paper. Find the minimum exposure that will produce the paper's maximum black, printed through a developed negative that has no image detail. The negative should have only base-plus-fog density. Then use the same exposure time to print your test negative.

In the resulting print, you should see some detail in the darkest shadow areas. If your negative/development combination is correct, you should also have separation between the lightest image areas and specular reflections.

If your highlight areas are *burned out,* showing a uniform white without any detail, negative

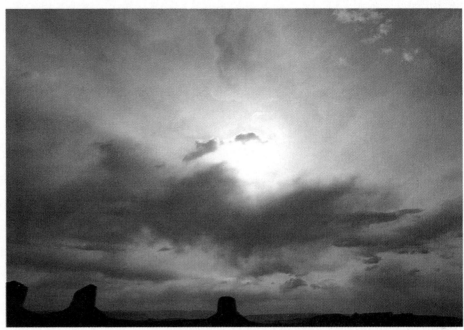

When the meter is set to the effective film speed of a slide film, a meter reading from an 18% gray surface should give optimum highlight exposure. In this photo, for example, there is a noticeable difference between the brightness of the specular sunlight and the diffuse light from the brightest clouds. The exposure reading was made from the clouds immediately below the sun. In a contrasty subject, the darkest subject parts may fall beyond the film's exposure latitude. They'll record black, as the desert foreground here.

I didn't want the detail in the background to detract from the backlit bush. By underexposing and overdeveloping the film, I achieved what I wanted. I kept the background dark and enhanced the contrast between it and the bush. Choice of an appropriately contrasty printing paper gave me further image control. The bush looks almost as if it were illuminated internally.

image contrast is too high. If the highlights are gray and dull, the image has too little contrast.

If the negative contrast deviates from the ideal by only a little, make a new test. Increase or decrease the film development time by about 10%. If it deviates considerably, try a 20% or 30% change in development time.

You can, of course, manipulate contrast at the enlarging stage to some degree. Use a different grade of paper and dodge and burn in. But to get a useful test evaluation, you should use normal-grade enlarging paper— which is intended for "perfect" negatives.

Normal-contrast paper might be

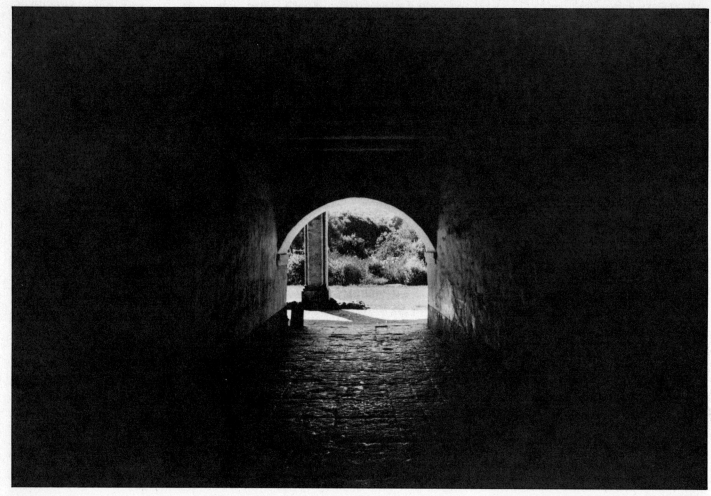

described as the ideal paper. However, a roll of film that has every frame developed in the same way is going to require different grades of paper to yield high-quality prints. Typically, negatives are made of subjects with varying subject-brightness ranges.

Even the entire range of papers available will only compensate for a portion of the subject contrast differences you are going to encounter. In addition, the extreme paper grades—#1, #5 and #6—tend to reproduce the relationship of the tones differently. By mixing extreme paper grades you may well get the same maximum and minimum densities in prints made from a wide variety of negatives. But the tonal characteristics from print to print may differ considerably.

ADVANTAGES OF SHEET FILM

Sheet film provides the greatest flexibility where testing is concerned. If you have 35mm equipment and feel happiest using that in your work, I won't suggest that you change. But I should at least point out to you the distinct advantages of being able to develop each image separately.

If you use roll film under widely differing conditions, I advise you to consider using two cameras. One should contain film destined for extra development for more contrast. The other should have film that's to be developed for lower contrast.

PRINT THE FULL TONAL SCALE

A good photographic print

nearly always requires some good blacks and some good whites. But scenes differ considerably. Some have a long brightness range, with deep shadows and brilliant highlights. Some are average. Others have a short brightness range, limited to light grays and dark grays.

Obviously, this often leads to a distortion of reality. With few exceptions, such as landscapes photographed in a fog or mist, this distortion is not only acceptable, but desirable. A good print needs

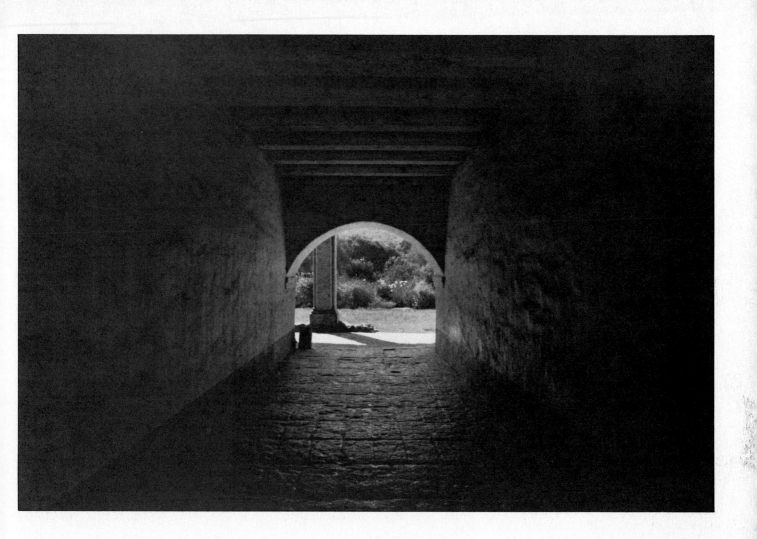

some black and some white. One thing that should not be distorted is the tonal scale. The subtle steps in subject brightnesses must be recorded on the film without loss.

You'll realize how important some black and white in each picture is when you examine good high-key and low-key photos. The high-key photo will nearly always contain some black, even if it's only the pupils of the subject's eyes. The low-key shot will nearly always contain some clear white, even if it's only the white of the eyes of the black cat in the dark alley.

Imagine a rural scene with trees, rock formations, grass and some white sheep—all in brilliant sunshine. Suppose the subject brightness range is about eight exposure steps. You expose film, process the negative, and make an enlargement. It is an attractive

and lively photograph, with rich blacks and brilliant highlights.

When you return to the scene, the sheep have gone, and so has the sun. The subject brightness range is now four exposure steps. You make another photograph, using the same film and technique you used before. You develop the film in the same way as before, and make another enlargement, on the same grade of paper.

The result is a gray, dull and lifeless photograph. The only way to put some life back into it is to print it for higher contrast, to once again include some black and some white.

At low light levels, you can encounter film *reciprocity failure*. This is an effective decrease in film speed under those conditions. It also tends to cause a color imbalance. This photo was taken at the end of the day. The violet color cast evident here was not at all evident at the scene. It was caused by reciprocity failure and the unusual color characteristics of the light at that time of the day. When this kind of thing happens unexpectedly, you can only hope the result will be equally unexpectedly attractive.

Aesthetic Image Control

Producing images that are technically excellent reproductions is only part of success in landscape photography. The other part is creative control. A scene that's appealing to the eye can look disappointing when translated into a two-dimensional plane. It can lose impact when enclosed within the limiting borders of the picture format. To make a subject *work* as a picture you must consciously control several basic elements.

There is usually general agreement among viewers about whether a landscape photograph is successful or not. This suggests an inherent human tendency to appreciate certain image qualities and characteristics. These qualities are independent of the subject portrayed.

If the success of a photograph were dependent only on the appeal of the subject, every technically good photograph of that subject would be equally successful. The choice of subject *does* play a role in the success of a photograph. But the *way* in which the subject is presented is an essential part of the creation of a good landscape photograph. The relationship of the various image elements to each other and to the whole subject is important.

Some photographers have an almost intuitive ability to see a picture in a subject. With little effort, they can arrange the elements of a subject within the picture format and then apply the appropriate techniques. Not all of us are so fortunate. We must work hard to

Generally, our view of the world is in a horizontal direction. Undoubtedly one of the reasons for the attraction of mountains is their ability to give us a new viewpoint. Point your camera down—or up—to get a new perspective on the world.

achieve success. It takes a high degree of sensitivity and awareness to instantly know what picture elements will or will not work.

VIEWER RESPONSE

Cultural background and personal experience play a significant part in determining what visual stimuli elicit positive responses. As a result, each one of us responds more readily to some visual stimuli and less to others. As the photographer, you must always bear this in mind if you want to get positive viewer response.

However, your photography would be boring if your main consideration were conformity to traditional requirements. Each image would be trite, without any element of surprise. Your photography would not arouse much more than a passing glance. What holds the attention and provides a stimulating visual experience is the uniqueness of your individual expression. But it should remain within the bounds of the *visual vocabulary* of the viewer of your photographs.

IMAGE FRAMING

When a painter represents a scene in a picture, he can include or exclude subject components at will. The painter is also free to rearrange subject elements to satisfy any kind of interpretation.

The camera does not afford the photographer quite the same freedom. The camera basically records reality. The photographer can manipulate that reality to some extent, to suit specific aesthetic needs, by changing framing and perspective.

You frame a picture to deliberately include only that area of the scene that contributes to the making of a meaningful image. Framing also involves the placement of the subject components in a way that provides a satisfactory composition.

The amateur photographer does not always give framing the thought it deserves. This is borne out by the many photographs that show heads or bodies "cut in half." Some photographs have too much meaningless image area around the central theme. Others feature vertical components right in the center of a horizontal-format picture, effectively cutting the image in half.

Let's take a look at some of the basic aspects of image framing.

Inclusive Framing—In landscape photography, inclusive framing can be thought of as being almost synonymous with a panoramic view. It can be considered to frequently involve the use of a wide-angle lens. An expansive scene often does not have a specific *border* area, where the scene comes to a natural end. A wide-angle view best simulates the kind of angle the viewer might comfortably scan from one specific viewpoint. It also best reveals the expanse and grandeur of a landscape.

Selective Framing—When the major interest of a scene lies within a specific area, surrounded by irrelevant subject matter, you must frame selectively. Sometimes the subject framed will be self-sufficient. The viewer will not give any thought to what surrounds the picture. An example might be a tree by a pond, or a mountain cabin with a peak in the background.

At other times, the content of the picture will suggest what lies beyond its borders. An example would be a tree by a river, the river running into the distance and eventually out of the picture. The viewer's eye would follow the river to the picture border. Beyond that point the viewer's imagination would take over. It is a challenge to the photographer's skill to stimulate the viewer's imagination. You can specifically suggest within the picture what happens beyond its borders.

Exclusive Framing—In landscape photography, exclusive framing refers to photography of close-up detail within the scene, rather than of a total scene. A photo of a gnarled tree trunk or of detail in the wood carving in a church door are typical examples.

Lighting that is appropriate for a landscape or scene is not necessarily satisfactory for a close-up of a small component in that scene. In daylight, be sure the light direction and the general lighting conditions are suitable for the subject.

The Viewing Mask—What means do you have at your disposal for previewing the scene or subject before you make the photograph? You can change lenses on your camera until you find a focal length that gives the framing you want. Or, you can move the camera back and forth until you get the desired composition. But both these methods are inconvenient.

A zoom lens with an adequate zoom range would give you an immediate visual reference on framing. But it is not likely that you are going to use a zoom lens for much of your landscape work.

Tight image framing can actually make less look like more. This dense growth of brush did not extend far beyond the picture frame. By filling the entire frame with the brush, I created the impression that I was standing before a wide vista of brush. The viewer tends to assume that it continues beyond the immediate angle of view.

The best device for image framing is a simple framing mask. It is easy to make, costs almost nothing, and is readily portable. You simply cut a rectangular opening in a piece of dark cardboard. The aspect ratio of the opening should correspond to that of the film—or the printing paper—you use.

A 35mm camera gives an image format of 24x36mm—an aspect ratio of 2:3. A viewing mask for 35mm film could have an opening of 2x3 inches or 4x6 inches. Both have the required 2:3 aspect ratio. However, if you are shooting negative film from which you normally make 8x10 enlargements, and you want to fill the paper with the image, you'll need a mask with an aspect ratio 4:5.

As you look at the scene through the mask, use just one eye. If you view with both eyes, you will not get a clearly defined image outline. You can simulate the action of a zoom lens by simply moving the mask toward or away from your eye. The farther you move the mask from your eye, the narrower the angle of view through the mask will be. Moving the mask away from you is like changing to a longer-focal-length lens.

By moving the mask at right angles to your line of view—up, down or sideways—you can select the part of the scene you want to record on film.

Having chosen the viewpoint and the angle to be covered, attach the appropriate lens to your camera and point the camera in the required direction to make the photograph.

THE THREE-DIMENSIONAL VIEW

In the previous section, I discussed image framing. This involves the selective control of the expanse of view that is to appear in the photograph. The next concern is not the width and height of the picture, but its depth. In other words, it is about the penetration of the image *through* the frame. On two-dimensional paper this is, of course, an impossibility. So we must find means to create the *illusion* of depth. There are several ways to do this. I'll introduce you to some of the more effective ones.

Relative Object Size—Our most obvious indication of distance is the relative size at which we see objects. This is most effective with objects we know to be of the same size. A good example is a receding row of utility poles. We know they are all the same size. In the picture

they become progressively smaller. This provides us with the message that they are farther and farther away.

The distance that objects are from each other can only be conveyed effectively with objects whose size is known to us. Houses, cars, people, horses and trees are typically familiar objects.

You can manipulate the apparent depth of the scene—or perspective—as well as the relative size of image components. Do it with careful placement of those components and by choosing the camera's viewpoint and distance wisely. Use a lens of the right focal length.

At 30 feet, you can take an impressive photograph of a small log cabin, rising into a blue sky. There'll be little indication of the mountain peaks behind. Move back 100 feet, use a lens of appropriately longer focal length, and take another picture of the cabin at the same size. There'll be a significant difference. The mountains will now appear very large behind the cabin.

Depth of Field—Depth of field, or the limitation of it, can be used creatively in many ways. You can photograph a sharp foreground against a blurred background or a sharp distant scene against a

As these four photos show, part of a scene can be framed exclusively for a variety of purposes. 1) I wanted to concentrate interest on one element of the subject.

2) My purpose here was to establish a relationship between the moss and the foliage. To achieve this, I had to eliminate other distracting subject elements.

blurred foreground. Or, you can record a sharply-focused object in the middle distance surrounded by unsharp foreground and background.

You can also determine the extent to which part of the scene should be out of focus. Sometimes a total blur, which makes that image part completely unrecognizable, is desirable. In other situations you may simply want to tone down part of the scene by placing it slightly out of focus.

Natural Framing—When we *view* a distant scene, we're aware of our total relationship to that scene. We can see everything between us and the most distant part of the scene. No frame limits our view. A *photographed* scene is always limited by a frame. A landscape photograph in which everything is far away lacks spatial depth because the frame eliminates foreground information.

To get a three-dimensional effect, you must include some foreground detail in the picture. You can use a person or a tree in the foreground, or you can frame the scene through an arch or with foliage. With a wide-angle lens, you should have adequate depth of field to get foreground and distant scene in sharp focus.

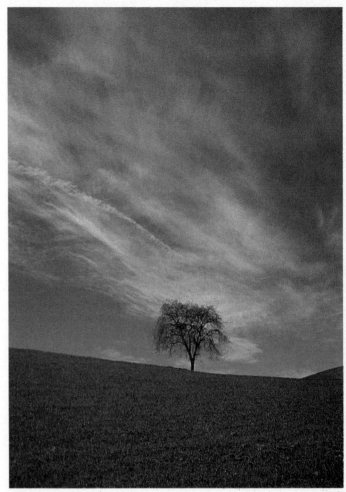

This is an effective landscape composition. Land and sky meet about where the rule of thirds—see page 111—would indicate. The clouds form a diagonal across the sky, suggesting movement. The tree is almost in a central position, giving a feeling of tranquility.

3) Abstraction can be a good reason for exclusive framing. I photographed part of a recognizable scene and turned it into an abstract photo of texture and pattern.

4) Here, I used a little deception. I photographed reflections in water with a wide-angle lens and then turned the image upside-down. The deception wouldn't have worked if I hadn't cropped tightly.

With a lens of longer focal length, you may need to use a small lens aperture to obtain the required depth of field. If you want to have the foreground unsharp, focus selectively and use a lens aperture that limits depth of field toward this end.

Atmospheric Haze—In landscape photography, atmospheric haze is often an effective clue to distance. Haze is a diffusion of light by minute dust and moisture particles in the air. The greater the distance between the camera and the scene, the heavier the concentration of such particles. Therefore, the more pronounced the haze.

Distance can be determined by the relative amount of haze. Except on a very clear day, you will see the density of the haze increasing with distance. A near mountain range may be clear and

sharp, with good contrast. The next will appear a little veiled, and will have lower contrast. The third will appear a bluish-gray and flat, with little subject detail. The most distant range may be no more than a uniform light gray outline against the sky.

In color photography, the more distant the scene, the more bluish it will reproduce. We are all familiar with the bluish appearance of distant hills on a hazy day.

There are ways of penetrating haze with the use of filters. With b&w film, you can use yellow, orange and red filters. With color film, UV or skylight filters can help. However, often you will want to reproduce the haze to create the illusion of depth.

Beware when you are using a long telephoto lens. If your angle of view is limited to part of a scene

that is entirely in haze, image contrast will be very low. Unless you specifically want such an image, you may need to use an extra contrasty film/developer combination.

Camera Height and Angle—Camera viewpoint not only implies a choice of camera position in a horizontal plane, but also in a vertical one. Vertical movement is rarely as easy as movement around the flat ground. You need a hill or mountain, a tall building, perhaps an airplane, or at the very least a ladder. But when you have access to vertical movement, it can give you a lot of added scope in your landscape work. Your capability of creating the illusion of distance and depth will increase.

As anyone who has ever learned about perspective drawing knows, as you move upward the horizon appears to move upward

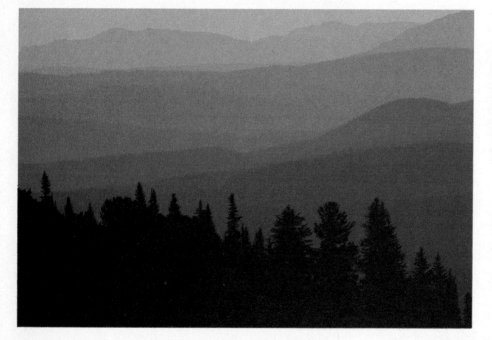

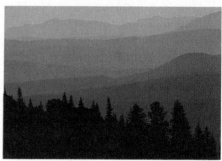

A telephoto lens compresses distance. It brings distant subject elements closer. However, the effect of the telephoto is not achieved entirely in the camera. It's also dependent on the distance at which the picture is viewed—or the degree to which it's enlarged. These two reproductions are of the same photo. In the smaller one, the mountain ranges appear to be farther away from each other. See the discussion on *Perspective* in Chapter 3.

with you. Consequently, distant objects and features will lie higher than near ones. For the landscape photographer, this is a useful clue to distance and depth. We need not then be familiar with an object or its relative size, to know how far away it is. Its position relative to the horizon tells us without a doubt where it is located.

Don't be tempted to go too high. A near-vertical viewpoint can be as meaningless as a totally horizontal line of sight. You begin to lose perspective and depth. This is particularly true when you are photographing features that have considerable height of their own—such as tall buildings and hills.

Focal Length and Viewing Distance—Let's assume that all negatives are going to be enlarged to a standard size, and the prints are going to be viewed from a standard distance. The focal length of the camera lens will determine the manner in which we see distance. A scene recorded with a wide-angle lens will appear to have relatively great depth or distance. A photo made with a telephoto lens will seem to have distance "squeezed" into a small zone.

As a landscape photographer, you can use your camera lenses creatively. With them, you can generate the illusion of great distance, or the opposite.

Converging Lines—A classic visual clue to distance is parallel lines that appear to converge. We know that roads or railroads, for example, have parallel sides or tracks. When they appear to converge in a picture we know that they are running into the distance.

Obviously this feature cannot be exploited visually when we are looking in a horizontal direction or vertically downward. We must select the most effective in-between angle of view.

The parallel lines need not be located in a horizontal plane. They could, for example, be the top and bottom of a fence or wall, or a row of telephone poles.

For the lines to converge in the image, it's necessary for the camera to be aimed at an angle to the plane containing those lines. However, a camera that features swings and tilts can accentuate or minimize the convergence by

Use your wide-angle lenses creatively in landscape photography. In the photo at left, a wide-angle lens enabled me to include the nearby rocks and distant mountain to form an attractive composition. To make the photo above, I tilted the camera upward. The close viewpoint and wide-angle lens gave me the dramatic distortion of perspective I wanted.

camera manipulation. One situation in which converging lines are generally corrected—made parallel again—is the photography of an upward view of tall buildings.

The convergence of parallel lines is minimized by long-focal-length lenses. They compress the effect of distance and fill the frame with less of the scene. The convergence of parallel lines is accentuated by wide-angle lenses.

Light and Shade—One of the most effective tools for bringing the illusion of three dimensions into a two-dimensional photograph is proper choice of lighting. More specifically, it is the effective use of light and shade.

Every photographer knows that the soft lighting of a uniformly overcast sky produces a flat-looking photograph. Perhaps that's why that kind of illumination is called *flat*. Directional light from the sun, coming from the side, can give modeling to the scene and make it appear three-dimensional in the photo.

The landscape photographer's light is governed by the time of day and the whims of the weather. You must be patient and await the right kind of light, from the right direction, to make the most effective image. When photographing close-up detail, you may be able to use artificial light. This gives total control of where the shadows fall.

Backlighting can be remarkably effective and attractive. A very convincing feeling of spatial depth is created when the shadows fall toward the camera. Sometimes you may be satisfied with the main subject being a silhouette. If you want detail in the subject, however, be sure to expose the film accordingly. Or, use a suitable reflecting surface—natural or artificial—to throw sufficient light back into the shaded areas.

Receding railroad tracks always make for an attractive composition. The right photo was made with a wider-angle lens, causing the tracks to appear to converge more dramatically. Notice that, depending on the direction of the light and the tone of the track, you can create different effects. In the left photo, the rails are bright against a dark background. In the right photo, the rails are dark against a bright background.

It is rarely advisable to place the major image part in the center of the frame. This picture is an exception. Here, central placement emphasizes the symmetry of the structure and its foreground.

Haze is usually associated with distance. With a telephoto lens, you can effectively compress distance. When you photograph a hazy scene with a telephoto lens, the artificially close haze appears more dramatic. Always include some dark foreground detail to give the image contrast.

Use your wide-angle lenses creatively. Don't just resort to them when you can't get back far enough to include the subject with a longer lens. I could have made both these photos with a longer lens. There was plenty of room. But the images I visualized had to be made from these specific viewpoints, calling for a wide-angle lens.

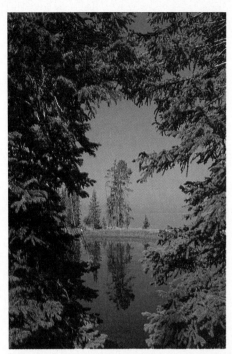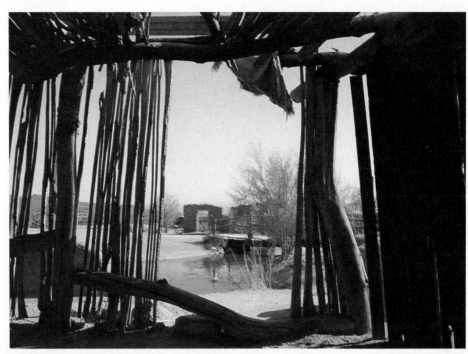

You can frame a picture with subject foreground. This helps lead the viewer's attention into the picture. It can also provide a feeling of depth and distance. But don't overdo it, as I have deliberately done here.

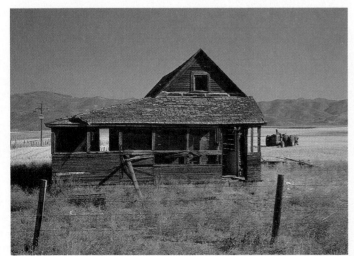

You can control the apparent distance between subject parts with the careful choice of viewpoint and camera lens. In each of these pictures, the farm machinery was the same distance from the abandoned building. For the right photo, I came much closer to the building and used a wide-angle lens. This kind of perspective control can be one of your strongest creative tools in landscape photography.

7 Natural Factors

The qualities of natural illumination, the atmospheric conditions and the mood of a scene fundamentally affect how you photograph a landscape. Even though nature dictates the conditions that affect your subject, you can still control image characteristics. You may not be able to control the effects of nature, but you can influence how they record on film.

Your first step is to become aware of the natural elements involved and understand how they affect film. The second step is to choose appropriate times to photograph. Third, you should select equipment and materials that enable you to translate your visualization into realization on film.

When the sun and other natural elements are involved, you obviously can't *control* the lighting. You have to *wait* for the right moment. Sharpen your awareness of meteorological and atmospheric conditions. Your ability to control the image will then significantly increase, allowing you to photograph successfully regardless of conditions.

THE ILLUMINATION

Although a much overused statement, it bears repeating here: Light is the essence of photography. Everyone knows that light has *quantity*. We give a lot of attention to measuring that quantity and translating it into exposure recommendations. We tend to forget that light also has *quality*. Correct exposure alone does not guarantee a good photograph. The

Above: Direct sunlight causes deep shadows with hard outlines. It also gives a warm glow. Below: Light clouds in front of the sun act as a diffuser. Shadows become lighter and have a softer outline. Much of the warm colors of sunlight are filtered out, giving a cooler, more bluish image.

effectiveness of a landscape photograph depends on other light characteristics.

For example, light can be directional and hard or diffused and soft. It can come from a variety of directions. Daylight has a different color at different times of the day and under varying atmospheric conditions.

The eye readily adapts to illumination of different colors. Films—particularly color-reversal films—respond noticeably to even slight color variations in the light. As a photographer, you must be aware of the color changes that can occur during the day.

The nature of the illumination will also affect the overall brightness range of a scene. It can have a wide variety of other subtle effects on the image, too.

Lighting Ratio—Two factors contribute to subject brightness range: The difference in reflectivity between the lightest and darkest subject tone and the difference between the illumination level in highlights and shadows.

Effective subject *contrast* is the brightness difference between the lightest subject part that is brightly lit and the darkest subject part in deep shadow. This represents the extreme case. Lesser contrast occurs when the darkest subject

Translucent fall foliage, backlit by the sun, can provide a brilliant color photograph. Here, diffuse light coming through the leaves has helped to lighten the foreground.

Still water reflects everything like a mirror. In this composition, I deliberately placed the horizon about one-third of the way from the top of the picture.

This photo shows many facets of water—ice, snow, mist and clouds. It makes for a picture with an atmosphere of mystery.

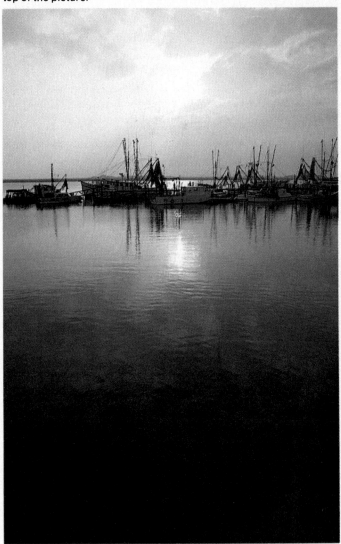

part is not in shade or when the brightest subject area is not brightly illuminated. The important thing to remember is that contrast depends on the most and least light reflected from the subject. This, in turn, depends on the brightness—or reflectivity—of the subject areas and the brightness of the light reflected from them.

You can determine the subject brightness range directly with a reflected-light exposure meter. Take a reading from the darkest and lightest parts and compare them. This will enable you to check whether the range is within the exposure range of the film you're using. When you're using b&w film, you can determine

whether special development techniques are required to extend the film's exposure range. See Chapter 5 for details.

Once again, remember that your eyes have special capabilities for adapting to contrast. They accommodate easily to different brightness values and scan a scene rather than taking it in all at once. Contrast will nearly always appear lower to the eye than it will record on film. So, keeping the brightness range of the scene within the recording capabilities of the film is an ever-present problem.

You can get a better impression of subject contrast by looking at the image through the camera viewfinder. The entire scene is compressed into a small area. You come much closer to looking at the whole scene at once, without the need to scan. This gives you a better impression of the scene's photographic contrast. For the most accurate viewed impression, stop down the lens as far as possible to eliminate flare within the camera system.

Light Source—Daylight illumination can vary immensely from one scene to another. The most obvious reason for this is that the direction, intensity and color of the light from the sun changes during the course of the day, and from season to season. Weather is one of the most important influences on illumination.

Let's consider a few of the primary qualities of daylight that affect landscape subjects. The most dramatic difference in terms of photographic image quality is between direct sunlight and diffused light. Unobstructed sunlight is *hard* and causes harsh shadows. Diffused light from a blue sky, through an overcast of clouds, or reflected from the scene's surroundings, is *soft* and leaves only weak or no shadows.

Hard light is illumination that emanates from a relatively small source relative to its distance from the subject. The unobstructed sun is such a light source. It creates

The sun was high in the sky. There were few shadows and the scene had a flat appearance.

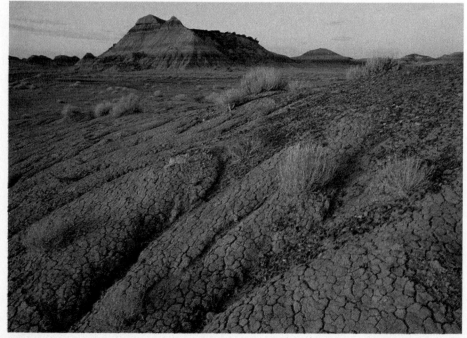
To reveal the texture and contours in a desert scene like this, low direct sunlight is best.

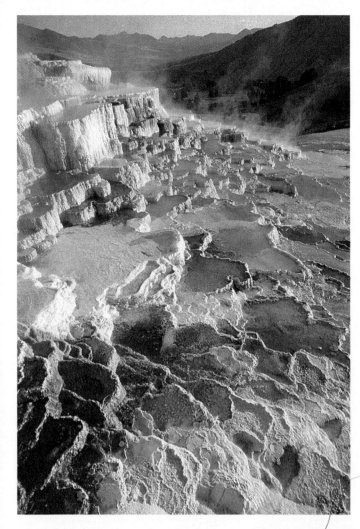

The effective use of backlighting can achieve a variety of effects. Here, I used it to highlight the foreground subject against a dark background.

Low morning sunlight outlined the terraces and pools of the Mammoth Springs at Yellowstone National Park. Overhead midday sun would not have been nearly as effective.

sharply defined lines of distinction between highlight and shadow.

Soft light occurs when the source is relatively large in terms of its distance from the subject. It is characterized by gradual, less distinct transitions from highlight to shadow. The most common soft light source in landscape photography is an overcast sky.

The softness of a light source is dependent more on the size of the source than on the amount of diffusion. For example, a totally overcast sky, which is a large light source, gives soft and shadow-free illumination. If the sun is only partly obscured by a haze, the light reaching the earth will still be from a relatively small source—the sun. This will lead to distinct shadows.

Color film can record only a limited subject brightness range well. The brightness range of a subject depends on two main factors. One is the reflectivity range of the scene itself. The other is the lighting. With deep shadows and bright highlights, the effective subject brightness range will be greater than it would be in soft and shadow-free illumination. In other words, hard light tends to increase the subject brightness range while soft light decreases it. In direct sunlight, many scenes may be too contrasty for satisfactory recording on color film.

Here's a good general rule to follow: Wait for direct sunlight for a scene that is inherently flat, with a low reflectivity range. Shoot by the soft light of an overcast sky when the subject's inherent reflectivity range is high.

The Direction of the Light—The direction from which the main illumination strikes the subject or scene is generally stated relative to the camera's viewpoint. For example, when the light source is behind the camera, it strikes the subject frontally and is called *front light.*

Side light, sometimes called *cross light,* is illumination falling on the subject from an angle of approximately 90° to the lens axis. *Back light* shines toward the camera's viewpoint. *Quarter light* is between front and side light. It falls on the subject from an angle roughly 45° on either side of the lens axis.

These lighting angles refer to horizontal deviance from the lens axis. Vertically, the light is always higher than the lens axis. This is particularly true in the context of landscape photography, in which the major source of illumination is the sun.

The height of the sun above the horizon has a significant effect on a landscape photograph. For many scenes, early morning or late afternoon sun is best. The low light

leads to long, distinct shadows and provides a three-dimensional effect. In addition, an early morning fog or haze can give character to a scene.

When the sun is low, near the horizon, its rays have to travel through a relatively thick layer of the earth's atmosphere. The atmospheric particles scatter much of the blue content of the light. This leaves the sun appearing more reddish in color. You can use this reddish-orange glow to your advantage when shooting a sunrise or sunset. However, when you want true color rendition—such as for a portrait—you'll need to use corrective filtration in low sunlight.

Suit your lighting to the subject. For example, suppose the subject is a nearly vertical cliff and you want to bring out a patterned, textural quality in its surface. You'll want direct sunlight to skim across the face of the cliff. If this angle of illumination occurs only during the middle of the day, obviously that is the best time to photograph.

If the cliff happens to face due south, early morning or late afternoon light might be most effective. Remember, you can't move the sun. You can only wait for it to take its daily course, and observe the effect it has on your chosen scene. When the sun is in the right place, that's the time to shoot.

Familiarize yourself with the effect the sun has on different subjects and scenes when striking them at different angles. In the studio, you move your lights to suit your photographic needs. The sun moves itself. You have to wait for it to get where you want it.

Watch some familiar scenes from day to day. Observe the effect the position of the sun has on them. Also, become aware of the different positions of the sun at the different seasons. Watch the color of the sun's light at different times of the day and under different atmospheric conditions.

To make great scenic pictures, photographers often plan ahead. This planning includes not only a choice of time of day, but sometimes even the season of the year. Basically, in the continental United States, the sun moves from just south of east to just south of west in the summer. In the winter it moves from southeast to southwest. At midday in the summer, it is high in the sky. Its highest point in winter is relatively low.

Eventually, you'll become familiar with the daily course of the sun through the year. You'll also become more expert in determining where the sun has to be to give the effect you want on a particular scene.

The Color of the Illumination—The color of daylight is ex-pressed in *color temperature,* measured in degrees Kelvin (K). The color temperature of a light source is described by the temperature to which a standard "black body" must be heated to radiate light of the same color. Average daylight has a color temperature of approximately 5500K. This represents the light reaching the scene from a combination of direct sun, some white clouds and some blue sky. Daylight-balanced color films will reproduce the colors of a scene faithfully under this kind of illumination.

Of course, daylight isn't always "average." The sky may be totally overcast, or your scene may be under an expanse of blue sky with the sun obscured. Or, the sun may be very low in the sky and reddish in color. These irregularities can be corrected by filtration, as described in Chapter 10.

Remember that your eyes adapt easily to color changes in the illumination. So you must be especially alert to conditions that may lead to an untrue color rendition in the image on the film. One of the more common imbalances is reddish when the sun is low. Another is bluish and is caused by an overcast sky or an expanse of blue sky. A green imbalance can result from photographing under an expanse of foliage. Green leaves act like a green reflector.

For correcting a color shift, a

With backlighting I highlighted an expanse of distant water against a silhouetted foreground tree.

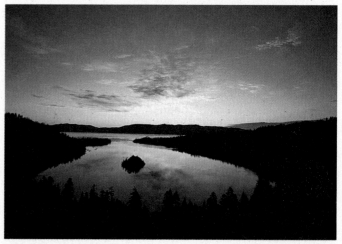
I faced east just before sunrise. The bright morning sky was reflected in the lake while the surrounding forest was in deep shadow.

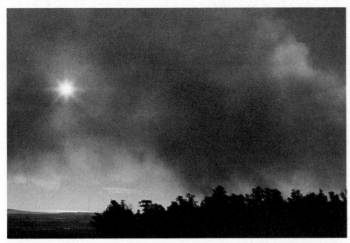

Haze, fog, smog and smoke all affect sunlight. However, their color-filtration effect varies. The smoke from this forest fire, for example, was colored an unexpected brown. The starburst from the sun was caused by the lens diaphragm, which was set to a very small aperture.

When the subject is in open shade, determine what the real light source is. When it's primarily blue sky, as in this scene, the effect will be to *cool* the scene. The white wall of this building appears distinctly bluish.

color-temperature meter is a useful tool. When used according to the manufacturer's instructions, it can tell you what filtration you need to correct the imbalance of the light for use with daylight film. Often, however, a color imbalance is a desirable part of the scene and should be included in the picture. Distant haze, for example, *is* bluish, and generally should be recorded as such.

Under a deep blue sky, *shadows* are freqently distinctly blue. The shadows are lit mainly by light from the blue sky. This is especially noticeable in snow scenes. The main subject and most of the snow, lit by the sun, will have normal color balance.

Smoke and smog are other atmospheric conditions that can affect the color balance of daylight. The precise color imbalance largely depends on the nature and size of the particles in the air. Be observant, and make color corrections when you think they are necessary. Of course, if you deliberately want to show the effect of smog, don't correct the colors.

Color Filtration—To correct an imbalance in the color of the illumination, you must use color filters. This is essential with color-slide films. With color-negative films it is desirable, although not essential except in cases of extreme imbalance. This is because with negatives color correction can also be made at the printing stage.

Color-conversion and *light-balancing* filters will balance the color temperature of the light to suit the film you are using. They enable you to correct for light that's too red—perhaps because the sun is near the horizon. They also let you correct for light that's too

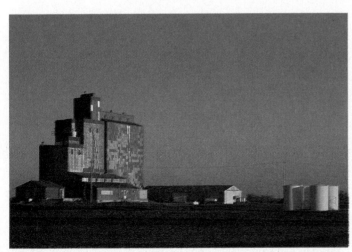

I made this photo in early morning sunlight. The sunlit areas are distinctly warm. The shadows appear distinctly blue. You can't eliminate both color imbalances with filtration. Usually an unfiltered image of such a scene is most effective anyway.

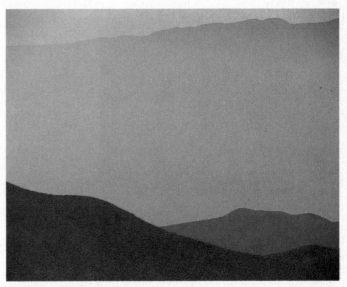

At high altitudes, there is a relatively high level of ultraviolet radiation. Although you don't see it, color films will record it. You can use a haze or UV filter to reduce its effect. Sometimes, you may want to record it for a special visual effect, as I've done here.

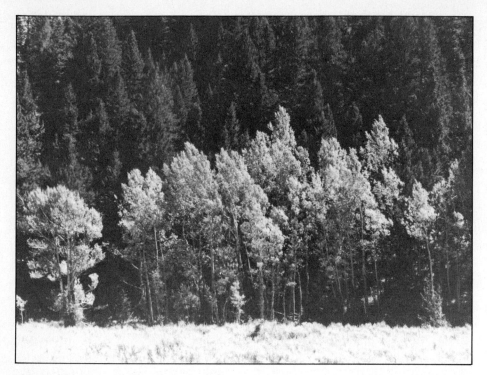

The fall foliage on the foreground trees was orange. The distant firs were a dark blue-green. No filter was used for the photo at left. The picture at right was made with a yellow-orange filter on the lens. The foreground trees are now lighter and stand out better against the background. If I had used a blue-green filter, the tones of the two tree groups would have almost matched. This would have led to a dull picture.

blue—because of a large expanse of blue sky. *Color-compensating* (CC) filters enable you to remove imbalances from causes not related to the illumination. A good example would be a picture having an excess of overall green because it was taken under an expanse of foliage.

Color filtration is discussed more fully in Chapter 10. For now, be assured that you don't need a mass of filters for successful color landscape photography. Amber light-balancing filters in the 81 series to remove excess blue from the light source and bluish 82-series filters to remove excess red from the light are desirable. A few CC filters—including magenta of various strengths to reduce a green imbalance from foliage—are also useful.

The most common imbalances you're likely to encounter are excessive blue and green. Therefore, if you begin with only the amber 81-series filters and the magenta CC filters, you're already adequately equipped.

Flare—So far, I've discussed *image-forming* light. It is reflected from the scene to produce a corresponding image on film. Flare is a different kind of light. It's not image-forming and is not useful. It consists of the scatter of stray light within the camera and lens, forming a veil of light on the image.

When flare records on film, it affects the shadow areas by lightening them. It has much less effect on brighter image areas. Flare tends to reduce both image contrast and tonal detail in shadows. It also distorts tones that would otherwise reproduce faithfully on the film.

Flare is dependent partly on the

The inherent contrast of a backlit scene can be lowered considerably by flare from the light source. The effect will vary at different lens apertures. Use your depth-of-field preview, so you can determine the effect visually before you take the picture. Lens flare also tends to desaturate colors, giving a pastel effect.

optical system used and partly on the amount of unwanted light that enters the camera lens. Old, uncoated lenses produce much more internal flare than do coated ones. Lenses with many elements, such as zoom lenses, tend to produce more flare than lenses of simpler optical design.

Most photographers are aware of the importance of preventing stray light reaching the camera lens. Lens shades are made to protect against this. What you may not know is that the subject itself can also generate flare. It can come from bright catchlights from water, windows or cars. It can also originate from a very light and brightly lit part of the scene.

Obviously, a lens shade will not help here. Your best protection in such a case is to choose a lens that is minimally prone to flare. Also, use a mid-range lens aperture. Avoid flare from the subject if you can, unless it is an inseparable part of the image you want to create.

ATMOSPHERIC CONDITIONS

It is a popular misconception that there are only two conditions good for photography—flash, and direct sunlight coming from behind you. However, in creative landscape photography neither really applies.

As I've indicated, a low sun is frequently best for landscapes. In addition, some of the most effective scenic photographs are made under less-than-ideal weather conditions. Rain, mist, wind and snow can enhance some scenic views, even though they may not add much to your shooting comfort.

In the past, film and lens speed

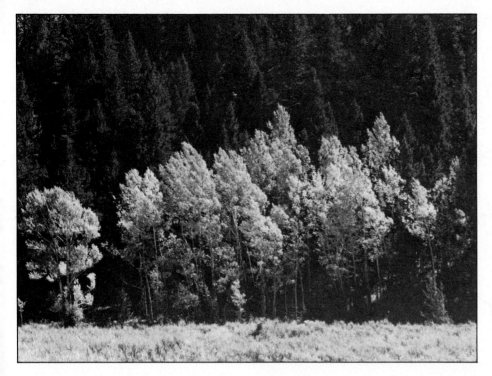

were definite limitations. Today it's different. There are fast films and lenses. And the processing manipulation with b&w film that's possible means there's almost no limit to what you can shoot outdoors.

Subject Brightness Range—The effective brightness range in a scene greatly depends on the illumination and the atmospheric conditions. Direct sunlight gives the highest lighting contrast and, therefore, the greatest subject brightness range. When the sky is overcast, the effective scene brightness range is lower. The same is true, to an even greater extent, when the subject is confronted by a veil of mist or haze.

You must make the creative decision of how much or little subject contrast is appropriate for a specific scene. When you deliberately want to control image contrast in a b&w photo, you can do so by choice of film and processing technique. With color film, try to choose a film type that gives you the appropriate contrast.

Fortunately, low contrast usually coincides with relatively dim light. A color film of relatively high speed, which you'll normally use in these conditions, generally also gives higher contrast.

For example, if you normally use Kodak Vericolor S negative film for sunlit subjects, you can substitute Kodacolor 400 in dim and low-contrast lighting. The film is available in 35mm and 120 formats.

Using a faster color film means more apparent graininess in the photograph. This is generally accentuated by the conditions you are shooting in. Grain is most noticeable in areas of uniform midtones, which are common in dim-light and low-contrast scenes.

With b&w film, the situation is a little different. Unfortunately, the potential for developing for higher contrast is much more limited with fast b&w films than with those of slow or medium speed. This presents a problem.

To preserve the softness of a haze, don't use a high-contrast film. This foggy scene was photographed on Ektachrome 64 Professional film.

93

Contrasting colors, like blue and orange, can attract attention and enhance an image.

You need a developer that provides you with the speed and contrast you need, and the least possible graininess.

An effective answer is to use a medium-speed film and develop it in a phenidone/hydroquinone developer. Acufine and Ilford Microphen are such developers. Even with normal development, these developers provide a 2/3-exposure step increase in effective film speed. With the extended development required for scenes in heavy overcast or fog, the effective speed of a medium-speed ISO 125/22° film will be doubled.

Distance and Contrast—When you photograph through a layer of mist, fog or drizzle, two things happen. First, the distant parts of the scene are recorded in a lighter tone than the closer parts that are less affected by atmospheric obstruction. Second, because the thickness of the atmospheric haze increases with distance, image contrast also decreases with distance. Similar scene elements at different distances appear—and record—less contrasty as they recede from the camera position.

What this means in practical terms is that distant brighter areas of the scene are less contrasty than the nearer darker parts. To retain some tonal separation and detail in the more distant, lighter parts, expose the highlight areas as midtones. Effectively, you must underexpose the film a little. This will give lighter areas the contrast and sparkle they need, without noticeably reducing the increase in overall brightness with distance.

You must understand the difference between *brightness* and tonal *detail*. You want the distant scene to record lighter than nearer parts of the scene. That's the essence of the atmospheric effect. But, at the same time, you want to retain some tonal detail in that distant scene. This tonal separation and detail will help to make the distant scene appear even brighter than if it were just a uniform, light-gray veil.

To achieve the required end and compensate for the different contrast along the tonal scale, use an appropriate fast b&w film. I suggest you use Kodak Tri-X Professional. It's available in 120-size and sheet film. Kodak doesn't recommend it for outdoors because it's designed for tungsten-light use. Even so, it has ideal characteristics for foggy scenes when processed in a high-energy, non-compensating developer such as Kodak HC-110 or Agfa Rodinal 1:25.

Among color films, you can't select one that has the ideal sensitometric characteristics for the purpose. However, you can exercise some control in another way. Expose the film so the low-contrast mid- and light tones reproduce as midtones. In practice this means, again, underexposing the film a little. With color reversal film the need to underexpose is minimized. You should already be exposing for the highlight areas rather than the shadows.

If you're working with color-negative film, you can choose a contrasty printing material like Ektacolor 78. Hold back the closer and darker areas of the scene, if

necessary, to preserve shadow detail.

Exposure Placement—Sometimes, your interest lies in recording the entire tonal range of a scene as faithfully as possible. At other times, your main concern may be to get the required tonal effect in one specific part of the scene. In doing this, you may have to compromise. Differences in subject tone are recorded with less contrast in shadow and highlight areas. Subtle gradations in highlight and shadow areas will be recorded with less detail than areas reproduced as midtones.

For example, if you are photographing in a forest, and mist partially obscures important shadow areas, you should give a little more than *normal* exposure. This way, the extremely delicate shadows are recorded as midtones. Fortunately, this exposure shift will normally do no harm to the highlights because the subject in question has inherently low contrast.

With color-reversal film, it's the highlight areas you must pay particular attention to. If you give too much exposure, highlight details that are reduced in contrast by mist may lose all detail if they are recorded as highlights. You can compensate for this by reducing exposure a little. If the subject brightness range is long, you may need to sacrifice some shadow detail—but that's probably the better of two evils.

Some final advice on photographing in hazy and misty conditions: To be sure you'll get the results you want, bracket exposures.

Texture—When you photograph interesting texture in a subject, the camera is usually close enough not to be much affected by intervening mist. However, sometimes you may want to record texture in a large distant area or small detail at a relatively great distance through a telephoto lens. In such cases you have to take some special precautions to get good image quality.

The first step is to *penetrate* the haze. With b&w film, use an appropriate yellow filter. With color films, you can try to use Kodak series HF haze-cutting filters, intended for color aerial photography. You can use the HF-3 filter alone; the HF-4 or HF-5 should always be used in conjunction with the HF-3.

With filters, you can penetrate haze. Filters are less effective with the pollutant-type atmospheric obstructions such as smog and industrial fog.

To retain maximum detail of

The lighting was very soft. The subject brightness range is almost entirely dependent on the scene's range of reflective values.

Early morning ground mist tends to be warm, giving this picture a yellowish appearance. Midday fog tends to be more bluish. It would give a photo a cool appearance.

As long as a color-slide film is not overexposed, it generally offers enough contrast to give good tonal separation in highlight areas. Without the mist, this scene would have considerably higher inherent contrast.

texture in a photo, it is always best to use a slow, fine-grain film. It gives highest image resolution. When you are shooting through haze that tends to reduce image detail, this is especially important.

To retain highlight and shadow detail, especially in a subject with a high reflectivity range, expose for the midtones. Whether you get the detail you want in both shadows and highlights depends on subject contrast and the exposure range of the color-reversal film you're using.

With b&w film, your choice of film developer can make a critical difference in preserving tonal separation in a negative. Theoretically, an acutance-type formula would appear to be most effective. The acutance effect should preserve the most pronounced density distinctions between subtle tone differences in the subject. In practice, however, a prepared acutance developer is not readily available. The true acu-

tance formulas from which you can mix your own developer tend to produce a very grainy result.

The best compromise is to use a very dilute solution of a high-energy developer. Consider Kodak HC-110, dilution D or E, Ilford Microphen 1:3, or Agfa Rodinal 1:75 or 1:100. With gentle, occasional agitation, these developers promote maximum acutance and tone differentiation.

Color Effects—The color effects

of various atmospheric conditions on a scene can be variable and unexpected. To be a landscape photographer, you must be *aware*. You must realize, for example, that things do not look the same under the warm light of the direct sun and the cool light from a heavy cloud overcast. The latter contains a lot of scattered blue and ultraviolet.

When the direct rays of the sun don't reach the subject, the deep

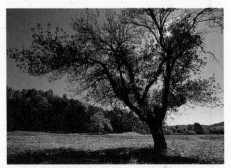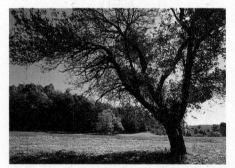

The natural factors in these two photos—grass, foliage and sky—are identical. If you are familiar with the characteristics of different slide films, you can interpret a scene in different ways. The left photo was made on Kodachrome 25 film, the right photo on Fujichrome film.

blue sky is the only illumination. It gives a bluish appearance to everything in the scene. Your eyes are used to seeing the world under a variety of lighting conditions. Your brain compensates, so that everything appears of the *right* coloration, no matter what the color of the light. Color films are much more selective in their response to color imbalances.

What color film you select can make a considerable difference in whether a gray-day scene is reproduced faithfully or with an excess of blue. I find Ektachrome films to be the most sensitive to blue shifts. They are most in need of corrective filtration to remove excess blue.

Kodachrome films seem to me to respond less undesirably to an excess of blue. I think Agfachrome films reproduce the gray appearance of a gray day most accurately. Perhaps this is because the latter originate from northern Europe, which is well-known for its overcast weather. Fuji films tend to have a warmish color bias and are affected little by the bluish effects of atmospheric conditions.

Choosing a film with a response favoring neutral tone reproduction is just one part of dealing successfully with atmospheric effects. Regardless of the film, reduce the unpredictable and unseen result of

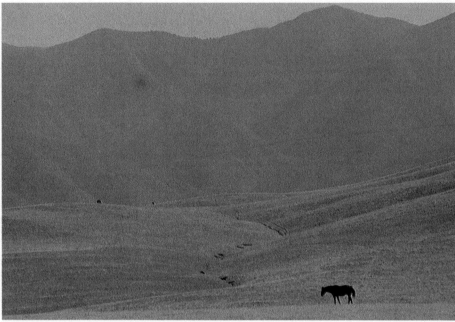

A high-key photo consists mainly of bright tones. This doesn't mean there should be no dark components. Quite the contrary. The horse in this delicate scene does more than add foreground interest. It extends the overall tonal scale without spoiling the high-key effect.

ultraviolet radiation as much as possible by using an appropriate filter.

The popular skylight filters provide very little benefit and "haze" filters are nothing more than slightly denser skylight filters. I find Tiffen UV filters to be among the most effective available. They hold back ultraviolet while restricting the transmission of visible rays

very little. UV-reducing filters are advisable whenever atmospheric conditions are part of a scene and when all or most of the sky is overcast.

If you are using Kodachrome, you may get a more neutral response by adding an amber No. 81 or No. 81A filter to the UV filter. With Ektachrome 64 film, try using a No. 81B or No. 81C.

Differences in the color sensitivities of color-slide films are most evident with neutral-tone subjects like this. I made the left photo with a film having a slightly warm bias. For the right photo, I used a film that had high ultraviolet sensitivity. The result shows some unexpected colorations, ranging from pink to bluish.

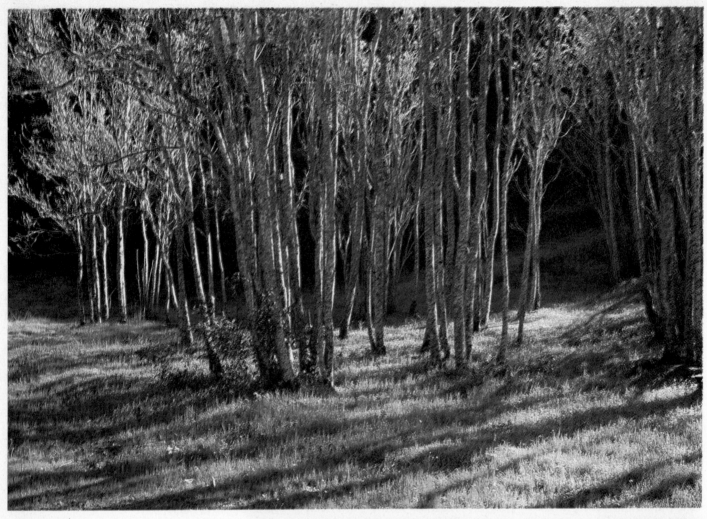

This scene has reproduced with a full tonal range in both color and b&w. Important detail lies in the midtones. I've permitted the background shadows to go black. With this scene, it's actually an advantage. It creates the feeling of depth and mystery of the forest.

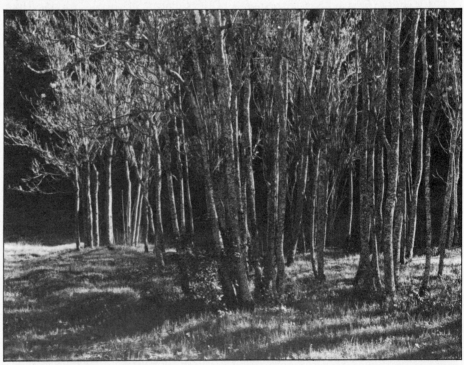

MOOD

A landscape photograph is more than simply a realistic representation of a scene if it has that something extra called *mood*. If a photograph can suggest warmth, cold, isolation, sadness or any other emotion, it has mood.

The retention in a photograph of the mood you see in the scene involves the steps of *perception, visualization* and *realization* discussed in Chapter 2.

The mood of a photo can be set by the content of the scene. It may be the solitary vastness of a desert, the grandeur of a mountain or the threat of an approaching storm. However, another factor that creates mood is the tonal values recorded in the photograph.

Let's look at the latter aspect of mood and see how your view of a scene can be translated into an effective *mood* photograph.

Making the *best possible* image of a soft, misty scene would involve expanding the limited tonal range characteristic of the scene. A negative would be produced that has a full tonal range. From this, a print would be made, having good whites and blacks. But this kind of bright image would totally destroy the mood of the scene.

As photographer, the objective you should have in mind is the creation of a soft image, with a limited tonal range. Overexpose the film just enough to reproduce the shadow areas as midtones. This will ensure detail and tonal separation in the delicate shadows.

You can print the negative in two ways. You can expose the printing paper so the deepest shadows are nearly black. The other tones will then be a midtone gray, and the picture will have a dark, somber appearance. You can also expose the print so there are no deep blacks or clear whites in the print. The entire scene can be represented in a light to medium gray. The mood of such a print is much brighter and more cheerful. And yet the scene, and all its

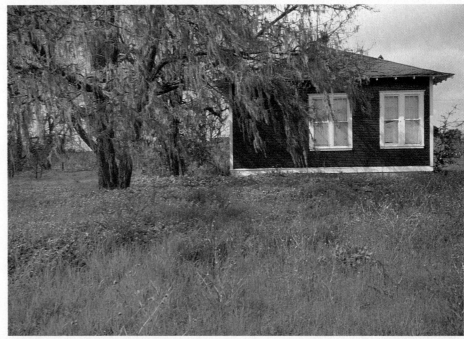

The use of complementary colors in a scene—such as red and green or blue and yellow—can add life to a landscape photograph.

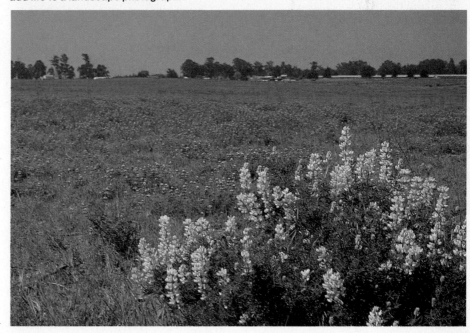

details, are essentially the same as before.

A full-scale image is one that uses all or most of the potential tones available in a photographic print or transparency. A landscape with a full tonal scale can rarely be regarded as a *mood* picture. Typically, we associate a full tonal scale with normal, everyday scenes. The major impact of such a picture comes from *subject content* rather than from *tonal representation*.

The following describe what I consider the three basic techniques for eliciting mood through tonal control:

Limited Tonal Scale—You can produce a mood landscape by selecting a scene that has a limited tonal scale. Or, you can manipulate exposure, film development and printing techniques. Alternatively, you can do a little of both. You can create an image that has mainly bright areas and no blacks, or one that is essentially dark and

has no midtones or highlights. It is generally difficult to make a photo that consists only of gray midtones. Even a low-contrast scene usually has a sufficient tonal range for a full-scale print or transparency. A photo of this kind is also generally not very effective or attractive. Your best way of shortening the scale is to deliberately eliminate the shadow or highlight end.

High Key—A high-key image is one that's predominantly light and bright. It calls for a specific kind of scene—one that has no significant dark areas. It also calls for soft, diffused lighting, with no significant shadows.

A high-key image appears almost entirely light in tone, without any deep shadows or dark subject areas. However, it generally uses the entire tonal scale. A portraiture example may best describe what I mean.

Only a predominantly bright subject is suitable for the high-key

treatment. A light-skinned and light-haired woman, in bright clothing and with a bright background, is ideal. A man with black hair, a beard and dark clothing is unsuitable.

Although most of the image is at the highlight end of the tonal scale, there should be some—but very limited—black or dark areas. The subject's eyes or lips, or a small piece of jewelry, are enough. When a high-key picture contains some black, it is much more effective, and appears much more sparkling.

A typical high-key landscape would be a lake in an early morning mist. All tones would be of a light gray. Place a couple of dark birds in the foreground, and see how much more sparkle the picture gets, without losing any of the high-key effect.

Another good example is a snow scene with a couple of dark, isolated skis standing in the snow. A scene of desert sand dunes, set

When the sun is obscured by a thick layer of moisture-laden fog, your color images can have a distinct blue color imbalance. If you want to retain the atmosphere of the scene, don't attempt to use corrective filtration.

off by a single clump of sagebrush, has similar characteristics.

Because the high-key image has a full tonal scale—even though there is a predominance of light tones—normal exposure and development can be used. To ensure adequate detail in the bright areas, avoid overexposure.

Guard against making an average-scene exposure-meter reading. The brightness of the scene would obviously lead to gross underexposure.

Slow and medium-speed films, both color and b&w, are best. They tend to record maximum tonal separation in highlight areas. For b&w films, non-compensating developers, having a low sodium sulfite content, are best for superior highlight detail.

Low Key—A low-key image and subject is almost exactly the opposite of its high-key counterpart. The subject must be predominantly dark. Both the nature of the subject and lighting must ensure this. There should be some small highlight areas. In a portrait, these would usually be the white of the eyes, some highlights on the skin or a shiny piece of jewelry.

A typical low-key landscape would be a somber farmyard scene, covered with storm clouds, with two or three white chickens somewhere in the composition. As with the high-key photograph, the whole tonal scale should be recorded. There should be some white areas along with the dark.

Many low-key scenes tend to be contrasty. The greater-than-normal subject brightness range can be compressed on b&w film by reduced development. Film speed will be reduced accordingly. Exposure must be increased to allow for this.

With color-reversal film, you can either expose for the highlights and lose shadow detail, or expose for the shadows and have the brighter areas burned out.

One possible alternative is to use a contrast-reducing filter on the camera lens. Another is pre- or post-flashing the film. This is a multiple-exposure technique. It involves giving the film a brief and uniform exposure to white light in addition to the exposure to the scene. It provides increased detail in the shadows. For the best results, the flash exposure must be of a very specific amount. Too little will have no effect, and too much will reduce contrast below an acceptable level.

The following should be a useful starting guideline: Place a matte white card in the same illumination as the scene. Give this card an exposure equivalent to about 1/30 to 1/60 of the camera exposure to the scene. For example, if the exposure to the scene is 1/60 second at f-11, give a white-card exposure of about 1/500 second or 1/000 second at f-22.

You can bracket white-card exposures. For example, you can make three photos, exposing the scene the same in each but giving white-card exposures of 1/250 second, 1/500 second and 1/1000 second at f-22.

Subject components in these two pictures are the same. There are blue flowers, green grass and a dark neutral tone. However, the two images have a very different character. The viewpoint, quality of the light, hardness or softness of focus, and brightness of the image all affect the final image. How you record the image depends on how you visualize it.

Reflectance range of the various subject parts was great. The light reaching different parts of the subject also varied greatly. Together, these two factors created an extreme total subject brightness range. Use a low-contrast film, place your exposure carefully and develop for a soft image. Often, you won't be able to record the whole tonal range with detail. Compromise will be called for.

How you expose a photo depends on how you visualize the scene. The walls of this room were actually white. I intentionally shifted them down the scale to a midtone. I could not have achieved the effect of the bright window light if I had exposed for a white wall. Also, I would have lost much of the texture of the wall.

Beach scenes usually fall in the category of full-scale or high-key subjects. But when the surf is backlit by direct sunlight, brilliant specular highlights are created. The surrounding values are relatively dark in comparison. The negative for this print resulted from an averaged exposure reading of the scene.

Composition is the way you relate the various picture elements to each other. These include shapes, lines, areas of light and dark and image outline. Understanding the elements and dynamics of effective pictorial composition is an extremely important part of the creative process. However, because the camera records reality, the photographer usually has less compositional freedom and control than the painter or sketch artist.

Even when a painter is making a literal representation of a subject, he is able to arbitrarily add, delete or move any element. When he's painting a picture of a farmhouse that has an unsightly tree in front of it, he has an infinite number of options. He can change the tree's position, alter its size and shape, or omit it entirely.

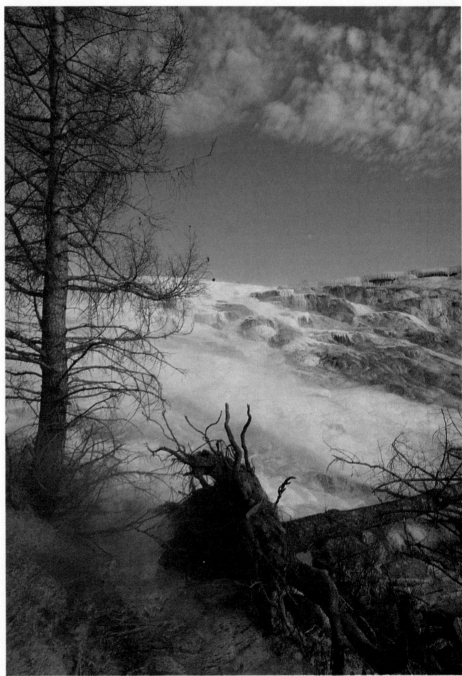

In the sketch, the photograph has been reduced to a few simple lines and shapes. The major elements of the composition are clearly shown.

As photographer, you must deal with the tree as it is. Your approach to *realizing* your *visualization* is much more passive, at least in terms of manipulating the subject.

What you can do to modify the relationship of elements in a landscape is usually limited to varying the camera's view. Only rarely can you move important picture elements—other than people.

With a camera, composition is a selective act. You compose the image by choosing the right viewpoint, camera distance and angle, and lens focal length. To do this effectively, you must develop a keen awareness of what specific compositional elements make up the scene. You must be able see them as the camera does.

To learn what will produce successful compositions, you must assume a realistic and practical attitude. In the past, arbitrary criteria of "good" composition were common. Images were to be composed according to specific and rigid rules. Today, anything that "works" is generally accepted. Just about every rule established and followed in the past is being broken by leading photographers today. Unique photographs are the result.

Specific rules of composition are easy to learn and can offer you some sense of security. However, if you follow them thoughtlessly, they often lead to static and boring images. This is to be expected. Rigid, explicit rules contradict the very nature of a free, creative process.

A successful landscape photograph results from more than an understanding of the basic, proven rules. It demands imaginative and bold experimentation.

The following discussion of the elements of composition is not intended to be conclusive. What follows are some of the basics. It's up to you to learn them, build upon them, use them—and avoid using them—as your personal experience and taste dictate. As you gain

You needn't always follow the dictates of the camera format. You can compose a rectangular image on square-format film. Or, as here, you can compose a square picture on the conventional 35mm format.

experience in landscape photography, the *rules* of composition will more and more become *guidelines*.

CROPPING

You *crop* the image to establish the perimeter that contains the part of the fuller scene you want to record. Photography is always selective in this respect. You can only represent in a picture a limited view, bordered by a kind of window.

When you look through a real window or door, you retain the feeling of three dimensions and of reality. The window or door is part of the scene. When you frame a picture within the borders of a photograph, you lose this feeling of reality. You must use the tool of composition to simulate a three-dimensional view. You must also compose the scene in a way that does not make the image outline disturbing.

A well-composed picture will keep the viewer's attention within the picture area. The viewer's eyes will not be tempted to stray to the

borders and outside the picture. There's also a right shape for each picture—square or rectangular, horizontal or vertical.

Film and Paper Formats—Different cameras and films offer different picture formats. These can differ in both size and shape. As far as composition is concerned, the size of the negative or transparency is less important than its shape. The shape of a photo can be square or rectangular. If rectangular, the image can be framed vertically or horizontally. Also, the rectangular format can have different *aspect ratios*. This is the relationship between the width and height of the image in the picture.

Standardization in aspect ratios in cameras and printing papers is limited. Let's look at 35mm, the most popular film format. The aspect ratio of its image is 24mm to 36mm, or 2:3. None of the currently available printing papers has a corresponding aspect ratio. For example, 8x10 paper has a ratio of 4:5. This means that, to fill the printing paper, you must crop

off some of the 35mm image. Or, you can print the whole image and not fill the printing paper.

The square image format, having an aspect ratio of 1:1, must also be cropped to fill any of the conventional paper shapes. Remember this at the time you compose the image in the camera viewfinder or on the focusing screen.

Film in the 4x5 format relates closely to the aspect ratio of 8x10, 11x14, 16x20 and 20x24 printing papers. Paper in the 5x7 size has a noticeably different aspect ratio.

Medium-format cameras that take 120-size film give three possible image formats. They are 6x6cm, 4x5.6cm and 6x7cm. Each has a different aspect ratio. The 6x7cm format is often called *ideal,* because its aspect ratio resembles most closely that of 8x10 and 11x14 enlarging paper.

Obviously, when you're composing a scene in your camera, you must bear in mind the aspect ratio of the final photograph. Many photographers resolve this problem by adding to the camera focusing screen an outline of the appropriate printing

paper's aspect ratio. Of course, if you plan to make prints of different shapes this practice is complicated.

If you're in doubt about the exact image area you will want to print, you can allow some extra space around the image on the film. This will enable you to crop at your leisure at the enlarging stage. Although this method can be useful with the larger film formats, it is not ideal with 35mm. The 35mm image is so small that you shouldn't plan to get a smaller image on the film than is absolutely necessary.

Image Proportions—The shape of the image plays an important part in composition. You are free to create a picture of *any* shape that best achieves the visual result you're after. You need not be limited by the aspect ratio of the paper you plan to print on.

The 3:4 or 4:5 aspect ratios need not control our visual creativity, even though they seem to have become a part of our Western culture. When we study oriental art, we see aspect ratios that are much more extreme.

Tradition and custom aside,

Some landscape subjects lend themselves to a crop even narrower than the 35mm format.

there's no doubt that different image formats have different effects on the viewer. The square format tends to give an image a solid, balanced and static look. It can be effective with some landscape subjects, although this is the exception rather than the rule.

The rectangular format has a greater potential for suggesting motion and action in a picture. The more extreme the aspect ratio, the greater this potential is likely to be. Of course, it depends on the scene. A horizontal landscape picture can have a very tranquil effect. A vertical scene of hills or mountains, waterfalls or billowing clouds can seem much more dynamic.

The standard aspect ratios tend to have a less dramatic effect, presumably because we are so accustomed to them. You have the ability to vary picture shape to best suit and enhance the image. The lines of the image itself should complement the picture outline.

SHAPE, TONE
AND BALANCE

Shape in a photograph is obviously two-dimensional—even though the shape depicted may represent a three-dimensional scene. Shape relates to specific image components that are usually recognizable as specific objects. Sometimes shape is not derived from an object at all, but from a mass of shadow or some other tonal phenomenon.

Whatever the shapes in your photographs represent, they are the building blocks of your composition. You *compose* the image by deliberately *managing* the various shapes. You manage their size, their relative position in regard to each other, and their contribution in balancing the weight of the entire scene. When you manage the component parts of a scene, you must also manage the empty space.

Tone—Shape is not only two-dimensional, like the silhouette of a face. Shape is solid. This solidity is brought out by effective lighting, or the deliberate use of light and shade. Color also plays a part.

Seen as a pattern on the printing paper, a house can appear to have very different shapes, even when photographed from the same angle. It will create totally different effects on the paper when photographed under an overcast sky, in early morning sunlight, at sunset or under noontime sun.

The difference stems from the play of the light—from the relationship between highlight areas and shadows. In other words, from the use of tones.

Lighting determines whether a ball will appear like a flat disc or the spherical object it actually is. The tonal area in the picture will appear different in each kind of lighting.

The visual balance of a picture depends on the shape and size of the different components in the composition. *Apparent size* and shape are affected by the lighting.

The so-called "weight" of an image component is dependent not only on its size. Tone also plays a part. For example, in a picture that is predominantly light, a dark body will have more effective weight than a light one. Conversely, a light body will have

more weight in dark surroundings. Ultimately, weight in a photograph is a visual thing. You tend to know instinctively if a composition is balanced or not.

A *balanced* image, in which there is an equal distribution of apparent *weight,* is not necessarily always desirable in landscape photography. No rule can dictate how much balance or imbalance an image should display. The important consideration is whether symmetrical balance or asymmetrical tension will most effectively reproduce the scene you visualized.

LINE

There are two kinds of lines. One is the *outline* that delineates the shape of an object. This kind of line is usually imaginary. When a child draws an object, he will give it a definite outline. However, the experienced artist can draw the object without blatantly putting a line around it to indicate its borders. When a car or an airplane is said to have *good lines,* it is being praised for its apparent outline, or design.

Shape dominates the composition in this photograph of an isolated rock. In most landscape subjects, shape is only one of the compositional elements. Line, texture and contrast also play a part.

The major element in this composition is shape. But lines and texture within the dominant shape also play an important part.

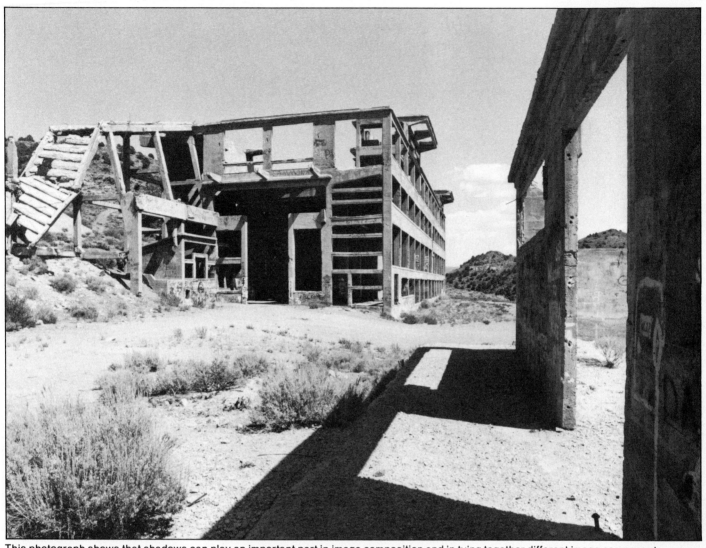

This photograph shows that shadows can play an important part in image composition and in tying together different image components.

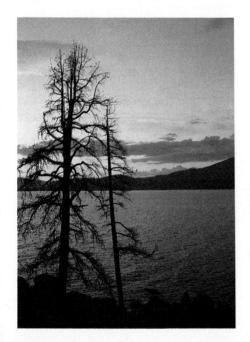

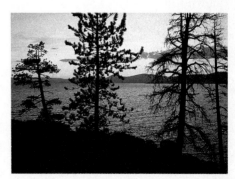

Visual rhythm is much like musical rhythm. Different beats satisfy different people. Whether a composition should be balanced to include two, three or four silhouetted trees against a lake at sunset depends ultimately on personal taste.

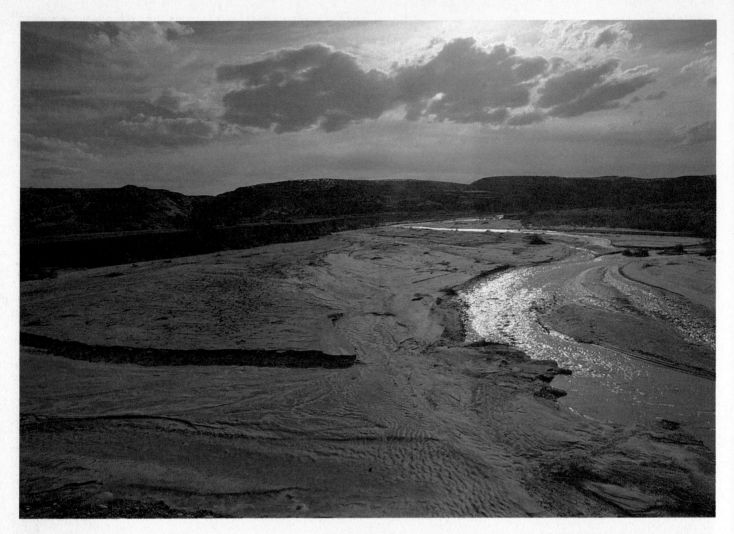

The second kind of line is more real. These lines represent objects, so we can call them *object* lines. In a landscape, you may see them as telephone poles, wires and picket fences.

Of course, even telephone wires are solid objects. But their width is so small relative to their length that they appear as lines without any substance. Whether something is a line or not depends on the viewpoint. From a distance, the cables holding up the Golden Gate Bridge are lines. When you're on the bridge, they suddenly become very solid objects.

Many image components are, strictly speaking, neither image outlines nor object lines. Tree trunks and branches, for example, have visible substance and width. But for compositional purposes you may often regard them as lines. Lines also occur within the texture of a material. Or between image components. In a mountainscape, for example, you will see lines separate rock formations at different distances.

Composition largely has to do with lines. Thin lines, without apparent substance, can effectively lead the viewer's eye to a specific point in the picture. Or, you can use them to lead the eye out of the picture. Lines can also form a coherent pictorial pattern or divide the image space.

Lines play an essential part in perspective. The converging lines of a tall building, the receding lines of telephone poles and the narrowing of a road as it disappears into the distance are all factors of perspective.

Lines can be straight, curved, irregular or interrupted. They can run horizontally or vertically. In a landscape, horizontal lines tend to suggest a peaceful and static scene. On a race track, they will suggest

An "S" curve can be a useful compositional tool, if used with discretion. It holds the attention and leads the viewer's eye through the picture. In the color photo, the curve is formed by the sun's highlight on a desert stream. In the b&w picture, it consists of the pathway, which leads your attention to the white chapel.

speed and motion. Vertical lines can suggest power and grandeur. Diagonal lines can suggest distance or motion, depending on the nature of the subject.

You can use lines to contain the viewer's attention within the picture area. Sometimes, you may want to lead the eye out of the picture, to suggest things that lie beyond.

When you are composing your landscape pictures, it may help you to think in terms of a line drawing. Try to *see* the outlines around the various image components and the lines of fences, poles and trees as if you were sketching them. This will make

you more aware of the presence of lines and outlines. You can then use them more effectively in composing your images.

THE RULE OF THIRDS

Perhaps the best known rule of composition is the *rule of thirds*. It governs the placement of the center of interest. The image area is divided into three parts, both horizontally and vertically. According to the rule, the ideal placement of the point of main interest in a composition is at one of the intersections of the divided image.

It is often true that the most effective location for the main point of interest is one third of the way into the picture area. However, total adherence to the rule would

deprive you of a lot of creative potential. Like other so-called *rules* in photography, it might better be called the *guide* of thirds. It should guide you, not rule you.

The placement of the object of main interest is not only an academic question of composition. Where that object is placed can tell a story. For example, a lone rock on a barren plane might be placed at one of the thirds in a rectangular format to produce a visually pleasing composition. However, to emphasize the isolation of the rock in its environment, it might be more effective to place it near the center of a square image.

Often, there are several important points of interest. In such a case, the important consideration

is not so much where one of them is placed, but how they balance and relate to each other. Just how a second or third point of interest relates to the first and to the image as a whole depends on the *weight* of each.

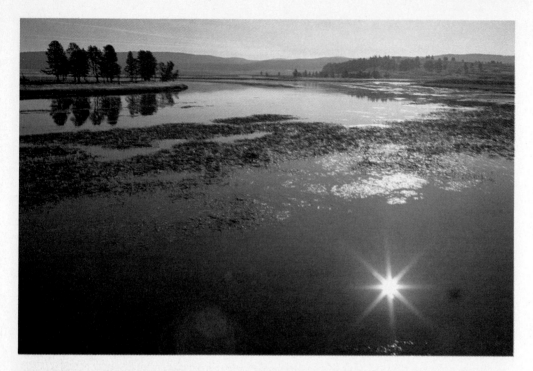

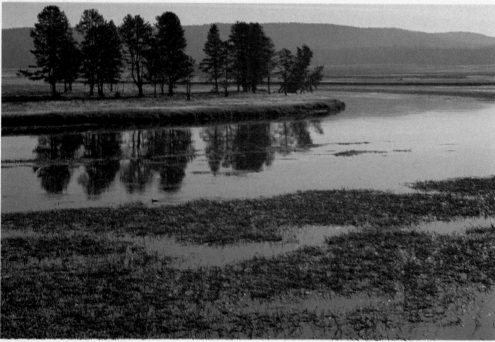

Here are two different effects with the same scene. Choose your viewpoint, framing and foreground interest to give the image you want.

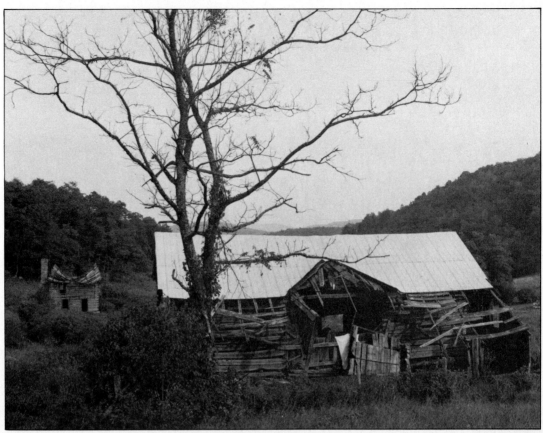

The light overcast gave the sky a uniform bright appearance. The tree serves to fill this space and break the monotony. Notice how the branches follow the skyline of the landscape.

This is a study in horizontal shapes and lines. The outline of hill against sky, the meeting between grain field and hill and the barbed wire all complement each other. The contrast of the fire-blackened hill against the bright grain field, and the lone tree on the hill, make for an eye-catching composition.

9 Special Situations and Conditions

All landscapes are different. That's why the photography that is the subject of this book is so fascinating. Frequently you'll find conditions that call for special treatment. The differences can lie in the characteristics of the scene itself, or they can be related to lighting conditions.

In this chapter I'll discuss some of the conditions you'll encounter that call for special measures.

WATER

Water is an integral part of many landscapes. It appears in various forms—oceans, lakes, streams, rivers and waterfalls. It can also occur in the form of rain, mist and fog.

Unlike rocks, trees, buildings and other solid components of a landscape, water has a peculiar vitality of its own. Sometimes it has motion; at other times it is still.

A body of water can have a placid, mirrorlike surface, giving a faithful reflection of everything around it. Or, stirred by the wind, it can have anything from gentle ripples to heavy waves. The varying patterns of light and shade water can generate are almost unlimited.

Depending on local conditions, the appearance of water can range from crystal-clear and transparent to ominously dark and opaque. Both the conditions under the water and those in the sky affect the appearance of water. Because the appearance of water is so changeable, give it special consid-

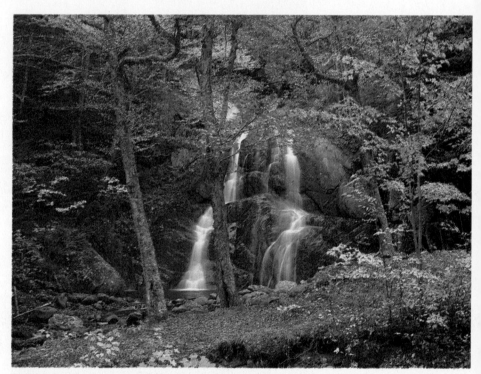

This photo was made on 4x5 film. The light level was low. The lens was stopped down for the required depth of field. The resultant shutter speed was slow enough to record the moving water as streaks. Photo by Dick Pietrzyk.

eration when it is part of a landscape you're photographing.

Rivers and Waterfalls—Rivers, streams and waterfalls all have motion. You may want to freeze the motion of a fast-moving stream cascading over a rocky bed. You'll want to capture the sparkle of the highlights dancing over the rocks.

These highlights are very bright. Some of them are direct specular reflections of the sun. Others are diffuse reflections, caused by the foaming water. To differentiate between the two in a photograph and maintain adequate tonal separation, you must be careful not to overexpose the highlights.

At the other end of the tonal scale, the banks of the stream might be wooded. The direct rays of the sun would be obscured and there would be deep shadows. The result would be a long subject brightness range, possibly several exposure steps greater than an average scene. You would want to try to preserve tonal detail at both ends of the scale—in the bright water and the deepest shadows.

Some of the most effective pictures of moving water are those in

which the motion is not frozen. A blur can make a waterfall or a stream look especially realistic. I'll say more about this under *Motion,* later in this chapter.

A final comment about waterfalls. In bright sunshine, a waterfall will often generate a beautiful rainbow. Look for it and photograph it. Guard against overexposure. To record on film the rich colors of the rainbow, you should underexpose a little. The main scene may appear a little dark in the picture. Sometimes this can actually help to enhance to dramatic effect of the rainbow.

Lakes and Oceans—Large bodies of water like lakes and oceans have similar characteristics. They present you with many of the same problems. Motion may or may not be a factor. Pounding surf at the seashore requires the highest shutter speeds to freeze the action. A calm lake may let you use very long time exposures without loss of definition.

The white foam of breaking waves will increase the tonal range of the scene. Sometimes the surface of the water acts as a reflector, to lighten shadow areas in other nearby parts of the scene. As a result, the total subject brightness range may be kept close to average.

Sometimes you'll find situations in which the water is the darkest element in a scene. It can extend the subject brightness range at the low end of the scale. This usually occurs when calm water is in the shade and reflects a dark, shaded adjacent area.

When you're working in color, large bodies of water present another variable that can affect the coloration of the scene on film. The color of water is influenced by the constituent elements in the water. You may get a brownish cast from decomposed organic matter or a greenish hue caused by living organisms or the water's mineral content. Throughout the day, the color of water reflects a wide variety of hues and

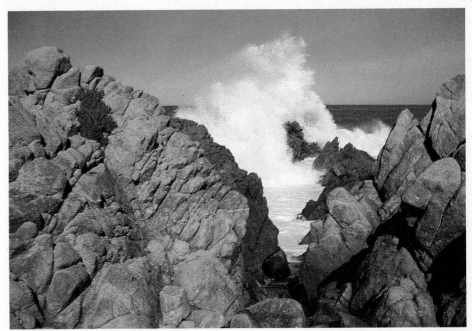

Breaking surf in full sunlight is very bright. It requires a fast shutter speed, even with a medium-speed film and a relatively small lens aperture. To prevent the subject brightness range from becoming too great for the film, it's best to select a viewpoint where other image components are well lit. In these two scenes, the rocks are lit frontally and from the side by the sun.

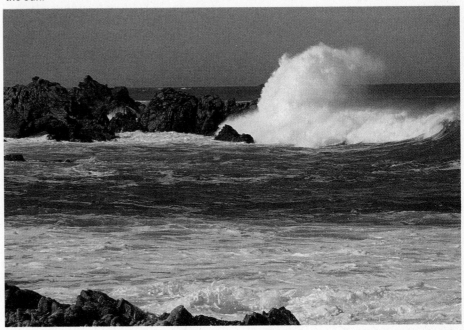

tints as the sun's path across the sky changes in angle.

The many shades and permutations of color taken on by standing water are apparent to the eye. They should be a decisive factor in your visualization of the scene. What is often not so obvious is how the reflective character of water can modify the color of the light illuminating other parts of the scene.

It was just noted that the smooth surface of a body of water can act as a reflector to fill shaded areas of a scene with light. If that illumination is a reflection of direct sunlight, for example, the color balance of the light will be largely consistent with normal sunlight.

However, if the scene is illuminated by blue sky rather than direct sunlight, the water reflecting that light will give shadows a distinctly blue cast. Or, your subject

might be illuminated by the warm, waning rays of late afternoon sunlight, while the shadows are filled by blue skylight reflected from water. This creates a decided contrast in color between warm highlights and very cool shadows.

Rain—Let's look at the modifying effect rain can have on a scene. Photographers often consider rain as just a nuisance. However, wet surfaces of all kinds affect the visual appearance and image-making properties of a subject.

For example, a surface that is diffuse and dull when dry becomes slick-looking and capable of reflecting specular highlights when wet. A wet surface takes on a gloss similar to that given by a coat of varnish. This effect involves an increase in both color saturation and image contrast. Wet surfaces also have the ability to reflect light sources such as street lighting, car headlamps and light from buildings.

Rainbows are rare. When you see a good one, you may want to photograph it. You should try to underexpose the scene so as to retain the color brilliance in the rainbow. The rest of the scene may appear a little dark. However, this is usually characteristic of the circumstances in which rainbows occur and can actually enhance the image.

During rain, the light level is usually low. This means you should use a tripod to steady your camera, even with fast film. Choosing a fast color film will work to your advantage because the inherent contrast of the faster films is higher than that of slower films.

If you're working in b&w, you may encounter some problems. Typically, you would extend development to increase contrast. But extended development combined with a fast film can result in graininess that is too apparent. A good compromise is to use the fast film with a soft-working, fine-grain developer. You'll have to sacrifice a little of the film's effective speed.

You can stop the motion of water by using a fast shutter speed. When the shutter is set to a slower speed, you can record moving water as streaks. For this picture, the exposure time was even longer. It recorded the water moving in several directions. The result is this ethereal, cloud-like effect.

There is no one established rule or set of guidelines to follow in photographing a scene containing water. The one characteristic water brings to a subject is unpredictable variation in its effect on the overall subject. The key to dealing with the ever changing characteristics of water is your own keen observation.

SNOW AND SAND
Snow and sand generally bring to mind cold and heat respectively. However, to the photographer they have several important things in common. They both share a high reflectivity, often distributed in large areas of the scene. They often have gradually undulating contours and a potential for specular highlights. In addition, they often afford working conditions that are hazardous to person and equipment.

Light Angle—The textural detail of snow and sand is best brought out by directional sunlight from a

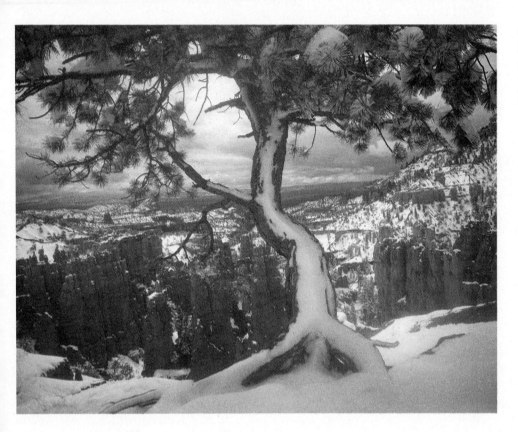

Snow brings a new dimension to this familiar view of Bryce Canyon, Utah. The snow helps to increase the subject brightness range to an interesting level. The overcast sky helps to keep contrast within manageable limits. Photo by Robert F. Morris.

It often requires patience waiting for conditions that can add special qualities to your landscape images. Pamela Roberson spent many hours on the Great Sand Dunes of Colorado waiting for a dramatic picture. Eventually, she was rewarded with strong sidelighting from the sun on the dunes and a somber dark sky in the background.

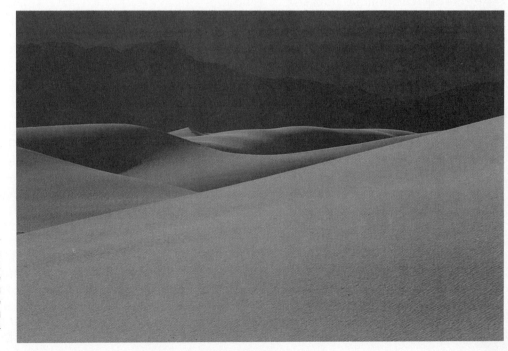

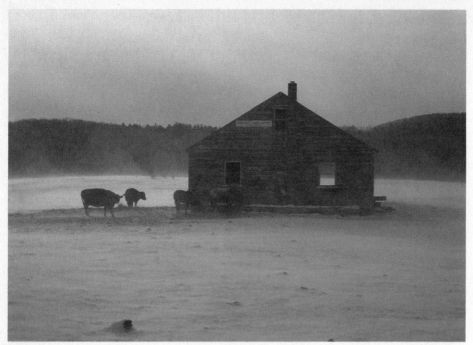

Severe weather conditions tend to discourage photographers. These conditions cause discomfort, can be hard on equipment, and usually create difficult lighting conditions. However, it is in precisely these conditions that you can capture the most rare and evocative images. This rural winter scene was photographed by Bob Curtis.

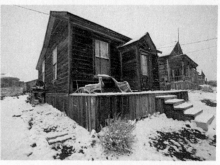

The overcast sky and reflectivity of the snow helped keep the contrast of this scene down. Under a sunny blue sky, any walls in deep shade would have been very dark. All detail in those areas might have been lost.

low angle. This means late in the day or very early in the morning from late spring to early fall. In the winter months, the best times are mid-morning and mid-afternoon. In winter in northern latitudes the sun traverses a path more closely parallel to the horizon. At that season the low-angle light you need lasts for a relatively long time during convenient hours of the day.

To photograph sand dunes in summer you may have to get up very early or work through your usual dinner time. Also, you must be prepared to work with unfaltering speed because the angle of the sun's illumination changes rapidly.

Brightness Range—When the entire image consists only of snow or sand, the image brightness range is very short. When relatively dark objects and people are included, the brightness range can suddenly become very long.

Let's look at some technical considerations. Be prepared to deal with greatly differing contrast possibilities and take with you an appropriate film selection. A scene containing just sand or snow has a very uniform reflectance value. The only contrast distinguishing the shapes of dune and drifts is the difference between highlight and shadow.

When the subject brightness range is very short, you can increase contrast with b&w film by extending development. The best films for this are slow, fine-grain films.

If you intend to work with color-negative film, I recommend Kodacolor VR 100 or VR 200, Fujicolor HR or Vericolor Commercial. I suggest you print on Ektacolor 78 paper. With color-reversal films you don't have much choice. The faster films give you more contrast but also the undesirable characteristics of coarse grain, poorer resolution and less subtle tonal gradation.

If there are elements other than sand or snow in the image area, be prepared to deal with a higher-than-normal subject brightness range. Select a fast b&w film and develop it in a soft, slow-working developer. For color, the negative film I recommend is Vericolor III, although its range is limited even when printed on the less contrasty Ektacolor 74 paper. When making slides, I find that I can obtain the best combination of shadow and highlight detail with Kodachrome 25, Kodachrome 64 and Ektachrome. Fujichrome is also suitable.

Tripod—Snow and sand scenes often call for the use of a tripod. This is not only for compositional convenience. Strange as it may sound when talking about these inherently bright subjects, you may need a tripod for camera steadiness.

Remember that you'll often want to use the smallest lens aperture, for maximum depth of field. The best lighting conditions occur early or late in the day, when the light hits the surface at an oblique angle. Slow or medium-speed films are often desirable, to keep graininess to a minimum and to maintain good tone separation. Therefore, exposure times may sometimes be long enough to call for the use of a tripod.

Wind—The wind can work wonders with sand and snow. It can create the most wonderful drifts, dunes and shapes. If you plan to shoot while it's windy, be sure to protect yourself and your equipment. Blowing sand, in particular, is one of the most potentially damaging things to camera equipment.

Weather—When you're going to work in sand or snow, consider the possible weather conditions. It may get very hot or very cold. In desert regions at high altitude, you may get hot in the daytime and very cold after sunset. Remember this and dress accordingly.

Access—Access to snow and sand is not always easy. Although you can often drive *to* the scene, you must walk *into* it. In doing so, you must be careful not to spoil the natural look of the scene with your own footsteps before you have a chance to photograph it.

Walking in heavy snow or on a sandy beach can be heavy work. Consider this when you select your equipment. It should be as light and convenient as possible. Also remember to give your equipment the best possible protection from the wet snow and the grains of sand. On a beach, the danger of sand is compounded by the hazardous salt spray from the ocean. This is especially prevalent when it's windy and waves are breaking on the shore.

FOREST AND JUNGLE

Trees hold a special fascination and beauty. The forest, with its mass of closely-huddled trees, seems to attract us all. Trees play a significant role in landscape photography. They are photographed as forests, in small groups, individually and as close-up studies of various of their parts. They appear different as they age and at the different seasons.

Light—Unfortunately, trees often deprive you of the essential ingredient for photography—light. The same umbrella of leaves and branches that creates the special environment of the forest leaves very little illumination by which photographs can be made.

It would not be so bad if the umbrella were complete. Then, a longer exposure time, and perhaps a faster film, could solve the problem. But the umbrella is seldom total. There are breaks that allow the sun to shine through. This can create undesirable patterns of light and shade with extreme contrast.

The effect of streaks of light shining through and between dark trunks can be visually appealing. This is especially true when the air contains particles of moisture, smoke or dust that catch the light to produce visible light beams.

With the beams of light at the highlight end of the scale and the shadows of the forest at the other, you will have an extensive subject brightness range. Often, you'll have to expose for the light beams, and let the shadow areas go dark and lose detail. Even the adjustment of b&w development is not always enough to give the added required tonal range.

The best solution to photographing within a forest or jungle is to wait for lighting that is most favorable. Atmospheric mist and fog occasionally provide an ideal situation by diffusing the sunlight. The resultant soft lighting opens shadows and reduces the subject brightness range.

To some extent the same effect can be achieved by placing a fog filter over your lens. However, this method should be used as a last resort. It tends to reduce image resolution and, although it gives a softer image, it does not give you increased image detail in the shadows.

The sun lit this flower from the front and back. How? I used a small makeup mirror, outside the field of view, to reflect the sun's light through the flower. This shows that small, simple devices can sometimes add a lot to an image's impact.

Clouds and Mist—Another alternative is to photograph when there is a thin layer of cloud that allows some direct sunlight to shine through. However, this may not be as appealing visually as an atmosphere of mist and fog. There may be periods during early morning or late afternoon when the scene is not struck by direct sunlight but is illuminated adequately by skylight. This will depend on the configuration of the terrain and the way the trees grow.

Color Imbalance—The color of the light may also pose a problem. A forest or jungle scene, illuminated by light from the sky, may photograph too bluish. A little additional blue will alter the greens only slightly. However, significant areas of brown or other warm tones can lose their richness and reproduce grayish. This can be corrected with one of the amber 81-series Kodak Wratten Light Balancing filters.

The foliage itself can lead to an unwanted color imbalance. When the leaves transmit or reflect sunlight, they impose a greenish cast on the scene. This will impart a color imbalance to tree trunks,

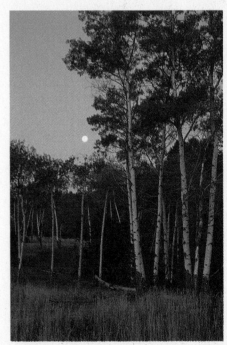

The tree trunks were illuminated by the pink light from the pre-dawn eastern sky. The full moon was still visible in the blue western sky.

Fog and mist in the forest offer exciting photographic opportunities. The fog can reduce the brightness of direct sunbeams and the depth of shadows. This leaves a moderate tonal range, suitable for color photos like this one. The light may be excessively cool. This is partly due to the blue light of an overcast sky and partly to the influence of green foliage. In these conditions, a series-81 warming filter can be useful. Photo by James Enright.

the ground, and especially to people in the scene. In a case like this, you can use magenta filtration to minimize the problem. However, you should not overdo the filtration, as this may totally destroy the true greenness of the scene.

Space and Perspective—In the forest or jungle, you usually don't have much room to move about. There are only a few locations from which you can compose a satisfactory image without unwanted trees and shrubs getting in your way. One solution is to use a wide-angle lens. This will give you the added advantage of greater depth of field.

Perspective can present a problem. When you're at the base of very tall trees, you must tilt your camera upward to compose the image. This will tend to make the trees appear as if they are falling in on each other.

Sometimes you can use this perspective effect to your advantage to create a dramatic image. At other times, it may help you to find higher ground or, if necessary, to climb a tree. For the sake of both you and your equipment, climb with care.

URBAN SCENE

As I indicated in Chapter 1, city scenes can also be considered landscapes.

Candid Photography—Conditions in the city can be hectic for the photographer. People and traffic can hinder or help you. When a good pictorial situation presents itself, you must grasp the opportunity while it exists. It won't stay for long. You need to be a candid photographer, taking advantage of things as they happen.

Walking is the best form of transportation for the urban photographer. After five or six miles of walking you'll have more meaningful pictures than after riding for hours on a bus or in a car. Travel light. You are best served by a 35mm SLR camera. A couple of zoom lenses can be very

The mirror-like facades of modern buildings are not everyone's idea of beauty. However, sometimes they can help you make a fascinating picture. The sun was reflected by the windows of such a structure, causing this interesting light effect on the building across the street.

helpful. Take a wide-to-normal 24-50mm lens and a moderate-telephoto-range 70-210mm lens. With them, you'll be able to shoot just about anything.

In areas surrounded by skyscrapers, like New York's Manhattan or the financial district of

San Francisco, a fast ISO 400/27° film is a good choice. In cities like Washington D.C. and Los Angeles, where you have a wider expanse of sky and more light in the streets, you can use a medium-speed ISO 125/22° film for most handheld picture taking.

You don't have to leave town to create a natural-looking landscape close-up. Even large cities offer many opportunities like this for the alert photographer. Be selective in your composition. Include what you want. Exclude anything that might reveal the city background.

I wanted to make an undistorted image of this relatively tall structure in the Taos Pueblo, New Mexico. The camera didn't have perspective-correcting movements. Fortunately, there was plenty of room to move away from the subject. This enabled me to point the camera virtually horizontally. I selected a lens that filled the film format well.

To keep your equipment to a minimum, and to keep the images on each roll of film to a consistent quality, you may want to consider shooting only one kind of subject at each outing. For example, you can spend an entire day photographing tall buildings. On another day you can shoot interiors. You can spend a day recording the scenes and activities in a park, or photographing the city skyline from a distance.

Just after the sun rises, and just before it sets, it often appears like a large ball of fire. By using a telephoto lens and shooting buildings from a distance, you can exploit this. A distant view, recorded with a telephoto lens, will increase the apparent size of the sun to give

you a very dramatic picture.

You can achieve a similar effect with the moon low on the horizon. This will call for a long exposure. Also, such pictures should be taken early in the evening, when the building lights are still burning.

Modern buildings are made from materials that differ dramatically from the natural environment. Polished metal, tinted glass and plastic panels often make up their facades. When contained within the frame of the film image, these structures can lose all meaning of perspective. Without a reference point in the picture, such as people or automobiles or trees, the viewer has no sense of scale.

Larger Camera—Although the candid approach can be lots of fun and should give you exciting pictures, for optimum image quality you may want to go to a larger image format.

When you point your 35mm SLR upwards to include the top of a tall building, the building's vertical lines will converge. The building will appear to be falling over backward.

You can use this effect to achieve a dramatic composition. If you want to avoid it, you should use a camera with camera movements. A view camera or field camera is best. Some medium-format cameras and even 35mm cameras will also provide a limited amount of rising front.

I could have backed away from these houses, to include much more. However, I wanted to show the striking contrast in the paintwork. The viewer experiences an element of surprise, seeing that these very different facades are actually part of a single structure.

Urban areas are sometimes drab and cheerless. But, if you stay alert, you'll find brightness and fun in the most unexpected places.

Pollution—Don't shoot distant scenes when there's air pollution and smog, unless you specifically want the effect given by those conditions. When you do shoot in smoggy or smoky conditions, don't limit your framing to distant areas. This would give you a flat and meaningless image. Frame your scene so there is some nearby foreground. The contrast between clear air nearby and the increasing veil of smog toward the distance will make your image more meaningful. It will also give you a greater subject brightness range.

On color film, air pollution will not only cause a veil over the image. It will also introduce a distinct color imbalance. Different kinds of pollution give different color effects. In some industrial cities the smog may appear greenish, in others amber.

The most troublesome forms of "pollution" for the photographer of the cityscape are trash, billboards, parked and moving cars, posters, telephone poles and power lines. Our eyes get used to them and we eventually ignore them. But you can't dismiss them from a photograph. One of the big challenges confronting the city photographer is the avoidance of these distractions. You obviously can't eliminate this form of

pollution. You have to compose your images around it.

To give your city pictures life and believability, don't overdo this visual cleaning up. To a large extent, billboards, cars and power lines *are* the city. So compromise. Too much junk in a picture will spoil the image. Too little will make the picture look clinical and unreal.

Color—The cityscape has its own colors. They may be man-made, but they are just as real as natural colors as far as the photographer is concerned. You can record them faithfully. If you want to improve on the scene you see, you'll have

to manipulate the scene. You can avoid certain colors by cropping, hiding an offending object behind something else or choosing a camera position and distance that minimizes the offending part.

MOTION

The landscape is largely regarded as a static subject. Motion is often considered irrelevant. However, working outdoors you quickly come to realize that there is much movement in nature. As a photographer, you'll find some of it desirable and some not so desirable.

Close-up view of grass bent by the wind. The effect was enhanced by the use of a slow shutter speed, to slightly blur the moving grass. Photo by Paul Kuhn.

Unwanted Blur—Wind can present real problems for several reasons. It can make it difficult for your tripod-mounted camera to remain steady during the exposure. It can also move the foliage and branches of nearby trees, so they are recorded on film as a blur. The solution is to use a fast shutter speed. However, in dim light this can mean that you may have to sacrifice some depth of field.

Wanted Blur—The other natural factor in landscape photography that most commonly involves movement is water.

The motion of water is often something you deliberately want to show in your picture. For example, a fast-moving stream and the water from a waterfall do not look natural when the water is *frozen* on the film. We experience the motion of water and see it as a blur. The best photos of streams and waterfalls are made with shutter speeds slow enough to slightly blur the moving water.

How much blur you want can be a matter of taste. As a rough guide, I would say an exposure time of 1/4 or 1/2 second usually gives the best result. Of course, you must have the camera on a sturdy tripod.

Deliberate motion in a photograph need not be limited to water. For example, you may be photographing a herd of grazing cattle. At the right shutter speed, you could capture motionless cattle sharply defined while those that were moving would be partially blurred.

Double Exposure—By making a double exposure on one piece of film, you can record a moving object as both a blur and a sharply defined image. A fast shutter speed would freeze the action and a longer exposure time would record the motion. The background behind the frozen part of the image should be dark. A light background would appear on the film and make the figure in front of look transparent.

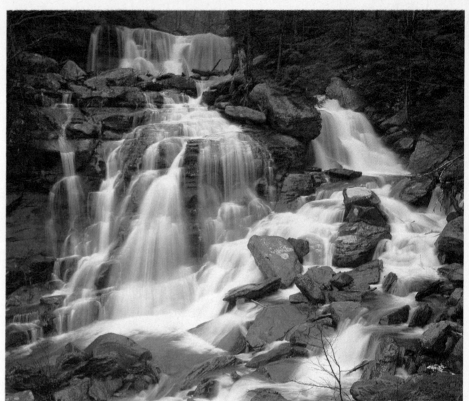

Soft light from an overcast sky helped maintain detail in the shadows in this inherently contrasty scene. The shutter speed was slow enough to deliberately streak the falling water. Photo by Vernon Sigl.

If you can't use a sufficiently long exposure time at the smallest lens aperture, use a neutral-density (ND) filter on the camera lens. This enables you to extend the time of one of the two exposures.

When possible, give several exposures of different durations for a moving subject. Speed of movement, subject distance and exposure duration will all determine the amount of blurring or streaking in the photo. Even with previous experience, it's difficult to predict the effect you'll get. Try as many options as are open to you with each subject.

SEASONS

The changing seasons can affect both your photography and your photographic equipment. In extremely cold weather, the lubricant in your camera shutter may harden. This can slow the shutter speed. If you're planning to work in conditions of extreme cold a lot, you might consider having a camera repairman winterize your camera. This involves changing to a more suitable lubricant.

Batteries in cameras, flash units and light meters are also affected by the cold. The useful life of a battery is greatly shortened under extremely cold conditions. You can reduce the effect by using special batteries that are more tolerant of the cold. Or, you can connect the batteries through special extension devices that enable you to keep the batteries in a warm pocket. If you can't take these precautions, take along extra batteries and keep them in a warm place.

Batteries don't die because of the cold—when warmed up they'll work again normally.

Extreme heat can be especially damaging to your film. This is particularly true if the relative humidity is also high. Don't break the seal on your film packages until you are ready to use the film. Have exposed film processed as

soon as possible. Avoid leaving your film or loaded camera in a hot place, like the glove compartment or trunk of a car.

From a visual standpoint, the landscape can change dramatically from season to season. Unless you're in a tropical or subtropical region, foliage comes and goes. In spring and summer it tends to change from a light to a dark green. Later in the year it turns yellow, and finally red and brown. Grass also changes, from a green and healthy look to a brownish appearance.

During winter, the ground may be covered with snow. Snow and ice can make for very attractive photographs. However, in some kinds of pictures you want to avoid snow. For example, if you want to make an attractive photograph of a new building, half-melted and traffic-soiled snow does not make an appealing foreground.

The seasons also affect the light. During the winter months the sun never gets high into the sky. Because the sun sets diagonally, the twilight time is longer. This gives you more time to photograph. In the summer, the twilight time is relatively short. When taking pictures around the time of sunrise or sunset, you must work fast and contend with ever-changing lighting conditions.

TWILIGHT

People who live in the northern parts of Canada, Scandinavia or Alaska know something about twilight. In the summer months, when the sun moves almost horizontally along the northern horizon, there are hours of twilight. The light that diffuses through the atmosphere when the sun is just out of sight below the horizon has some very special qualities. It is soft and subtle, often having an almost magical quality.

The main difficulty in photographing at twilight at the latitudes that encompass the conti-

nental United States is that the light changes very rapidly. Especially in summer, the sun goes down almost vertically. After every exposure you make, you'll find that the brightness, contrast and color of the light tends to change. To get the pictures you want, you must work fast.

It's a pity that more photographers don't take advantage of the special qualities offered by twilight. One reason is probably the fact that the conditions change so rapidly, making accurate exposure difficult. If you want to venture into this kind of work, I suggest you make some experimental outings. Use a tripod, so that you need not waste time recomposing the image between exposures. Shoot pictures under varying conditions of illumination. Make a careful note of your exposure data and the kind of results you obtained.

Another reason for the rare production of twilight photographs is undoubtedly the awkward time at which twilight occurs. I suggest you venture out just once at that time of day. You'll realize that it's worth changing your normal daily routine occasionally to take advantage of these brief periods.

CLOSE-UP

It may sound contradictory to talk about close-ups in a book on landscape photography. However, many landscapes and scenic views include detail that warrants separate photographic treatment. These details may be in a gnarled tree trunk, a shell on a beach or a small plant.

You can shoot a close-up by either coming close or using a telephoto lens. With inanimate objects, it's a good idea to come close. This enables you to see the detail you're going to be recording.

Sometimes you can't get close to the subject. Or, you may want to photograph living creatures that may be frightened by your proximity. Shoot from a more distant viewpoint, using a long-focal-length lens.

The best illumination on a close detail is not necessarily the same as that for the larger scene. Close-up, you may want to accentuate texture. Use side lighting. At a greater distance, this detail may be relatively unimportant and side lighting would not be useful.

Wait for the time of day when the light is best for the detail you want to record. Use reflector cards to put some light into the shadow

To shoot wild animals with a camera, you need a long telephoto lens. To record this stately buck, I used a 600mm mirror lens. Mirror lenses are light and compact and, therefore, ideal for field use. They have a fixed-aperture lens. In low light levels, you'll need to use a fast film. If the light is too bright, you can reduce exposure by adding a neutral-density (ND) filter. Most mirror lenses have ND filters built in.

areas. Depending on the subject, you can achieve different effects with reflectors varying from a small pocket mirror to a large umbrella reflector.

Don't use flash unless you have no alternative. You can't preview the effect of the flash. Also, if you give too much flash exposure, the end effect can look artificial.

When you're photographing flowers and plants, you may find the natural background distracting. To eliminate the background, use a clean piece of cardboard behind the flower. Sky-blue is a good color for this. You can also make the natural back-ground less distracting by using a wide lens aperture, to reduce the depth of field and throw the background out of focus.

A tripod is indispensable for close-up photography. It enables you to compose and focus the image accurately. You can make as many exposures as you want with the focus and composition remaining the same. In nature, many interesting close-up subjects are near ground level. For this reason the tripod should have an adjustable center post that enables you to mount the camera near ground level.

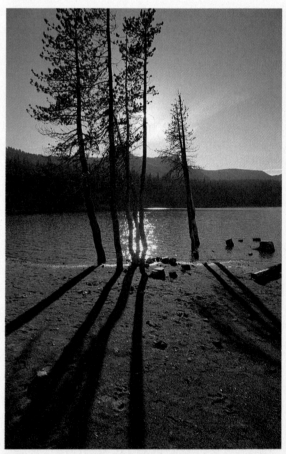

Backlit water scenes like this have very high inherent contrast. In evaluating exposure, you can generally discount specular highlights. You can also ignore the foreground in deep shade. This is because you'll normally want to record it in silhouette. Nonetheless, sometimes you'll have to sacrifice other shadow detail to get the midtone renditions you want.

I photographed this harbor scene under an overcast sky. The water reflected the skylight. There is tonal detail from bright highlights to deep shadows. Under a deep blue sky, the dark water would have caused contrast to be increased, possibly beyond what the film can record satisfactorily.

When you're surrounded by broad vistas or majestic mountains, take time to look down and immediately around you. Otherwise, you might miss significant foreground interest, as shown in these two photographs.

Close-ups in landscape photography are frequently of flowers. Look for an undistracting background that shows the flowers off to advantage. Here, I used a soft-focus effect to emphasize the delicacy of the subject.

An all-too-familiar vista can take on a hauntingly different appearance in the off season. This is an early-morning view of the Connecticut coastline in mid-winter. Jerry Howard needed no filter to produce this colorful image.

Often you will need to modify the way the film responds to the subject. This may be necessary to achieve an accurate color rendition or a special effect. The special effect may be a color change. Or, it may be the introduction of star-shaped catchlights, soft focus or a fog effect.

A wide selection of color filters is available. These can be used to *correct* color balance or *change* it for a special effect. Image modifiers are usually colorless. They are lens attachments that do not produce a color change.

In this chapter, I'll discuss filters and image modifiers that are important for landscape photography. Polarizers, which fall into neither of the above categories, are also useful. I'll discuss these, too.

Gelatin color filters are available in two-, three- and four-inch squares. Their advantages are relatively low cost, light weight and compactness for storage. It's also easy to use two or three of them at a time.

Circular glass filters are available in several standard sizes. Special-effect modifiers are generally made of glass. Use filters and modifiers in appropriate holders in front of the camera lens.

Several manufacturers produce plastic optical filters. They are part of a modular system that includes filter holders of several sizes. A wide selection of color filters, graduated color filters and special-effects attachments is available. Ask your photo dealer for details.

Some fisheye and long telephoto lenses have built-in filters with a limited selection of colors. Distortion caused by the fisheye and the color from the built-in filter combine to make this a surrealistic image.

COLOR PHOTOGRAPHY

Color filters have many uses in color photography. They have different characteristics to suit different needs. For example, just because two filters *look* blue doesn't mean they are *identical*. They may have very different spectral characteristics, designed to suit specific needs.

COLOR-CONVERSION AND LIGHT-BALANCING FILTERS

Daylight-balanced color film is designed to give good color rendition in lighting having a color temperature of average daylight. This is about 5500K. When the color temperature of the illumination is different, corrective filtration is needed for accurate color reproduction.

Color Conversion—Color-conversion filters convert the color temperature of the illumination to that for which the film is balanced. Such filters do not control individual colors, but tilt the total color balance toward the red or blue end of the spectrum.

The bluish 80-series filters convert standard (3200K or 3400K) tungsten illumination for use with daylight-balanced film. The amber 85-series filters convert daylight for use with film balanced for standard tungsten light. When using

daylight-balanced film in landscape photography, you should rarely need these filters. You'll need them when working in shade under a clear blue sky or under an overcast sky. In these situations, the light can be extremely blue. For example, in shade under a blue sky the color temperature can be as high as 15,000K to 18,000K.

Light Balancing—These filters are in the bluish 82 series and the yellowish 81 series. They are similar to color-conversion filters, but weaker. With them, you can "fine tune" the color balance of the illumination. For example, to reduce the excessive blue light from an overcast sky, use one of the 81-series filters. If you want to eliminate an excess of red from early-morning or late-afternoon sunlight, use a bluish 82-series filter.

Daylight is rarely undesirably reddish. At sunrise and sunset, you generally *want* to record the warmth of the illumination. An excess of blue in a landscape photo is much more undesirable. Whether it's caused by an overcast sky, blue-sky illumination in the shade or the effect of ultraviolet radiation, you usually want to eliminate it. Therefore, the 81-series filters are very useful to the landscape photographer. The 82-series filters are rarely needed.

Chart—Table I on page 138 shows the colors and relative strengths of color-conversion and light-balancing filters.

COLOR-COMPENSATING FILTERS

Color-compensating (CC) filters are designed to give you control of *individual colors*. When you have balanced the spectrum of the illumination to suit the film, you may still need CC filters. Foliage may reflect light onto a subject, imparting a green imbalance. Or, the color of a wall or other reflecting surface may cause an imbalance you want to remove.

The film itself may have an inherent imbalance that you want to correct. A film may have a tendency to record red with a slight magenta color cast. You can subtract the excess magenta by using a filter opposite in color—a green CC filter.

CC filters are made in six colors. Three are the

Tungsten-balanced film was used in daylight. The result is much too blue. If you want to use this kind of film in daylight, an amber series-85 color-conversion filter will correct the color balance.

This daylight scene was photographed on daylight-balanced film. The colors are accurate.

Here, a warming series-85 filter was used with daylight film on a daylight scene. The scene appears too reddish—unless the deliberate aim was to create a sunrise or sunset effect.

The photo at right is pleasant but lacks impact. The photo above was made on the same color-slide film with a sepia filter on the camera lens. This filter is useful in landscape photography. Notice the realistic and warm color of the wood in the cabin.

primaries—red, green and blue. The others are their complementary colors—cyan (blue-green), magenta (blue-red) and yellow (red-green). The filters are available in a range of densities, as shown in table III on page 138.

You don't need filters of all six colors. The cyan, magenta and yellow filters can give you all the colors. Consider this example: Suppose you want to enhance red. The magenta filter transmits only blue and red. The yellow filter transmits only green and red. Used together, these two filters transmit only red. That is, they have the same effect as a red filter of the same strength.

Each filter subdues its complementary color. A yellow filter reduces a blue imbalance. A magenta filter reduces an excess of green. The extent of the filter's effect depends on its strength, or density.

Two or more filters can be used at a time. The density values are additive. For example, CC 20 Yellow plus CC 10 Yellow is equivalent to one CC 30 Yellow filter. You can also use filters of different colors to achieve a desired effect. For example, a CC 20 Yellow filter reduces or eliminates a bluish color imbalance. If you use a CC 10 Red in addition, you'll reduce or remove a bluish-green imbalance.

You will rarely need to use more than two CC filters together. I advise you never to use more than three. The multiple layers in front of the camera lens could lead to noticeable image deterioration.

You can also use CC filters to *strengthen* colors. For example, you may be photographing green foliage on a film type you know does not record green ideally. By using a green CC filter, you can accentuate the color of the foliage. But don't overdo it. The filter will also impart a green imbalance to other subject parts. This will be most evident in neutral-gray midtones.

To help you identify the correc-tion needed for a color imbalance, Kodak produces special color-print viewing filters. You can view the photograph you have made through various of these filters. The one that visually gives you the effect you want indicates the filter you need to get a print with well-balanced colors.

IDENTIFICATION OF COLOR IMBALANCE

The eye is not as sensitive as color film to color changes or color imbalances. Therefore, you can't always visually predict a color imbalance on film or determine the corrective filtration needed. Unless a color imbalance is extreme, you may not notice it until you see it in a photograph. You must base future correction on what you see in the finished photo. This applies to the use of color-conversion, light-balancing and CC filters.

Sometimes you can predict a color imbalance from having previously encountered similar lighting conditions. For example, at high altitudes toward the middle of the day you can assume that the light will have a high blue content. To balance the light, you'll need to use filtration from the 81 series. The same applies when you're shooting in shade under a blue sky. But even when you can predict the color of the filtration, you usually won't know the *amount* of correction needed until you see a finished photograph.

A bluish color imbalance, also called a *cool* bias, is nearly always unacceptable. A reddish imbalance, also known as a *warm* bias, is often acceptable in a photo. For example, slightly warm skin tones are more readily accepted than slightly cool, bluish ones. Because of this, most people can detect a bluish imbalance much more readily.

When you're photographing scenes you can't easily reshoot, make exposures with different color filters of different strengths. This will ensure a good result. The principle is much the same as exposure bracketing.

There's a useful color-temperature-balance dial in the *Kodak Professional Photoguide* (Publication No. R-28). It's available from Kodak or professional photographic dealers. It shows the filtration needed in widely different lighting conditions.

POLARIZING FILTER

A polarizing filter is especially useful in color photography. It has the rare ability to affect the depth and brilliance of colors without imparting a color imbalance. It is itself colorless.

As the name implies, polarizing filters control polarized light. Light is polarized when it is reflected from non-metallic surfaces (or *painted* metal) at a specific angle—about 35°. It is also polarized in specific parts of a blue sky, as I'll explain in a moment.

Color Saturation—When you look at a colored surface, you see both the color and the surface reflection. The surface reflection usually has the color of the incident illumination. This light desaturates the subject colors and makes them appear weaker than they really are. For example, you may be looking at a bright red wall. The red is weakened by the surface reflection of an overcast sky.

When the angle between you and the wall is about 35°, the surface reflection consists of polarized light. This is light that radiates in only one plane perpendicular to the axis of the light beam. You can eliminate this surface reflection by using a polarizing filter on the camera lens.

Rotate the polarizer until the surface reflection is eliminated. You'll see when this happens by looking through the camera viewfinder. Only the color in the wall will be left. You can photograph it in its full brilliance.

The best way to learn the effect of a polarizer is to look through one without a camera. Aim it at a

The effect of a polarizing filter is not the same on all parts of the sky. The maximum darkening effect is achieved on that part of the sky that subtends a 90° angle between your position and the sun. The photo at right shows the maximum effect of a polarizer on blue sky.

car and rotate the filter. Notice how surface reflections disappear and reappear.

As the angle between the surface and you becomes greater or less than about 35°, the effect will become less. When you're facing a wall head on, for example, the polarizer won't have any effect at all.

Blue Sky—In b&w photography, you can darken a blue sky by using a yellow or orange filter. With color film, you can't use a color filter for this purpose. It would give the entire picture a color cast. Fortunately, the polarizer does the same job, without affecting color balance.

Here, too, the effect works only under specific conditions. Maximum polarization occurs when the sky and the sun are at right angles to each other as seen from your location.

To discover the effect the polarizer has, look through it and rotate it. You can do this through the camera viewfinder or with the filter directly in front of your eye.

Unwanted Reflections—Polarizing filters are useful for eliminating or reducing reflections from non-metallic surfaces. These include windows, furniture and water. Again, the angle at which you are facing the surface is important. When the angle be-

tween the camera and the surface is about 35°, you can get almost total elimination of reflections. As you get away from that angle, the effect becomes less.

This technique is useful when you want to see and photograph detail below water or behind a window. However, you should beware of overdoing it. For example, when all specular reflections are removed from a water surface, the effect can be dull and lifeless. You have control. By rotating the polarizer, you can vary the extent to which reflections are removed.

Filter Factor—Use of a polarizing filter calls for an exposure increase. This increase depends on the inherent neutral density of the filter. It also depends on the amount of reflection reduction the filter is set for and on the effect you want to achieve. Therefore, the filter factor varies. A good starting point is an exposure increase of two exposure steps. Bracket your exposures.

Unfortunately, readings of polarized light by through-the-lens meters in SLR cameras are not dependable. This can be due partly to the fact that the polarized light is modified by optical parts within the camera. It's also caused by the fact that the meter doesn't *know* what you're trying to achieve with

the polarizer. Sometimes it will tend to neutralize the effect you're setting out to achieve.

Make an exposure-meter reading without the accessory on the lens. Then apply the filter factor recommended by the filter manufacturer.

Special-Effect Polarizer—This is a novel lens attachment that gives unusual and abstract color effects in your photographs. It consists of two sandwiched polarizers that can be rotated independently of each other. Each polarizer is of a different color. Chromo-Blend filter pairs come in red and blue, yellow and green, and yellow and red. Filters of this kind are made by several manufacturers. Ask your photo dealer for details.

You place this attachment on the camera lens in the usual way. Observe the scene through the viewfinder and rotate one or both of the polarizers. Depending on the orientation of each of the polarizers and the nature and surface angles of the subject, you'll introduce a variety of colors. Some subject parts will be affected by the color in one polarizer. Some will be influenced by the color of the other. There will also be mixtures of different amounts of the colors in both polarizers. Some subject parts won't be affected at all.

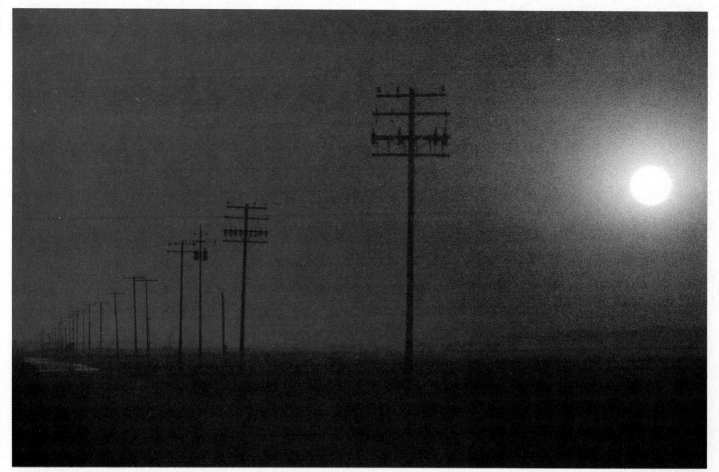

You can get some unusual colors by using special-effect filters. For this photo, I used a Spiratone magenta filter. Strong filters like this reduce lens flare considerably. Notice the clear, round image of the sun. Without a filter, the circle would have spread into an unrecognizably large blur.

Multi-colored, polarized *Chroma-blend* filters can give you many different color effects. This photo was made with the blue-red filter. By rotating the filter on the camera, you can change the color effect. Use these filters with restraint in landscape photography. Some effects are attractive—many are inappropriate.

The result will be abstract and unpredictable. You'll just have to experiment until you see an effect you like.

GRADUATED FILTERS

Graduated filters are designed to enable you to filter one part of a scene while not filtering another. Or, they enable to you filter two parts differently. The filters can be in color or of neutral-gray density. Filters of different densities, in both color and gray, are available.

A typical example is a filter for darkening the sky. The half of the filter through which the sky is recorded may be neutral gray or blue. The other half of the filter is clear. The transition between the two parts of the filter is usually gradual.

For these filters to work effectively, the division between the subject parts that do and do not need filtration should be a reasonably straight line.

Neither a color filter nor a polarizer will have any effect on a colorless overcast sky. To reduce negative exposure in the sky area, relative to the rest of the scene, you can use a graduated neutral-density (ND) filter over the camera lens. The dense part of the filter is located to affect the sky. This enables you to get detail in clouds, as in this photo.

B&W PHOTOGRAPHY

Color filters have a use in b&w photography as well as with color film. They are not the same filter types as those I've just discussed. They are designed to do a different kind of job. Their main purpose in b&w work is *contrast enhancement or reduction*. Polarizing filters and graduated filters are also useful here.

COLOR FILTERS

The one basic reason for using a color filter with b&w film is to change the tonal value of a color. Through proper filter selection, you can control the density in the b&w image of any color.

This is useful in contrast control. For example, you can darken the blue of the sky, to make white clouds stand out more clearly. You can increase the tonal difference between two adjacent colors in a scene, to increase contrast. Or, you can lighten foliage, a painted wall or a dress, to suit your pictorial needs.

Table IV on page 138 shows the filters most commonly used in b&w photography. When you choose any filter, remember this basic rule: A filter lightens its own color and darkens other colors. The complementary color is darkened most. For example, a red filter will lighten red objects in the image. It will have little effect on

orange and yellow. It will darken green and blue.

Here's a specific example: Your subject consists of red flowers among green foliage. On b&w film, the red and green record similarly in tonal density. It would be difficult to distinguish the flowers from the leaves. Color filtration can cure this.

If you use a red filter, the flowers will stand out brightly against the darker foliage. If you prefer dark flowers against bright foliage, use a green filter instead.

Because color filters absorb light, they have filter factors. These indicate the exposure increase that's necessary with their use. Filter and film manufacturers

provide filter-factor information. However, you should use the factors provided only as a guide. The exact exposure compensation needed depends on the exact nature of the subject, the color of the illumination and the end result you want. It's a good idea to bracket exposures.

POLARIZING FILTER

The polarizing filter does basically the same job in b&w photography as with color film. It enables you to reduce or eliminate unwanted reflections from nonmetallic surfaces. With it, you can also darken a blue sky. However, the latter can also be achieved with a yellow, orange or red filter.

As I mentioned earlier, on color film you can enhance color saturation by using a polarizer to remove surface reflections. In b&w photography, elimination of surface reflections can lead to a clearer and more contrasty image.

GRADUATED FILTERS

I've described graduated filters in the section on color photography. Neutral-density graduated filters can be used in the same way with b&w film. You can use such a filter to darken a bright sky or any other subject area that requires darkening. But the separation between the bright and dark subject areas must be a fairly straight line.

You can use a graduated color filter with b&w film, too. For example, to darken a blue sky you can use a filter that is half orange or red and half clear.

In the color photo, the white building stands out well from the deep blue sky. In the upper b&w picture, the sky is too pale and the picture lacks impact. Panchromatic films are highly sensitive to the blue and ultraviolet in a clear sky. They record the sky as too light. When the lower b&w photo was made, a No. 15 yellow filter was used on the camera lens. This helped to darken the sky to produce a much more dramatic image.

I wanted to make the Conservatory at San Francisco's Golden Gate Park stand out like a bright crystal. To do this, I had to darken everything around it. I had to darken two colors—the blue of the sky and the green of the vegetation. I chose a red filter because its color is complementary to both those colors.

IMAGE MODIFIERS

These are colorless lens attachments that can be used with color or b&w film. Their function is to alter the optical path of the light from the subject to achieve a specific effect. The possible effects are many. However, image modifiers should be used with discretion. Only a few are applicable to landscape photography.

SOFT-FOCUS EFFECTS

Soft focus does not mean *out of* focus. At least, not with a high-quality attachment like the Zeiss Softar. Some less expensive types may break up image resolution a little.

A good soft-focus attachment permits the sharp reproduction of each image point. Each bright image point is surrounded by a subtle spread of light halation. The soft-focus effect is produced by this gentle spreading of highlights into surrounding darker areas.

This is true of images made in the camera. However, it's not true when you make an enlargement from a negative, using a soft-focus attachment on the enlarger lens. What happens then is that dark image points spread out into the highlight areas. This effect is usually less effective or pleasing in the final image. Instead of making an image softer and brighter, it gives it a softer but darker appearance.

Do-it-yourself soft-focus attachments can be made easily by stretching a piece of silk stocking over the camera lens. To avoid a color imbalance in color photos, the material should be neutral in color.

Use the soft-focus attachment with discretion. It is only rarely appropriate in landscape photography. Generally, you'll want a bright and sharp image. At other times, the softness will be provided by the subject itself. Typical examples include mist, rain, fog and atmospheric haze.

FOG ATTACHMENT

You can simulate a natural atmospheric mist or fog effect with a fog attachment on the camera lens. Use a good-quality attachment to prevent image degradation. The attachments are available in various strengths. Try them on the camera, and examine the scene through the viewfinder, to determine which is most suitable.

Look at the effect with the lens stopped down to the aperture you plan to use. The effect differs with the aperture setting. It can also differ at identical apertures with different lenses.

A fog attachment will reduce image contrast. To maintain tonal separation and detail in the image, use a color film with inherent high contrast. With b&w film, you can regain some of the lost contrast by adjusting the processing, as described earlier.

If you have a spot light meter that measures at the film plane, you can determine accurately the effect the fog attachment has on image brightness.

STARBURST ATTACHMENTS

In their simplest form, they have two sets of closely-spaced parallel lines engraved in glass at right angles to each other. This grid diffracts light from highlight points in the subject to produce a pattern of four-pointed stars on the film. More complex types have a grid pattern that produces stars with six, eight or even more points.

The least expensive of these attachments can cause some flare and image degradation. The best of them are made with precision of high-quality optical glass. They have virtually no degrading effect on the image.

To use these attachments effectively, specific conditions are called for. There should be bright point-sources of light in the locations where you want the stars to appear. The background behind these light sources should be dark, so the stars stand out.

In landscape photography, probably the most common use of

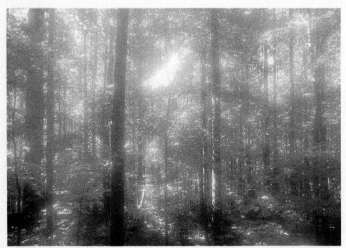 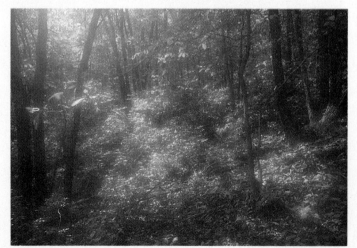

The extreme contrast of a backlit forest scene can be reduced considerably by the use of diffusion or fog attachments on the camera lens. When one color dominates, as in the photo at left, the attachment tends to infuse the entire image with that hue. When the image has a balance of more subdued colors, as in the photo at right, the end effect is more neutral in color.

starburst attachments is in urban night scenes. Street lights and other point sources of illumination produce the stars against the dark background of night. Effective results are also possible with close-up subjects. An example is plants covered with highlighted dew. Each of the point highlights can be converted into an effective star.

When the lens is set to a small aperture, you can sometimes achieve a star effect without a separate attachment. The shape of the lens diaphragm converts point highlights into starlike shapes. But it's not as effective as a starburst attachment.

DIFFRACTION GRATING

A diffraction grating consists of a grid that is extremely fine and closely spaced. When the light is diffracted to make stars, it is also broken down into the colors of the spectrum. This means you get stars whose light changes color as it radiates away from the central light spot.

VIGNETTERS AND MASKS

A vignetter changes the outline of the image from the customary sharp and rectangular one. Usually it gives an oval outline with a soft gradation. A vignetter is usually attached to a compendium-type or bellows lens shade.

When the outer area of the vignetter is dark, it yields a dark or black outline to the image. This is suitable for low-key subjects. When the outer part of the vignetter is white and translucent, the area outside the oval image will be light. This suits high-key subjects.

A mask completely blocks the light from a section of the image. It enables you to make double exposures for special effects. For example, you can make a composite picture of two different subjects, or can include the same person twice in the photo.

From the above, it will be clear to you that vignetters and masks have little application in landscape photography. I have mentioned them here only to make you aware of their existence. Use them, but do so sparingly and with discretion.

CONTRAST-REDUCTION ATTACHMENT

These are relatively new and unknown. However, Tiffen offers a series of Low-Contrast Filters in a wide variety of strengths. They are designed to reduce overall image contrast without significantly affecting other aspects of image quality. A small proportion of the light passing through the filter is dispersed over the entire image area. It is similar to pre-exposing the film to a uniformly lit surface before exposing the subject.

The scattered light has much more effect on shadows than on the brighter image areas. Overall contrast is reduced, so you can record a high-contrast scene on color-slide film and retain some shadow detail.

This photo was made with a diffusion attachment on the camera lens. The result can be very effective with delicate flowers.

This effect was achieved with a home-made aperture disc. To make the disc, cut a piece of black paper to the size of a filter. Use a leather punch to make a fairly large central hole, surrounded by many smaller ones. Place the disc in an adapter ring in front of the camera lens. Set the lens aperture to wide open. This dogwood blossom had a patterned light and dark background. The disc translated this into a delicate display of soft dots behind the subject.

Appendix

APPENDIX A
FILTRATION TABLES

Table I

COLOR-CONVERSION AND LIGHT-BALANCING FILTERS

Conversion filters enable you to convert the color of the illumination to suit the type of color film you are using. Balancing filters are similar but weaker. With them, you can fine-tune color balance.

← Filters increasingly bluish								Filters increasingly red-yellowish →										
Color Conversion				Light Balancing				Light Balancing						Color Conversion				
80A	80B	80C	80D	82C	82B	82A	82	81	81A	81B	81C	81D	81EF	85C	85	85B		

Table II

WARMING FILTERS

These filters are especially useful in landscape photography. They warm the image colors when the daylight is bluish. If you use a color-temperature meter, refer to the table to determine the filtration needed. Use the table when you're shooting on daylight-balanced (5500K) color film.

When color temperature of light is:	Use this filtration:
5,600K	81
5,700K	81A
5,800K	81B
5,900K	81C
6,000K	81D
6,150K	81EF
10,000K	85C
Above 10,000K	85C + 81-series filter

Table III

COLOR-COMPENSATING (CC) FILTERS

With CC filters you can correct imbalances of virtually any color. The filters are available in the colors and strengths listed below. You can use more than one filter at a time.

Filter color	Colors darkened	Filter strength (increasing from left to right) and exposure increase in exposure steps					
Cyan (blue-green)	Red	05C 1/3	10C 1/3	20C 1/3	30C 2/3	40C 2/3	50C 1
Magenta (blue-red)	Green	05M 1/3	10M 1/3	20M 1/3	30M 2/3	40M 2/3	50M 2/3
Yellow (red-green)	Blue	05Y 1/3	10Y 1/3	20Y 1/3	30Y 1/3	40Y 1/3	50Y 2/3
Red	Blue and green	05R 1/3	10R 1/3	20R 1/3	30R 2/3	40R 2/3	50R 1
Green	Blue and red	05G 1/3	10G 1/3	20G 1/3	30G 2/3	40G 2/3	50G 1
Blue	Red and green	05B 1/3	10B 1/3	20B 2/3	30B 2/3	40B 1	50B 1-1/3

Table IV

FILTERS FOR B&W PHOTOGRAPHY

Wratten No.	Color	Effect
6	Light yellow	Absorbs blue. Slightly darkens blue sky. Provides accurate tonal rendition of outdoor scenes.
8	Yellow	Absorbs blue. Gives correct tonal rendition of blue sky and green foliage.
15	Deep yellow	Absorbs blue. Darkens blue sky considerably.
11	Yellow-green	Absorbs blue and some red. Lightens green foliage and vegetation.
13	Yellow-green	Absorbs blue and some red. Stronger than No. 11. Tends to give skin a tanned appearance.
25	Red	Absorbs nearly all blue and green. Blackens blue sky. Penetrates haze.
58	Green	Absorbs nearly all blue and red. Lightens green foliage and vegetation.

APPENDIX B

REPRODUCTION METHODS

You can enlarge and print any type of film—color and b&w negatives, and color slides. The complexity of the processes varies. Kodak Ektaflex system and slide copiers using instant film are simple to use. However, such processes as making dye-transfer prints call for considerable skill and experience. The accompanying chart lists current major reproduction methods.

Original	Reproduction Medium	Result	Comments
Color negative	Ektacolor 74RC paper	Color print	General-applications paper.
	Ektacolor 78 paper	Color print	More contrasty than 74RC.
	Ektaflex PCT negative film	Color print	Needs Ektaflex Printmaker. Rapid, easy, one-solution process.
	Dye transfer	Color print	Very expensive and complex. Numerous steps involved. Requires skill. You can control image contrast. Dyes are highly fade-resistant. You must make a positive transparency from the negative and work from that.
	Panalure paper	B&W print	A panchromatic paper that reproduces all colors in realistic gray-tone values.
	Ektacolor print film	Large-format color transparency	Use normal color-darkroom equipment and methods.
Color slide	Ektachrome 14 paper	Color print	A reversal paper—makes positive print directly from slide. Use normal color-darkroom equipment and methods.
	Ektaflex PCT reversal film	Color print	Needs Ektaflex Printmaker. Rapid, easy, one-solution process.
	Agfachrome-Speed	Color print	Rapid, easy, one-solution process. No special processing equipment needed.
	Cibachrome	Color print	Positive-to-positive system. Yields brilliant colors. Highly fade-resistant dyes. See *Complete Guide to Cibachrome Printing,* published by HPBooks.
	Instant color film (Polaroid and Kodak)	Color print	Instant color prints suitable as proofs. Use instant slide copier—available from Polaroid, Vivitar and others.
B&W negative	Various printing papers	B&W prints	See table of *B&W Enlarging Papers,* Appendix C.

139

B&W ENLARGING PAPERS

Listed below are some premium-quality photographic papers I recommend for enlarging your landscape photographs.

I suggest using *fiber-base* papers rather than resin-coated (RC) papers. The fiber-base papers give a more permanent print. They also tend to provide a wider tonal range.

In my experience, papers that come in *different grades* give better tonal range and rendition than variable-contrast papers. *Double-weight* paper is preferable to single-weight. It is easier to mount and frame, does not curl so readily when not mounted, and is more damage-resistant.

My preference in paper surface is *glossy*. This includes shiny surfaces like *smooth lustre*. It gives the brightest, most saturated colors and longest reflection-density range. It also tends to give best image sharpness. You can select among many other surfaces and textures to suit your personal taste and the nature of your photographs.

Different papers give different tones.

Cool-tone papers yield bluish blacks. These are suitable for pictures that depict a cold scene, such as a snowscape or an ocean setting. *Warm-tone* papers give reddish-brown blacks. They lend themselves to many landscapes. A good example is a scene containing autumn foliage. There are also *cream-white* papers. These are intended primarily for portraiture but are also well-suited to some landscape and architectural photographs.

You can also tone photographic papers after processing. See *B&W Image Stability and Tone,* Appendix E. A variety of tones is available. Some papers are more suitable for specific toners than others. Read the directions provided with both the enlarging papers and the toners.

Different *paper developers,* as well as processing techniques, can be used to control image contrast. See *Developers for B&W Fiber-Base Papers,* Appendix D. See also the instructions with papers and developers.

Paper	Manufacturer	Properties
Brovira	Agfa	Neutral black and white tones. Black density can be improved in weak Rapid Selenium Toner with no significant color change. I recommend standard MQ paper developer.
Portriga Rapid	Agfa	Warm, slightly cream-white paper base. Rich blacks. *Warmish* tone when developed in *cold-tone* MQ or PQ developer.
Classic	Arista	Has a long tonal scale and produces shadows and highlights with good tonal separation. Gives neutral to slightly warm blacks with most popular print developers. Weak Rapid Selenium Toner improves blacks without affecting color of image tone. Imported by *Freestyle Sales Company,* Los Angeles, CA, and sold by mail order.
Brilliant		Outstanding quality. Relatively expensive. Good whites and blacks. Rapid Selenium Toner makes inherent warm tones warmer. Each grade gives higher contrast than same grade with most other papers. Available only through *Zone VI Studios, Inc.* Newfane, VT 05345.
Ilfobrom	Ilford	Bright, white paper base and neutral black image. Reproduces detail in a long tonal range, although maximum black is not the best. Mild selenium toning deepens blacks. Full range of contrast grades provides wide range of contrast control.
Galerie	Ilford	Warm paper base and warm image tone. Each grade is about half a grade more contrasty than standard when developed in Ilford liquid-concentrate developer made for Galerie. Ilford also provides fixer and processing treatment for archival image stability. Galerie gives good image detail in highlights and shadows. Rapid Selenium Toner deepens blacks well.
Kodabromide	Kodak	Cold-tone paper on neutral-white base. Excellent tonal gradation but not best maximum black. Offers widest selection of surfaces, weights, contrast grades and sizes.
Medalist	Kodak	Similar to Kodabromide in many ways. Has a warmer image tone and can be toned in several single-solution toners. Cream-white paper base. Grades 1 through 4 available in single-weight only.

Paper	Manufacturer	Properties
Polycontrast	Kodak	Only high-quality fiber-base *variable-contrast* paper currently available. Comes in a variety of surfaces in both single- and double-weight. Having one paper for all contrast needs can reduce paper waste. Not much development latitude. But contrast within one print can be controlled selectively by successively using different filters. Warm black tone.
Seagull	Oriental	High-quality paper with neutral image tone and exceptionally deep blacks. Responds to variations in development. Blacks get even better with mild Rapid Selenium toning. Exceptional reproduction of detail in both shadows and highlights.
Center	Oriental	Similar to Seagull but warmer tone and especially suitable for sepia toning. Neutral-white paper base. Blacks are not improved by Rapid Selenium Toner.
Pal Silver Bromide	Pal Chemical Corp.	Many similarities with Kodabromide, Ilfobrom and Agfa Brovira. Neutral to cool-black image. Neutral-white paper base. Has some development latitude. Moderately priced. To produce very cool, maximum-density blacks, process in Amidol developer.
Pal Chlorobromide	Pal Chemical Corp.	Warm-black image on neutral-white paper base. Good tonal detail in both shadows and highlights. Moderately priced.
Unicolor	Unicolor Div. Photo Systems, Inc.	Warm-tone image on neutral-white base. Smooth luster surface. Responds well to single-solution toners. Rapid Selenium Toner warms image but does not deepen blacks.

APPENDIX D
DEVELOPERS FOR B&W FIBER-BASE PAPERS

Developers for fiber-base enlarging papers can be divided into two groups. The developing agents in *MQ* developers are metol and hydroquinone. *PQ* developers contain phenidone and hydroquinone. They tend to have a longer useful tray life than MQ developers.

The following MQ developers are readily available: Dektol, Selectol, Selectol Soft and Ektanol. Each is made by Eastman Kodak and each comes in dry powder form. Some people are allergic to metol and should avoid getting MQ developer on their skin.

In the PQ group of developers you have a far greater selection. Most of these developers are supplied as liquid concentrates. Among them are Ektaflo I and Ektaflo II, from Kodak. Ilfobrom from Ilford and Ethol LPD are available in dry-powder form.

General-purpose cold-tone developers are the most widely used. Among these are Dektol and Ilfobrom. Some, such as Ethol LPD and Edwal Platinum can give a cold- or warm-tone image, depending on their dilution. Some developers are specifically formulated to give a warm-tone image. Selectol and Selectol Soft are among these. Ektanol is a warm-tone developer designed to minimize the danger of staining when you tone the print.

The experienced printer can use two or more developers sequentially to locally control image contrast. A common and effective combination is Selectol Soft (for a soft image) and Dektol (for a more contrasty image).

It's becoming more common for experienced printers to mix their own developers. This enables them to get more precisely the effect they want than is possible with commercially prepared developers. You can also choose developing agents that are not normally used for mass production. Amidol and Glycin are in this group.

Glycin can make an extremely effective warm-tone developer. Amidol is used in various formulas with sodium sulfite and a small amount of potassium bromide. Amidol can produce very rich blacks from some types of fiber-base enlarging papers.

Pre-measured quantities of ingredients, ready to go into solution for immediate use, are available by mail order from *The Photographer's Formulary*. The address is Box 5105C, Missoula, MT 59806. This service offers the best of both worlds. It provides convenient ready-to-use packaging and optimum special performance.

If you want total control of your creative printing, you must be familiar with your tools. I recommend that you make test prints with the paper and developer combination you plan to use. If one combination doesn't give the result you want, make further tests with other combinations. Keep careful notes of your test data. This will enable you to repeat the procedures and ensure that you get the result you want.

APPENDIX E
B&W IMAGE STABILITY AND TONE

Toning a b&w print can achieve two important goals. It can give the print an attractive tone that complements the nature of the image. It can also make the image more durable, delaying staining and fading. You can achieve this dual purpose with both a Rapid Selenium toner and a Gold Chloride toner.

The b&w photographic image consists of metallic silver. Just as home silverware tarnishes with time, so can the silver in a photograph deteriorate. This process can be slowed by converting the silver into, or protecting it with, a more durable substance. Gold and selenium are well suited for this job. Selenium is used more frequently, because of the high cost of gold.

Before toning, there are other needs you must satisfy to ensure a stable image. Develop the print fully and fix it thoroughly. After fixing the print, wash it well. This effectively removes all chemical traces. You can reduce the wash time by using a *washing aid*.

Many photographers use a simple fixer consisting of sodium thiosulfate and bisulfite. Neutralizing its residual chemicals is relatively easy. With this kind of fixer you also avoid the detrimental bleaching of delicate highlights that can occur with other fixers.

Fixer elimination and toning is possible with one bath, immediately after washing. This bath consists of Rapid Selenium Toner concentrate and a solution of washing aid such as Orbit or Husky . Dilute the washing aid with between 20 and 40 parts of water. Mix this solution in equal parts with the toner concentrate. The working solution neutralizes, stabilizes and tones.

If your main aim in using Rapid Selenium Toner is to achieve an appreciable color change, print on a paper with a high silver-chloride content. Such papers are Agfa Portriga Rapid, Kodak Medalist and Oriental Center. Some other warm-tone papers may also respond noticeably to strong selenium toning. However, the color change will tend to be toward a purple-brown.

If you want a neutral brown on a chlorobromide paper, I recommend Kodak Brown Toner. It's a single-solution preparation. The greater the chloride content of the paper, the warmer the tone. There are several other brands of single-solution toners that produce similar results.

Some toners contain a combination of ferricyanide bleach and a dye. These create brilliantly colored image tones. They also produce an unstable image that can deteriorate rapidly. If print longevity is an important consideration, I recommend you avoid them.

You can create a brown tone on a cold-tone paper that doesn't respond well to single-solution toning. Use a two-solution sulfide sepia toner, such as Kodak Sepia Toner. This involves bleaching the image in one solution and then redeveloping in another. Thorough washing between the baths and after the treatment is essential. Carefully follow the directions provided with the toner. The resultant prints can be as stable as those produced under the most desirable conditions.

Index

7.423907835108